# Art from Africa
Long Steps Never Broke a Back

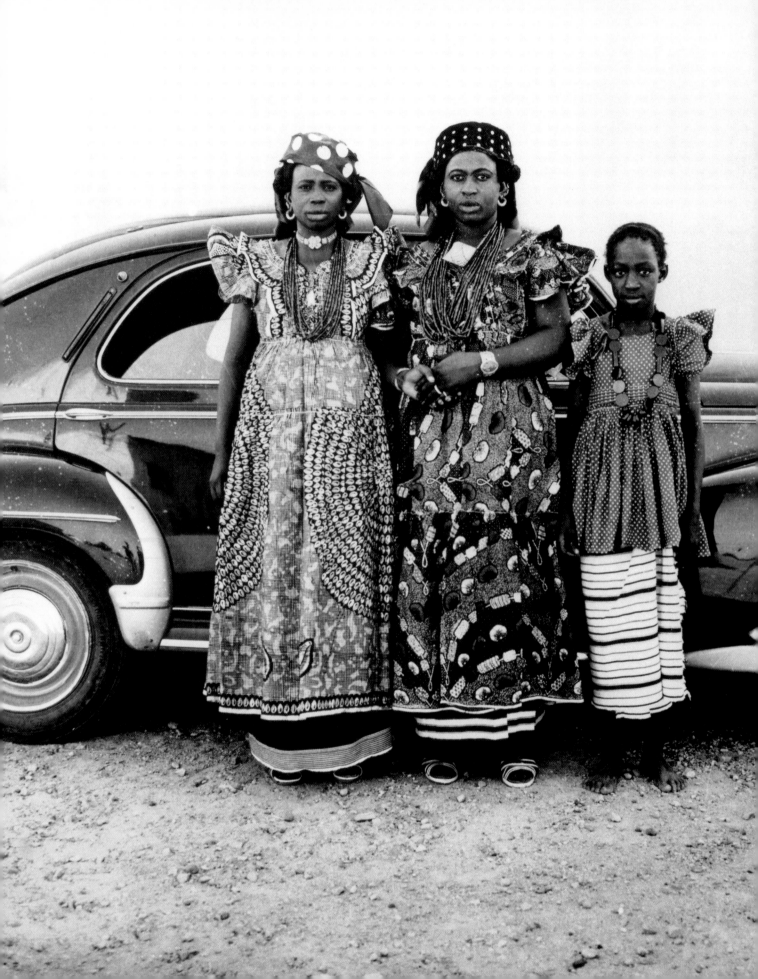

# Art from Africa
## Long Steps Never Broke a Back

**Pamela McClusky**

With a contribution by Robert Farris Thompson

**Seattle Art Museum**

**Princeton University Press**

This book has been published in conjunction with an exhibition on view at the
Seattle Art Museum from February 7 through May 19, 2002.
Operating funds from the Institute of Museum and Library Services, a federal agency,
are being used to support this project; publication of the book was made possible
in part by a research and planning grant awarded by the National Endowment for the Arts.

The exhibition, organized by the Seattle Art Museum, has been generously supported by

*Presenting Sponsor*

Washington Mutual

*Additional Support*

*Seattle Post-Intelligencer*
Seattle Arts Commission
PONCHO
(Patrons of Northwest Civic, Cultural and Charitable Organizations)
American Express
The Allen Foundation for the Arts
Contributors to the Annual Fund

*Deepening the Dialogue,* an initiative funded by the Wallace-Reader's Digest Funds, is a key component
of this exhibition, strengthening SAM's programming and community partnerships.

Published by the Seattle Art Museum in association
with Princeton University Press.

© 2002 by the Seattle Art Museum
All rights reserved.

Seattle Art Museum
100 University Street
Seattle, Washington 98101
www.seattleartmuseum.org

Princeton University Press
41 William Street
Princeton, New Jersey 08540
www.pup.princeton.edu

Project manager: Zora Hutlova Foy
Editor: Patricia Draher Kiyono
Proofreader: Jennifer Harris
Indexer: Laura Ogar
Designed by Ed Marquand with assistance by Elsa Varela
Typeset by Jennifer Sugden
Primary photography by Paul Macapia
Color separations by iocolor, Seattle
Produced by Marquand Books, Inc., Seattle
  www.marquand.com
Printed and bound by C&C Offset Printing Co., Ltd.,
Hong Kong

Library of Congress Cataloging-in-Publication Data
McClusky, Pamela.
    Art from Africa : long steps never broke a back /
Pamela McClusky ; with a contribution by Robert Farris
Thompson.
        p. cm.
    Published in conjunction with an exhibition held at
the Seattle Art Museum, Feb. 7–May 19, 2002.
    Includes bibliographical references and index.
    ISBN: 0-691-09275-3 (Princeton Univ. Press : alk.
paper)—ISBN: 0-691-09295-8 (Princeton Univ. Press :
pbk. alk. paper)—ISBN: 0-85331-848-8 (cloth : Lund
Humphries : alk. paper)
    1. Art, African—Exhibitions. 2. Art, Black—Africa,
Sub-Saharan—Exhibitions. 3. Masks—Africa, Sub-
Saharan—Exhibitions. 4. Ethnology—Africa, Sub-
Saharan—Exhibitions. 5. Art—Washington (State)
—Seattle—Exhibitions. 6. Seattle Art Museum—
Exhibitions. I. Thompson, Robert Farris. II. Seattle
Art Museum. III. Title.
N7391.65 .M28 2002
709'.67'074797772—dc21                 2001049735

Frontispiece: pl. 98, Seydou Keita, *Untitled (Family with Car
no. 266),* 1951–1952

# Contents

# Preface

African art was a source of inspiration for the art of Europe and America in the twentieth century. Once artists in Paris turned attention toward its restless and inventive formal qualities, modernism was forever altered. Not long into the century, this awareness spread to New York and led to waves of influence in gallery circles. In other neighborhoods, African aesthetics had long ago infused American icons, actions, music, and movement with compelling expressive force. By the end of the twentieth century, art from the African continent was admired not only for its striking forms but also for its meaningful impact on many other levels. Whereas African art's calling card of sculptural brilliance has been widely recognized, inquiry into the complex role it enacts in African lives is still growing.

*Art from Africa: Long Steps Never Broke a Back* catches up with that inquiry. Not a comprehensive survey of many objects, this publication instead pursues a small selection in depth and relies on a curator's individual voice to begin the exploration. Inside museums, curators pose questions about collections and construct domes of reference to contextualize objects. How curators trace the multiple histories of an object, its passage through different hands, its changing status and significance, is often secreted within museums, not explained to a public audience. This text renders more transparent the insider view of collecting, a complex and changing process. The book features a wide range of primary African sources—music, film, novels, and personal interviews—to reflect the fact that this art comes from settings immersed in many media. The publication and exhibition seek to recapture the joy, emotion, and meaning integral to the creation and use of these objects.

*Long Steps* is an invitation to learn more about collecting not just the objects but the meanings, stories, and ideas attached to them. A landmark scholar of African and African American art history long associated with the museum's collection, Robert Farris Thompson, was asked to revise a fundamental text. His contribution from *African Art in Motion* looks carefully at the basic stance a figural sculpture takes— standing, sitting, balancing, kneeling, or riding—in an interpretation guided by his broad sweep of experiential scholarship. After Professor Thompson's overview, Pamela McClusky adeptly guides the reader, providing the insight of a curator. She hands

viewers tools to enhance their enjoyment of the art, finding them in treasure houses, palaces, shrine complexes, performances, and community settings, and in the mix of voices of the leaders, priests, scholars, and artists whose words animate each chapter.

The Seattle Art Museum has been a major repository for African art since the 1980s. Before then, Dr. Richard Fuller, the museum's founder, had purchased only a small sampling of African objects from a few dealers. Gifts to the museum were rare but occasionally distinguished, such as the selection of miniatures offered in 1968 by Nasli and Alice Heeramaneck. In this quiet arena of acquisition an explosion was set off when the collector Katherine White offered the museum her holdings of nearly two thousand objects for a token purchase price. The Boeing Company made an unprecedented gift in 1981 that enabled Seattle to become home to a vast and distinguished gathering of art from Africa.

Katherine White was renowned for her exceptional dedication to buying what she considered the highest quality and the least recognized forms of art; she made her purchases from dealers and on trips to Africa throughout the 1960s and 1970s. Her death in 1980 at the age of fifty-one unveiled a new chapter in her legacy. When the downtown building of the Seattle Art Museum opened in 1991, the Katherine White collection formed the backbone of three major permanent-collection galleries. Following in the footsteps of White's two decades of rapid purchases, the collecting of the 1990s has been more selective and still relies on significant gifts. A new layer of contemporary art is moving into place, as is a fresh definition of the collecting process, seen in the final chapters of this book.

The Seattle Art Museum's strength in, and celebration of, African art is the work of curator Pam McClusky. She deserves accolades for the brilliance of this project, and for Seattle's acquisition of the Katherine White collection some twenty years ago. Pam and Katherine White shared a single passion; Pam's close relationship with Katherine White convinced the collector that SAM would be the most appropriate home for her art. In both the exhibition and this book, Pam, with characteristic modesty and unassuming demeanor, steps aside, bringing to the fore primary voices, African voices. She, however, is the leader, orchestrating the voices, writing the majority of this publication, and ensuring rigorous intellectual context and an imaginative approach.

This project, exhibition, and publication could not have taken place without the generous support of institutions and individuals. Vital corporate sponsorship for the exhibition was provided by Washington Mutual, whose community giving emphasizes education and reinforces the Seattle Art Museum's strong commitment to schools and teachers in the region. Additional support for the exhibition has come from *Seattle Post-Intelligencer,* the Seattle Arts Commission, PONCHO (Patrons of Northwest Civic, Cultural and Charitable Organizations), American Express, The Allen Foundation for the Arts, and the Wallace-Reader's Digest Funds, strengthening the museum's programming and community partnerships. New photography of the collection and the initial stages of the book were made possible by a research and planning grant awarded by the National Endowment for the Arts. The project was also supported by operating funds from the Institute of Museum and Library Services.

African art still beckons for admiration. Its geometric features, twisting planes, and vast formal vocabulary issue continual surprises for the eyes. Now, the swift surprise may expand into a sustained exchange with the artists, scholars, and original owners of this art. Our eyes no longer work in isolation, but are learning to take the long looks that activate appreciation.

*Mimi Gardner Gates*
*Illsley Ball Nordstrom Director*
*Seattle Art Museum*

# Acknowledgments

**The Artists**
We are all indebted to those whose work is interpreted herein.

**The Collaborators**
Many thanks to Daniel "Koo Nimo" Amponsah for refining written phrases, and for calling Kumasi for second opinions. Fu Kiau Bunseki gave lessons in cosmograms, medicines, and careful translations. Kakuta Hamisi offered challenging discussions about museums. Gilbert Mbeng coordinated research in the Kom kingdom. Won Ldy Paye must be thanked for years of keeping Liberian creativity alive in the Northwest. And we all benefit from Robert Farris Thompson's intensity that never lets up.

**The Collectors**
Katherine White gave Seattle her life's work, saying Virginia and Bagley Wright enticed her to do so. John Hauberg kindly set up a fund that supported research. Oliver and Pamela Cobb, Mark Groudine, and Cynthia Putnam now reign as generous patrons of African art, offering many friendly arguments about collecting.

**The Scholars**
Notes of appreciation go to David Conrad for clarifying elements of hunters' behavior, Donald Cosentino for allowing the use of his collected stories, Manthia Diawara for inspired writing, Perkins Foss for maintaining current information about Urhobo research, Babatunde Lawal for narrating Gelede performances, Cynthia Schmidt for locating Mende women to consult, Evan Schneider for constant access to his outstanding photographic archives, and the late Gilbert Schneider for answering questions.

**The Photographer**
The photographer of the collection was Paul Macapia, whose attention to visual details is always evident.

## The Book Producers

Zora Hutlova Foy, Manager of Exhibitions and Publications, cajoled and consoled, often in the same conversation. Patricia Draher Kiyono, editor, monitored how much unorthodox was too much, and guarded the entire configuration with diligence. Susan Bartlett, Exhibitions and Collections Coordinator, was a study in grace—supremely calm despite constant twists. The whole was delivered to Ed Marquand, designer, and his assistant, Elsa Varela, whose artistry stepped it up to another level of distinction. Marie Weiler managed the details for all of us.

## The Staff

Many people at the Seattle Art Museum went far beyond the call of duty; I thank everyone who did so, but can mention only a few pivotal individuals: I will never forget Erika Lindsay, Public Relations Associate, who on a doubtful day told me she and her fiancé were together reading the draft of each chapter. Or Helen Abbott, former Publications Manager, who insisted I write more than labels. Or Mike McCafferty, Exhibition Designer, who often seems to have better taste in African art than I do.

I owe a large debt to a sequence of Deputy Directors: Patterson Sims and Trevor Fairbrother were supportive, but Chiyo Ishikawa was the constructive catalyst who made a three-month leave possible for the final writing. Two assistants endured the endless debates sparked by not following a formula: Leasa Fortune kept pace during a year of changes and wrote "The Trouble with Tarzan," an essay that reviews the creation of African clichés in the American film industry and the ways in which African films are overcoming them. Carol Hermer never faltered in any dimension of research, from videotaping interviews to tracking down source material.

Some museum work is best when invisible. High points of perfection in mount making were reached by a group of artists working in the museum's basement. There could be no better gathering of talent to work with than Chris Manojlovic, Jack Mackey, Gordon Lambert, Paul Martinez, Ken Leback, and Scott Hartley. Care and handling of the art was overseen by Gail Joice, Deputy Director of Museum Services, whose exacting standards and sympathetic solutions set a tone for a large division in which Lauren Tucker, Marta Pinto-Llorca, and Julie Creahan have been especially attentive.

The waves of grants and fundraising efforts that sustained all the affiliated museum projects were deftly managed by Maryann Jordan, Deputy Director for External Affairs. Among her staff, Carol Mabbott, Laura Hopkins, and Laura Bales finessed innumerable documents and meetings with government and corporate donors.

**The Allies**
Charlotte Beall, Marita Dingus, Teresa Domka, Kathy Fowells, P. Raaze Garrison, Evelyn Reingold, Kay Tarapolsi, and Victoria Moreland continue to be the best African art docents imaginable. Our finest era of training was enhanced by Beverly Harding, Educator, and is continually sustained by the assistance of Elizabeth deFato, Librarian.

**The Originators of Quotations**
Thanks to all of the following individuals whose words have added a wealth of perspectives to this text: Roland Abiodun, Obo Addy, Emma Agu, T. J. Alldridge, Daniel "Koo Nimo" Amponsah, Jina Bo II, Yaw Boaten, Fu Kiau Bunseki, Kwame Butuakwa, Seydou Camara, Maryse Conde, Camille Coquilhat, Donald Cosentino, Manthia Diawara, George Ellis, Ralph Waldo Emerson, William Fagg, M. J. Field, Eberhard Fischer, Perkins Foss, Paul Gebauer, Colonel Hall, David Hammons, G. W. F. Hegel, Hans Himmelheber, Obaro Ikime, Nsemi Isaki, Pa Joe, Cheick Mahamadou Cherif Keita, Salif Keita, Seydou Keita, Babatunde Lawal, Kenneth Little, Wyatt MacGaffey, John Mack, Patrick McNaughton, Susan Minot, Paul Nchoji Nkwi, Linda Nochlin, Mvemba Nzinga, Bruce Onobrakpeya, Won Ldy Paye, Chano Pazo, Ruth Phillips, John Picton, Prempeh I, Kane Quaye, Darrell Reeck, Theodore Roosevelt, William Rubin, Malcolm Ruel, André Salmon, Thierry Secretan, Banzumana Sissoko, William Smith, Renée Stout, P. Amaury Talbot, François-Xavier Tchoungui, Jean Marie Teno, Joseph Thomson, Issa Traore, Leon Underwood, and John H. Weeks.

**My Teachers**
This writing draws from Dorothy Cooper's stories, Wanda Corn's art history, Charlie Grebo's visits upcountry, the late Jacques Hymans's history, Michael McColly's truthful writing, and Fred Wilson's curatorial prowess.

**My Family**
Kris McClusky introduced Duncan and me to it all. I hope GK and I can do the same for Aldo Jan. We count on help from Toyin Ajayi, Andy Frankel, Gene, and Lolade.

*Pamela McClusky*
*Curator of African and Oceanic Art*
*Seattle Art Museum*

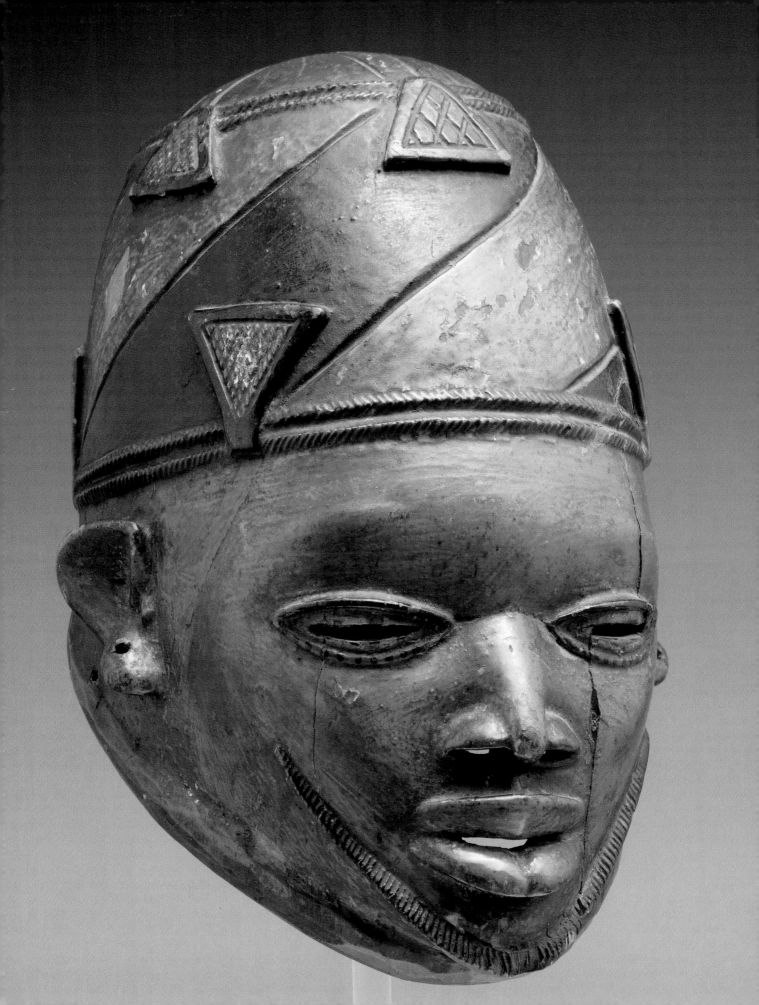

# Introduction

Long steps never broke a person's back.

*Irin nla ko kan eyin ri.*　　　–Yoruba saying

A Parisian describes long steps taken to ragtime music in 1902: "The dancer thrusts the torso forward and throws the shoulders backward, bending as much as possible; the arms are extended horizontally, then folded, while counting two beats to the measure. In this position, in which balance is rather unstable, it is a question of advancing while raising the knee just as high as it will go with each step."[1] This image of the cakewalk comes to mind when I pick up an African mask in museum storage and prepare it for display. While holding it carefully and walking with a measured pace, my mind begins taking the mental leaps that connect the object with its origins on another continent. One foot remains grounded in the present, but the other dangles in midair, attempting to span great distances.

A bit of irony hovers in the air while one holds this pose. The cakewalk was originally intended to satirize the pompous manners of white plantation owners, just as museum-handling procedures can seem overly precious. Wearing gloves to place a mask in a velvet-lined storage cart, and pushing it through the hushed repository, is in extreme opposition to the dynamics of a masquerade. As the caretaker for the ideas and associations that once surrounded the mask, I envision taking steps away from the sterile enclosure and back into the messy vitality of the mask's home environment.

The first step on the imaginary return of this object from the museum to its original home is Los Angeles, where it once joined a dense crowd of African faces, figures, jewelry, and furniture that had overtaken every room in the house of an American woman named Katherine White. In 1961, at the age of thirty-one, she began buying art and never stopped until her death at fifty-one. In an intense effort over twenty years, she compiled her collection, which came to the Seattle Art Museum in 1981. Conscious that she was enacting a private quest for what would someday become public property, White kept a journal of her journeys to galleries and museums in Europe and America, and of her experiences in African markets, palaces, and ceremonies.

Katherine White's records open the door to the process of collecting, revealing some of its complexities and concealing others. At times, she documents all the details of an acquisition, including her own doubts about how to recognize excellence in objects from other cultures. But in many situations, she simply states a dealer as the source and goes no further. By the 1960s, silence surrounds the removal of many African objects from their original owners. "Runners," or African agents, supplied dealers in Europe and America with art obtained from sources that are rarely recorded. Several exceptions to these undocumented sales are featured in this publication: gifts from palace treasuries given by Cameroonian kings to American friends, an Ejagham costume in which a certain professor was initiated, and a recent collaboration with the Maasai that closed out the century.

A scholar renowned for his long steps was asked to revise an essay instructing viewers in how to read the stances, postures, and gestures of a range of African figural sculpture. Robert Farris Thompson's prose doesn't just step; it cartwheels and propels readers to think in complexes of sound and motion. Thompson equates his interpretive method with crossing a stream on stepping stones, but he also updates the cakewalk with the lunge of a *capoeira bencao*.[2]

The remaining texts, twelve case histories, I devised to encourage an American audience to collapse the juju fetish witch doctor in the savage spaces of the mind. This space is occupied by stereotypes that may unexpectedly swing into place. Author Wole Soyinka refers to the Neo-Tarzanism phenomenon, the tendency for Western-ers to peg Africa as the place of animal, jungle, and discord requiring a white savior (preferably from an aristocratic family). However outdated, an excerpt from Edgar Rice Burroughs's *Tarzan and the Leopard Men* of 1935 depicts a crude cliché of an African "gallery and curator" that prevails:

> The wavering torchlight played upon carved and painted idols; it glanced from naked human skulls, from gaudy shields and grotesque masks hung upon the huge pillars that supported the roof of the building. It lighted, more bril-liantly than elsewhere, a raised dais at the end of the chamber, where stood the high priest.... Below and around him were grouped a number of lesser priests; while chained to a heavy post near him was a huge leopard, bristling and growling at the massed humanity before him, a devil-faced leopard that seemed to the imagination of the white man to personify the savage bestiality of the cult it symbolized.[3]

Replacing this torchlight bestiality, the case histories offer a chance to visit many real galleries and curators. In Ghana, one enters a royal sitting room where skilled linguists preside. In Cameroon, within a remote mountaintop palace, a king's council-lor is preparing a display of thrones. In Sierra Leone, a forest sanctuary conceals the place where female teachers are putting on full costumes. In Nigeria, a marketplace theater hosts a masquerader who sings all night about the problems of men and women. The case histories introduce the African equivalents of highly trained cura-tors and the storage rooms or galleries they have worked in. They present biographies of objects usually displayed in the galleries with minimal texts. This museum limits

labels to seventy-five words, mandatory terse shorthand notes. While the literature on African art has greatly expanded in the last three decades, it is often not adapted for typical museum visitors who want to know specific things about particular objects: "Who collected this and why?" "Is this a fetish?" "Why is this on display in a museum?" "Is this significant or ordinary, rare or common?" "Are these kingdoms still in existence?" "Do people still perform this masquerade?" Such questions are often asked but require more thorough answers than labels can provide. In response, these texts offer an involved look at a select few rather than a hurried survey of hundreds.

Extreme restraint kept the number of case histories small, pushing aside thousands of objects that could have been chosen. Receiving attention here are a few objects known to have unique stories of collection and documentation. Their sequence is guided not by region, geography, or importance, but by the evolution of the collecting process from 1969 to 1999. The first discussion, of hunters' shirts, reveals how museum doors were opened to their range of provocative media. During the 1970s, the notion of securing complexes or multiples inspired Katherine White to acquire assemblies of art, largely from West Africa. From the 1980s to the end of the century, collecting became more experimental, as seen in the gift of a coffin, the purchase of photography, and an exchange enacted with a community in Kenya. The momentum for collaboration led to an exhibition of the same name. Numerous individuals whose work is cited in this text visited Seattle to add new facets to this documentation.

In essence, the case histories are an extension of the exercise I perform as I cakewalk with an African mask. If long steps could catapult me across the Atlantic, where would I meet the person who was closely connected to this object and what might we talk about? What has been said that needs to be corrected? The case histories unveil multiple paths of interpretation and the many voices that contribute to the exploration. Primary sources, from proverbs to epics, songs to films, guide the texts. Misreadings and conflicting views about the same art are not avoided, but are put forward to show how words and realizations evolved through history. Individuals who loom large in African history but whose names remain largely unknown to an American audience are introduced—Afonso, Prempeh, Sundiata, and Yu. And no accounts leave readers in the past, but instead follow the steps an object takes into the present.

Long steps carry an African mask from America to its home and back again. To this purpose, Robert Farris Thompson sets out the framework of a "democratic opera without divas," and the notion of seeing art moving in places far beyond museum walls. I add the specifics of following that mask through performances, both in Africa and in America. For it is right in front of us that we find African creativity camouflaged in American yards, music, dance, and altars. In and out of the museum, we witness how a spiritual buoyancy keeps the back from breaking.

## Notes

1. Jody Blake, *Le Tumulte Noir: Modernist Art and Popular Entertainment in Jazz-Age Paris, 1900–1930* (University Park, Penn.: Pennsylvania State University Press, 1999), 21.

2. *Capoeira* is an Afro-Brazilian martial art that combines elements of tumbling, dance, self-defense, and percussion. *Bencao* is a straight kick.

3. Edgar Rice Burroughs, *Tarzan and the Leopard Men* (Tarzana, Calif.: Edgar Rice Burroughs, Inc., 1935), 148–49.

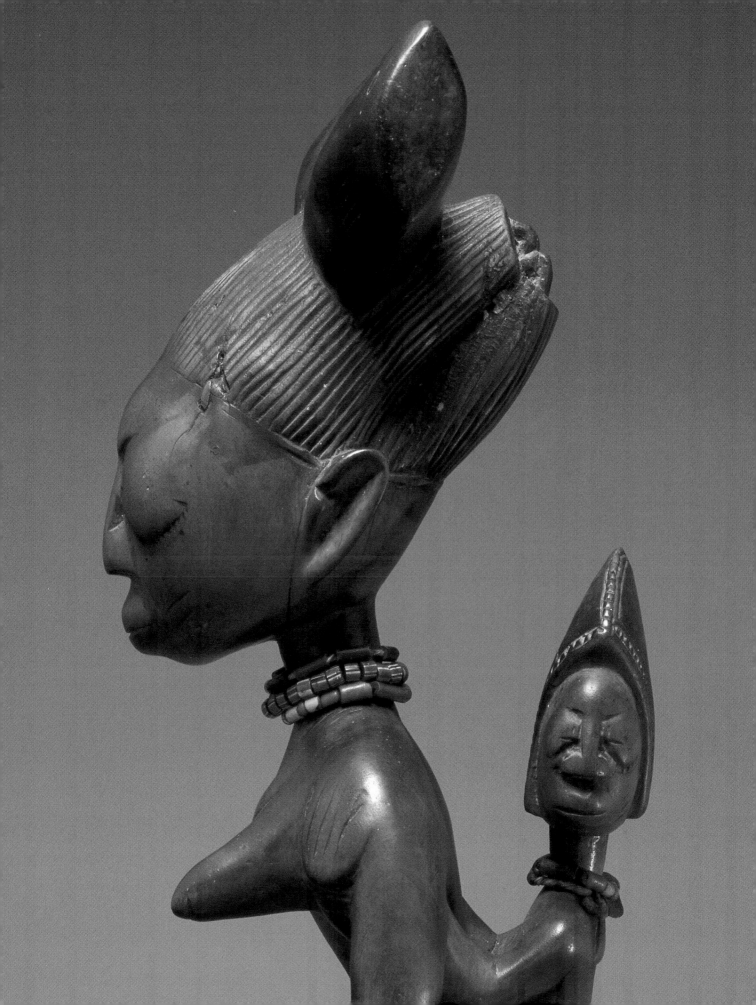

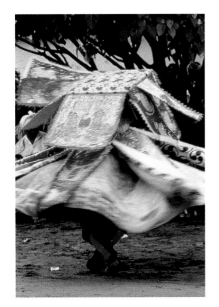

# African Art in Motion

The body as metaphor is an all-important concept in the art south of the Sahara. Combine that metaphor with metaphors of motion and, in the words of an African American rap group of the 1980s, one "steps into the cipher." We enter, in other words, a code, a stylized form of consciousness, involving all in deep and primary vitality.

Tropical Africa has elaborated a different art history, a history of danced art, art danced by multimetric sound and multipart motion. Danced art completes things, returns them to themselves by immersion in stylized motion. It was in the village of Oshielle, not far from the Egba metropolis of Abeokuta in southwestern Nigeria, in the winter of 1962, that I began to notice how African statuary, not only masks, could be involved in motion, how icons called for corresponding actions. For as the women gathered their twin images, they cradled them in their arms and danced them, singing, to a special mat and placed them there to be photographed. And then they danced them back to their shrine, tenderly nestled them in special cloths, and closed the door.

Years before, intellectual ancestors, Fernando Ortiz working in Cuba and Frances and Melville J. Herskovits working in Trinidad, had noted the same phenomenon—that dance in black Atlantic contexts moved objects beyond the more obvious extensions, like headdresses for a sacred dance, or knitted costumes, or other forms of straightforwardly choreographic paraphernalia.

For the Herskovitses witnessed an Afro-Trinidadian, overcome by the spirit, swinging his body on his knees, "dancing" in his hands a candle and a glass filled with flowers before an altar. Ortiz, similarly, saw objects that one would not ordinarily associate with the dance turned into special emblems for higher service and sacred meaning when taken in hand or hoist upon the body. The tradition leads, in the black Americas, to the dancing of paintings: Haitians once celebrated the completion of an important commission by dancing the canvas through the streets of Port-au-Prince. In these instances, African and African American dance overcomes material, re-creates it, extending the aliveness that an object must embody to function as a work of art.

Pl. 13 (detail)

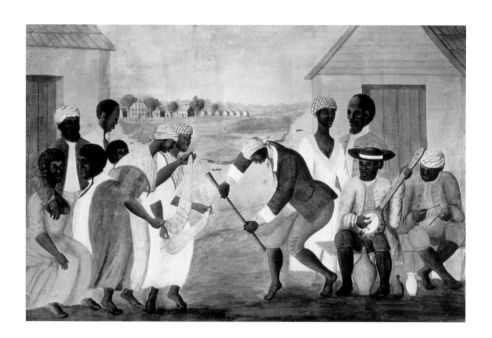

Fig. 1. *The Old Plantation,* 1800, watercolor, H. 45.7 cm
(18 in.). Courtesy of the Abby Aldrich Rockefeller Folk
Art Museum, Williamsburg, Virginia.

The semantic range of the concept "dance" appears therefore broader in Africa
and African-influenced regions than within the West. As to the last point, compare
the *Concise Oxford Dictionary:*

> *dance* 1. Move with rhythmic steps, glides, leaps, revolutions, gestures, etc.
> usua. to music, alone or with a partner or set (~ to one's tune or pipe, follow
> his lead); jump about, skip, move in a lively way (of heart, blood, etc.)
> (~ upon nothing, be hanged); perform (minuet, waltz, etc.) ... cause to dance

However full these definitions—built around the core concept of enacting rhythmic
motions, patterns, gestures to music—they nevertheless do not include sharing the
motion with objects. Yet "causing to dance" is an English idiom that prepares the way
for grasping the African phenomenon. For if Westerners "dance" an infant with affec-
tion, then an equation for understanding danced sculpture stands before us. We have
only to fill in, or insert, the following—[objects, cloths, and other things activated
by love, ecstasy, and respect for higher force]—to move within the wider, inherently
spiritual, sub-Saharan domain of meaning. An immediate example of danced art:
among the Tiv of Nigeria the verb *vine* means to dance. But one can also dance a top,
imparting a spin to the object, or dance a cutlass, twirling the metal, causing the
blade to glitter as it bites into the wood.

Without my realizing it, black Puerto Rican mambo dancers culturally prepared
me for African dancing of cloth, to impart special motion to an object, as early as
1955, six years before I went south of the Sahara. In the early spring of 1955, in the
southwest corner of the Palladium ballroom on Broadway at Fifty-third Street in
New York, connoisseurs tacitly reserved space for the hottest and most inventive
black and Puerto Rican mambo dancers. Enter Anibal Vasquez, star *mamboista.* He
danced part of his clothing as he moved in ways I had never seen before, let alone
imagined. He tugged on his jacket with thumb and forefinger, causing the cloth to fan

in and out, mirroring the mambo eighth notes, sounding on the offbeat all around us. Vasquez was not only dancing as Westerners would understand it, making his body move to the beat; he was simultaneously breaking up a part of his dress into rhythmic fragments, alive pulsations, pattern on pattern, beat on beat, as if he were personally reinventing cubism right then and there. I stared, taken and compelled. Then I looked at the band. Men on saxophones and trumpets were swaying from side to side while playing mambo. They were dancing their instruments.

Centuries earlier a painter in South Carolina documented a woman of African ancestry "dancing" a strip of cloth held before her body (fig. 1). I was to see this very action many times in Yorubaland in the 1960s and 1970s: women dancing, swinging suddenly close to the earth, showing off youth and flexibility, dancing a strip of cloth held before their bodies as a final fillip of design. They were dancing a cloth while dancing the dance. They were, in the terms of Zora Neale Hurston, decorating the decoration.

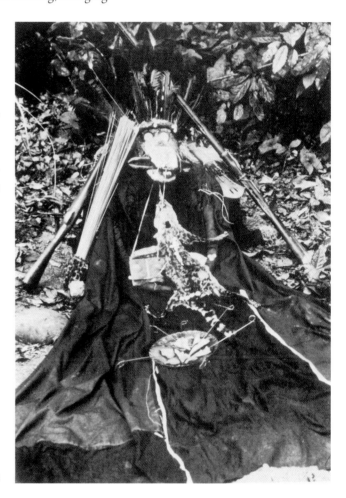

If love of an infant makes you want to rock the tender body, love of the spirit, caught in an object, makes you want to give spirit back its motion. Here is part of the rationale for dancing a coffin to its grave in numerous African civilizations. This overlaps a portion of the New Orleans black jazz funeral, pallbearers "dip-stepping" and followers "second-lining" on the casket's way to glory. If dance includes the ritual twirling of a sword in Edo, or the transformation of hammer on anvil into a sonic means of salutation among the blacksmiths of Efon-Alaiye, among the Ekiti-Yoruba it reminds us that objects can, conversely, embody an aliveness and vitality of their own.

The fact that Basinjom, the famous witch-finding gowned figure among the Ejagham and Ejagham-influenced civilizations, must be spiritually moored with two crossed rifles when at rest (fig. 2) is a measure of its believed visual aliveness. In Kongo, ritual experts are famously skilled for making and elaborating "medicines of God" (*minkisi*), the aliveness of which is enhanced by all sorts of astonishing touches of feathers, earths, buttons, and beads. Some spirits dwelling in such spectacularly caparisoned objects must be specially arrested or controlled. The image is, accordingly, bound up with ties of string or cord or cloth.

Fig. 2. Basinjom costume displayed in grove, Cameroon, 1973.

Handling superalive images by binding is a tradition that carries over directly into the myriad tied charms and figures on the Petwo, or largely Kongoizing side, of Haitian vodun worship in the West Indies as well as among the Fon of Benin and the Fon-influenced Rada side of vodun. I shall never forget a life-size human figure shrouded in red literally chained to a wall in a Petwo shrine near Gressier in the spring of 1970.

Jackson Pollock's concentration on bodily gesture daringly oscillographed upon the canvas (fig. 3) and Duane Hanson's unsettlingly alive image of his own son as doctor (fig. 4) remind us that modern art, as well as African, in its own powerful

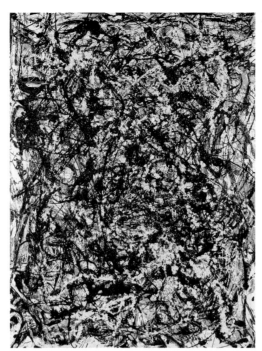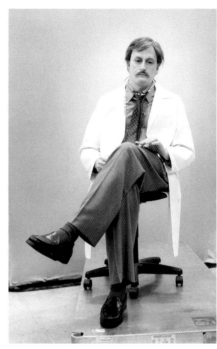

Fig. 3. Jackson Pollock, *Sea Change,* 1947, oil and pebbles on canvas, H. 147 cm (57⅞ in.). Gift of Signora Peggy Guggenheim, Seattle Art Museum, 58.55.
© 2002 The Pollock-Krasner Foundation/Artists Rights Society (ARS), New York.

Fig. 4. Duane Hanson, *Medical Doctor,* 1992, life-size figure and chair, mixed media. Collection of Dr. and Mrs. Craig Hanson, Bainbridge Island, Washington.
© Estate of Duane Hanson/Licensed by VAGA, New York.

ways builds the riddle, How do we distinguish art from life? Or, as Yeats voiced the matter in a celebrated line, "How can we know the dancer from the dance?"

All art that is truly physical, as David Anfam argues, has an organic life beyond words. What, then, is the difference between modernist vitality in painting and sculpture and the active potentiality of the sculptural image south of the Sahara? Provisionally, I would suggest: contexts of ancestoristic reverence and spiritual reembodiment. Pollock and Hanson were operating as free spirits, avatars of self-expression in a world outside religious patterns of belief. Their art went into strange, agnostic temples, often characterized by white walls, polished floors, and indirect lighting. True, there is such a thing as mixed-media installation art in the West, but it is a far cry from the famed unity of the arts in African performance, a democratic opera without divas, a people's orchestra without conductor, all graced with lickety-split cameo leaps into the dancing ring, enabling anyone, anyone with confidence and courage, to share the limelight for a moment.

What all this leads to, in understanding African danced art, is not to empha-size motion over sculpture, or painting at the expense of music. Sculpture is not the central art south of the Sahara, but neither is the dance. For both depend on words and music, and even dreams and divination, sources indicating the very sanction of the other world. Music, dance, and visual objects are all important, separate or together, and if motion gives body to music or special zest to art, sculpture deepens the understanding of time and motion by freezing aspectual unfoldment into a single text for comprehension. This strong interrelationship—sound, motion, vision—obviously stems from a combined aesthetic. Shared norms of quality structure the media. Shared organizing principles, in turn, underlie the confidence and quality in African act and icon.

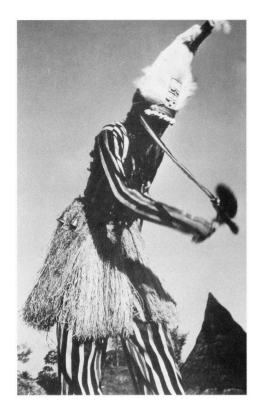

We study icons and we look at attitudes, defined as positions of the body. Ritual reenactments of important attitudes, it is said, restore ancient modes of self-presentation to modern contexts. A Yoruba priest of Egungun from Ouidah in the Republic of Benin told me in the summer of 1972 that a person who stands well is born with that power. He said this apropos of a photograph of a Montol image of a standing woman, knees and arms richly inflected with readiness for the dance (pl. 1). Africans in other places have similarly observed that commanding attitude and commanding presence are gifts of the spirit. In fact, Bernard de Grunne has shown how ancient Malian images set in different postures of reverence and worship are placed on altars expressly to show the supplicant the way to move and gesture within his worship. Taking on the attitudes of the ancestors and the gods turns the person into sculpture, in ultimate relation to the goddesses and the gods.

Sculptural icons in African art therefore take their radiance in part from important attitudes of the body. These, in turn, appear in groupings that suggest a grand equation of spiritual stability and response. Thus icons of command (standing, being enthroned, riding on horseback) correspond to icons of service or submission (kneeling, supporting objects with both hands, and balancing loads upon the head).

There are many things to learn, but one seems paramount: if spirits can challenge gravity by moving on stilts twelve feet in the air (fig. 5) to stirring slit-gong percussion and hocketed singing in the forest villages of the Dan of northeastern Liberia; if athletes in northeastern Yorubaland can shoulder nearly a hundred pounds of carved wood sculpture for a quarter of an hour while dancing before their king (fig. 6); if initiates honoring the collective moral dead can spin and spin and spin and spin and spin

Fig. 5. Dan Gle Gbee stilt masquerade, Liberia, 1967.

Fig. 6. Oloko (Lord of the Farm) masquerade, Epa festival, Otun, Ekiti, Nigeria, 1977.

Fig. 7. Yoruba Egungun performance, 1994.

(fig. 7) until the very concept of human dizziness begins to lose its meaning—then anything is possible.

Ideally, the reader of such phenomena will emerge with respect for what happens when hard work combines with discipline and the spirit in traditionalist villages and barrios of modern Africa. African danced art, in all its spiritual complexity, invokes an ideal future. Women dance cloths held before their bodies, honoring themselves, honoring their guests, honoring God, teaching us to live, strongly and well.

## Icon and Attitude

> There is in the African a latent lyricism which tends to express itself in movement, so that every gesture, every attitude of the body takes on a special significance which belongs to a language of which I caught only a few words.
>
> —Richard Wright, 1954[1]

Traditionalist Yoruba believe that the founders of their civilization created the styles of proper bodily address and dance.[2] To adopt them, in the deepest spiritual outlook or belief, is to align oneself with the best of the past, with the Great Time of the ancestors. Elsewhere in Africa traditionalists similarly believe that when they perform ritual dances, or strike an honorific pose, they are standing or moving in the image of their ancestors.[3] Ritual forms of flexibility and communal strength therefore take on an aura of reincarnation.

Ancestorism, the belief that the highest experience reflects the closest harmony with the ancient way, shapes stance, attitude, and gesture in the art of Africa. "Stance" refers to standing. "Attitude" refers to stylized positions of the body or self-carriage, indicative of mood and status. "Gesture" refers to motions of the body and the limbs, communicating thought or emphasis.[4] The stylized positions of the body considered in this text are strongly present in known collections—standing, sitting, riding, kneeling, supporting, and balancing. The close relation between art and the dance in African aesthetics causes us to reread Marcel Griaule with a pointed interest:

> The dance only repeats essential gestures. It is accompanied by a staccato rhythm and a few words alluding to the events which determined the creation of the personage in question. [This] simplification should teach us to study every detail.[5]

Griaule's point, intensification of the icon through simplification of its formal means, is important. Listen to traditionalist Africans hinting of such matters when remarking just the single attitude of standing:

> Yoruba in Benin: "One who is standing like that is born with that stance."
> Banyang (Cameroon): "He stands like a person," that is, in a principled manner.
> Suku (Democratic Republic of the Congo): "I have seen that pose. It reminds me of what I was told: long ago at the feast for our ancestors, they calculated, 'what was the image of our grandfather' . . . and they remembered their grandfather when he was standing. [And then] they began to make standing images of the ancestors."[6]

Tradition selects. Bodily positions defining lordliness and command come to predominate: standing, being enthroned, riding on a horse. Tradition also underscores postures set at levels of respect: kneeling, supporting, and balancing things upon the head without the use of hands. Service confirms command and vice versa. Reading the details of the icon at rest, we sometimes discern split-second freezing

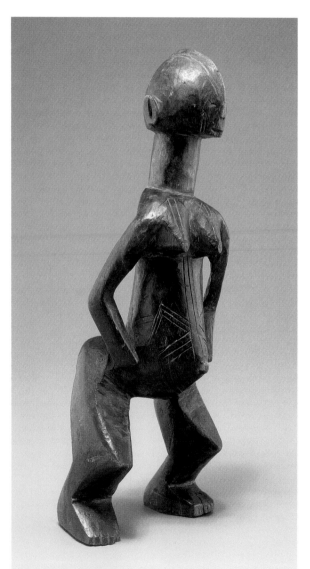

of a complex of actions. Implied condensation of vital enactments makes it seem almost inevitable that statuettes and icons and even monolithic sculptures like the *aguru epa* headdresses of the Ekiti-Yoruba area would be danced, would be pulled into motion. Part of the marvel has to do with what one distinguished ethnomusicologist calls "polycentrality" in the dance of Africa and another calls "the two-part body system": the torso divides both icon and dancer into two related parts. A twist at the waist, in dance, often underscores the division. Upper and lower portions of the body engage in different motions and directions, not only in African hip-swinging dances but even in some forms of work.

Such icons blur into the Yeatsian vision, confounding dancer with the dance. This is splendidly true with respect to the Montol figure of a standing woman (see pl. 1). Unheard dance music divides her body at the waist into two different axes of expression. Head, spool-like neck, and upper torso align in shared, assertive verticality. But precisely at the waist, already emphasized by concentric cicatrization about the navel, she surges forward with a countervailing, forward accent. This thrust, in turn, is simultaneously mirrored by a surging backward of the hips. The line of the torso thus zigs back to the buttocks, then forward and down, legs flashing facets. Her body turns into lightning. The Montol figure does more than stand. With arms akimbo, she challenges the world. In the ballet of African iconography, head erect, lips back, feet flat upon the ground, she performs on her own terms the first position.

Being seated is also outwardly simple but inwardly rich. It can conceal the spiritual electricity of several ideal actions coming together as one. This was made clear to me by a young Mu-Suku named Piluka Ladi, in the city of Kinshasa, Democratic Republic of the Congo, March 1973. I showed him a photograph of a sculpture attributed to a master carver of Kumasi, Ghana, Osei Bonsu (pl. 2), and asked him to comment. What he said was extraordinary:

> She is purely there. She gives milk to the child. She secures his body with the other hand. She is sitting well, like a person of character.

He caught three verbs in sculptural allusion—sitting, giving, securing. And since her position blends generosity, the highest form of morality in many of the religions of the black Atlantic world, with the inherent dignity of the enthroned position, she emerges, as Piluka Ladi says, being purely there. That purity of presence becomes the subject matter of this book.

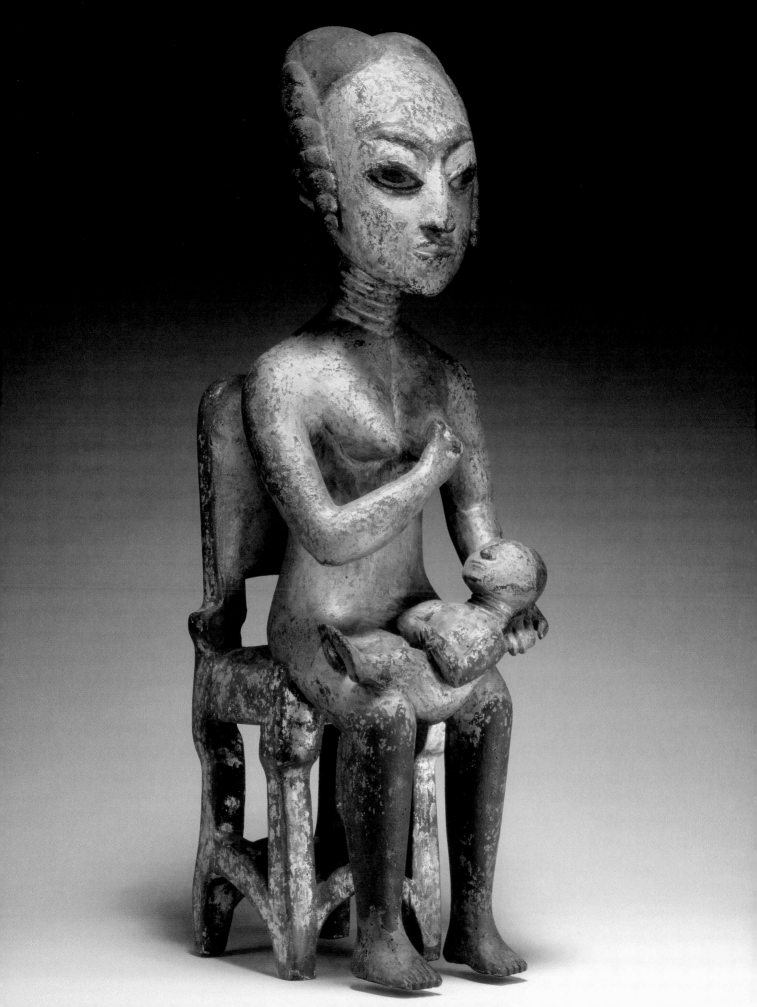

Pl. 3
**Standing figures**
Kulango, Ghana
19th–20th century
Wood, chalk, metal
Left: H. H. 81.9 cm (32¼ in.); right: H. 96.5 cm (38 in.)
Gift of Katherine White and the Boeing Company,
81.17.225.1+.2

Pl. 4
**Twin statuette** (*flanitokole*)
Bamana, Mali
19th–20th century
Wood
H. 48.3 cm (19 in.)
Gift of Katherine White and the Boeing Company,
81.17.27

## Standing

> The perpendicular is an opposition.        —Bruce Glaser, 1964[7]

Standing is a task. The remorseless pull of gravity makes it so. To stand against magnetic earth is to intervene in a decisive way, keeping vertical and maintaining balance. Engaging the whole of the person, standing is a complex of energy and strength as distinguished from a simple species of immobilization, like fixing an iron bar within the earth. A person, unlike an object, stands with affect and expression. The way a person stands ultimately communicates lived relation with the world. Standing embodies vitalized persistence and becomes an icon of ideal righteous being.

Begin with the Akan of Ghana, who see the twelve hours of the day, dominated by the light of heaven, as that time when women and men are "standing up alive."[8] Standing up thus corresponds to light and life. It is the stance of daytime, the time of morality. So we assume two standing figures, attributed to the Akan-related Kulango civilization of Ghana, were meant to have their touches of spiritualized white clay (*hyire*) gleam with implications of purity and the light of day (pl. 3). These images are definitely standing up alive. The positive associations of their stance are deepened by the quality of their gesture. Both place their hands near the heart. Their purity of presence is already secured by application of the sacred white porcelain clay. But hands extend that purity by pointing out the heart:

> If he wants to refer to the person's goodness … the Adjukur [an ethnic group in southern Côte d'Ivoire affiliated culturally with the Akan] will localize it within two central organs of the body: the stomach and the heart. The heart is a source of life, in that it is the literal headquarters of respiration or breath, thought, sentiments [and] will…. Goodness comes from the heart and stomach and is an internal realization.[9]

The Kulango figures embody assertion in their verticality. But, with their hands, they also indicate mind and internal goodness.

A Bamana twin statuette (*flanitokole*, literally, "the double who remains") evidences another form of ideal standing (pl. 4). Elaborate coiffure alludes to life lived well, for such a crest could be made only through the cooperation of others, sympathetic sisters or co-wives. There is great subtlety to the gentle bending of her knees, creating the slightest modulation to the uprightness of her noble posture. Against that axis, buttocks and breasts form strong assertions of vitality. She lends, in turn, an ordering, vital posture to the world.

The famous twin statuettes of the Yoruba (*awon ere ibeji*) present a fascinating instance of nuanced iconic standing (pls. 5, 6). First of all, twins are traditionally described as "standing straight and tall" (*aduro gangan*). According to Araba Eko of Lagos, "their position, hands at the sides, arms parallel to the body, is a sign of alertness, being ready to do everything. They do not relax. They are standing, either to hear a prayer or to act."[10] God himself stands this way, as envisioned in the Yoruba saying, "Great God almighty, standing upright behind the power to make things happen truly" (*olodumare aduro gangan lehin ashe otito*).[11]

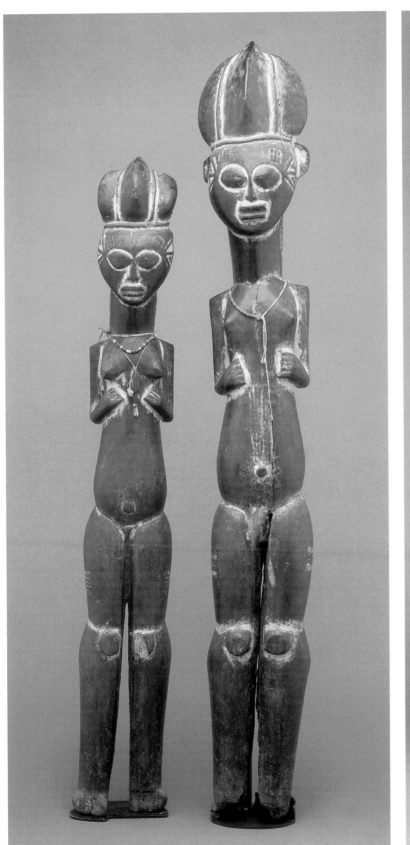
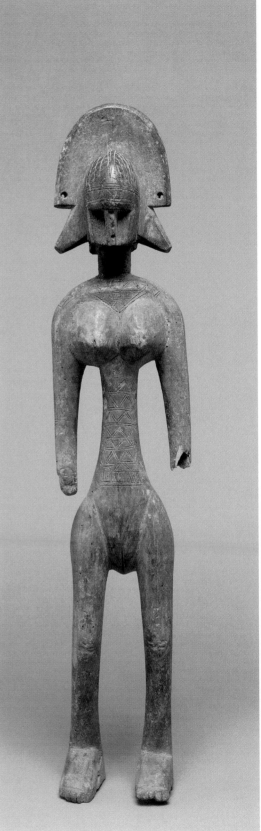

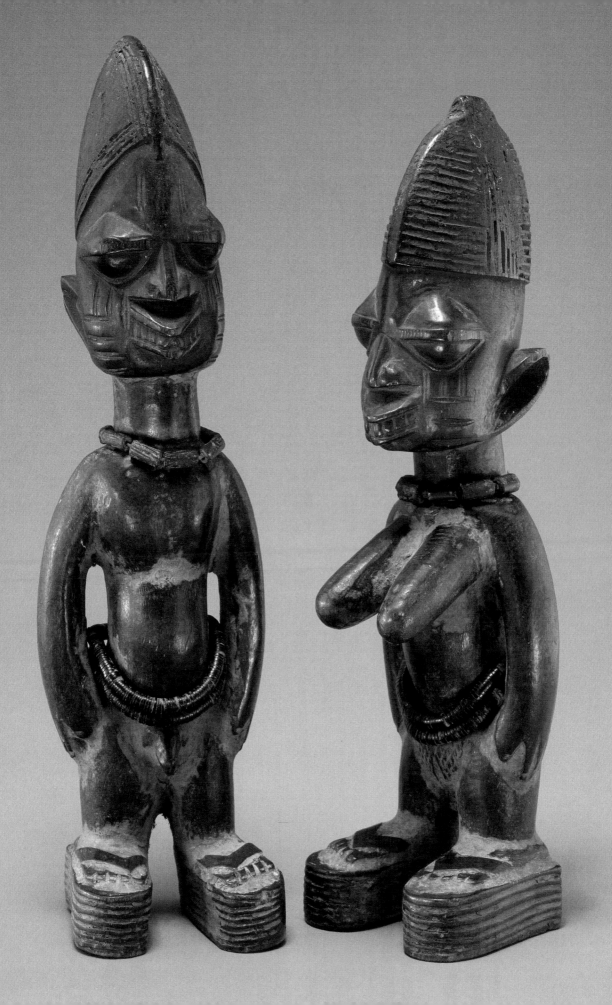

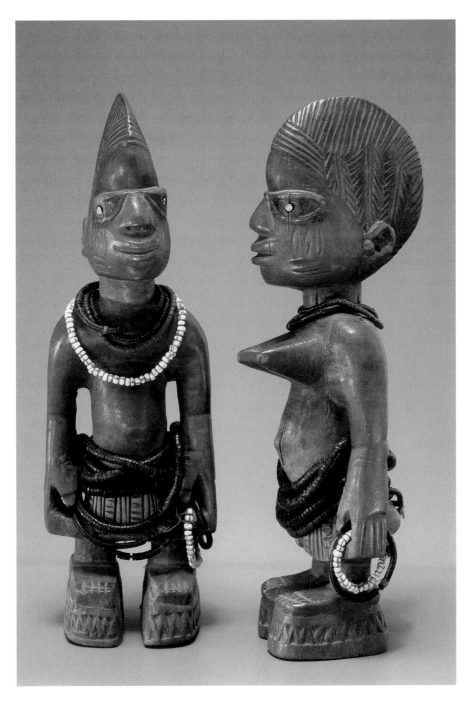

Pl. 5
**Commemorative twin figures** *(awon ere ibeji)*
Yoruba, Nigeria
19th–20th century
Wood, pigment, beads, encrustations
Left: H. 32.4 cm (12¾ in.); right: H. 34.9 cm (13¾ in.)
Gift of Katherine White and the Boeing Company,
81.17.610.1+.2

Pl. 6
**Commemorative twin figures** *(awon ere ibeji)*
Yoruba, Nigeria
19th–20th century
Wood, beads, nails
Each: H. 24.5 cm (9⅝ in.)
Gift of Katherine White and the Boeing Company,
81.17.611.1+.2

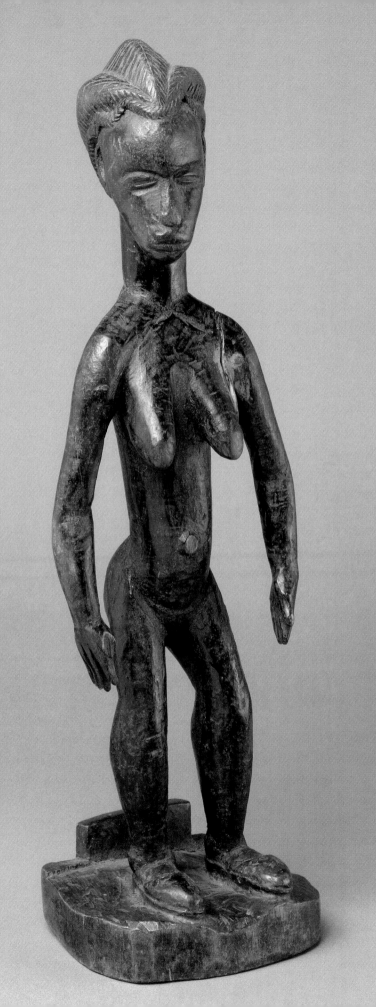

In his study of human motion, F. J. J. Buytendijk argues that "however the final phase or the initial moment of a movement are characterized, the standing position is always the first phase of a new activity."[12] That power, to initiate or begin things standing, becomes a setting for further strengths. The exorbitant eyes hint that the images take power from above, the power to make things happen, even as the eyes of an actual devotee of the Yoruba gods in Brazil, when taken and compelled by the force of a god, faces the world with a laserlike stare that sees across worlds. The constant placing of the arms of the twin statuettes by the sides is more than a sign of spiritual alertness. Dejo Afolayan, the distinguished Yoruba linguist, in the process of translating a long string of praise epithets for the twins, shows how the very presence of these beings attests a life well lived, for God gives twin children specially to the generous and the upright:

> Let she who fantasizes having twins adopt a gentle character
> Let him remain transparently honest.[13]

Blessings become truth. The advent of twins magnetizes the luck of heaven to the family of the double child. That gift from above is written into their stance—that is, holding their arms tightly parallel to their sides:

> Stand, o twins, with anus straight and parallel
> That earth might touch the sky.[14]

From the Yoruba we come now to the Guro of Côte d'Ivoire. We contemplate a standing image of a woman, possibly carved for a Dan patron to the west (pl. 7). She projects a handsome verticality. Her eyes narrow down. This wreaks erotic havoc on the young men of the Dan, who border on Guro country. The image fulfills another Dan canon of fine standing: "It is not good for a beautiful person to be stiff in body when standing" (*me sa ba do kpei da sy ka sa*).[15] Relaxed arms and relaxed legs fulfill this demand. And the outstretched arms are seen as positive, "as if to embrace [a person]."

A woman standing naked with her breasts exposed communicates, in Africa, far more than is dreamt of in the philosophy of Freud or other theorists. She stands thus to give life to the righteous—or death to the evil. Among the western Dan, a mother swears on her breasts, or upon life itself, when sealing a vow. But when confronted with an enemy, she can squeeze, in righteous anger, a droplet of milk from her left breast and slap her thigh. This unleashes a curse of unfathomable dimension. By standing naked, and using the breasts as instruments of grace or punishment—far removed from ordinary contexts of lactation or sexual arousal—women are exalted. They empower themselves, they empower their family, in the depths of their femininity. This is the case with the famous Dan *wunkirmian*, or "feast-making spoon," a "spoon woman" object, bringing together handsome legs (or a handsome head) with a symbolically generous ladle (pl. 8). Dan carve such spoons for Wunkirle (Feast-Making Woman), the most hospitable woman of the village. The spoon is her badge of honor, symbolizing her acts of generosity. Only Wunkirle can carry *wunkirmian*. She and her kin are by definition enterprising cultivators. They have plenty of rice.

Pl. 7
**Standing figure**
Guro, Côte d'Ivoire
19th–20th century
Wood
H. 42 cm (16⅝ in.)
Gift of Katherine White and the Boeing Company, 81.17.257

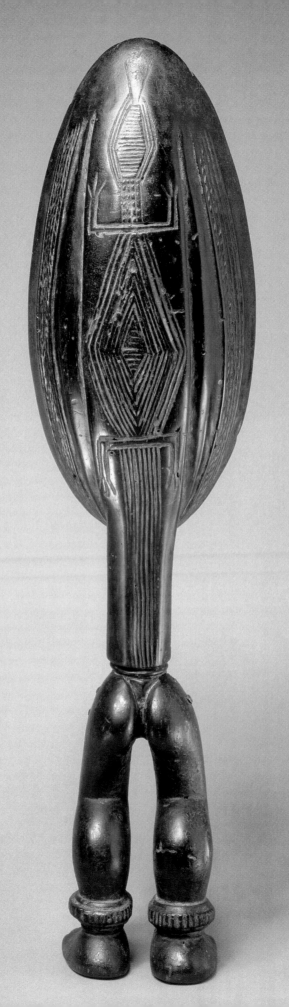

They share it. On feast days Wunkirle swings and dances the spoon-emblem before her, in the midst of a chorus of hocketing women. They back their sister with call-and-response. Other women follow, carrying bowls brimming with rice. When all have arrived at the village square, Wunkirle dips into the bowls and begins a distribution, dancing out ideal largesse.

The spoon compacts the ceremony. Beautifully inflected legs allude to a lovely woman and her readiness to dance. The ladle is generosity. The lizard on its back alludes to prayer: reptiles move on the earth, where the dead are hidden, indicating the place where calls for children ultimately are heard. The extraordinary fusion of object and person in the making of the *wunkirmian* matches the marvel of the dress of Wunkirle. Blasting away ordinary differences of gender, Wunkirle appears at her feast wearing a flowing male robe and a striking male helmet.

Further examples of heraldic standing grace the collection. For brevity I now incorporate them, lawyer-like, by reference (pls. 9, 10). All illustrate the insight of Guido von Kaschnitz-Weinberg, namely, that the standing position represents a world that is intelligible and clear. Mind and body, in expression of strength, align with the vertical axis. Women and men standing in life, standing as sculpture, standing as dancers, contest the laws of gravity. In so doing, they memorably establish a principle of assertion.

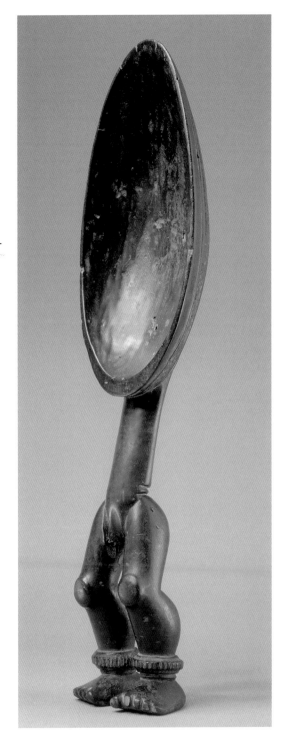

Pl. 8
**Feast-making spoon** (*wunkirmian*)
Dan, Côte d'Ivoire
20th century
Wood, iron
H. 61.4 cm (24¼ in.)
Gift of Katherine White and the Boeing Company,
81.17.204

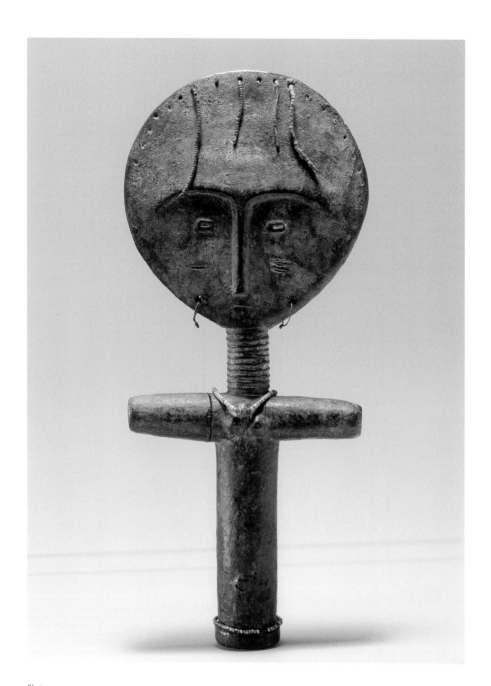

Pl. 9
**Figure of Akua's child** *(akua-ba)*
Asante, Ghana
20th century
Wood, beads, polychrome
H. 25.1 cm (9⅞ in.)
Gift of Katherine White and the Boeing Company,
81.17.329

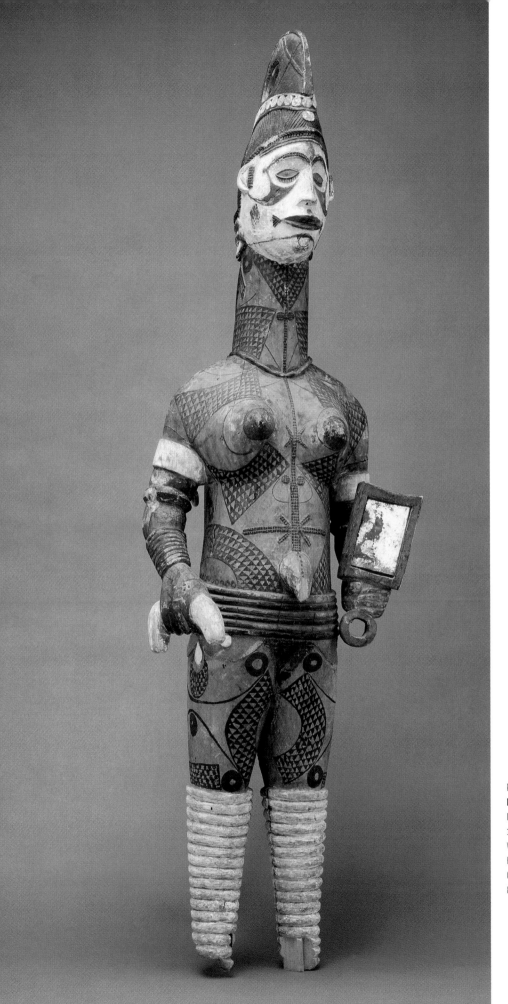

Pl. 10
**Display figure** *(ugonachomma)*
Igbo, Nigeria
19th–20th century
Wood, pigment, mirror
H. 127 cm (50 in.)
Gift of Katherine White and the Boeing Company,
81.17.525

Pl. 11
**Seated figure**
Baule, Côte d'Ivoire
19th–20th century
Wood
H. 77.5 cm (30½ in.)
Gift of Katherine White and the Boeing Company,
81.17.233

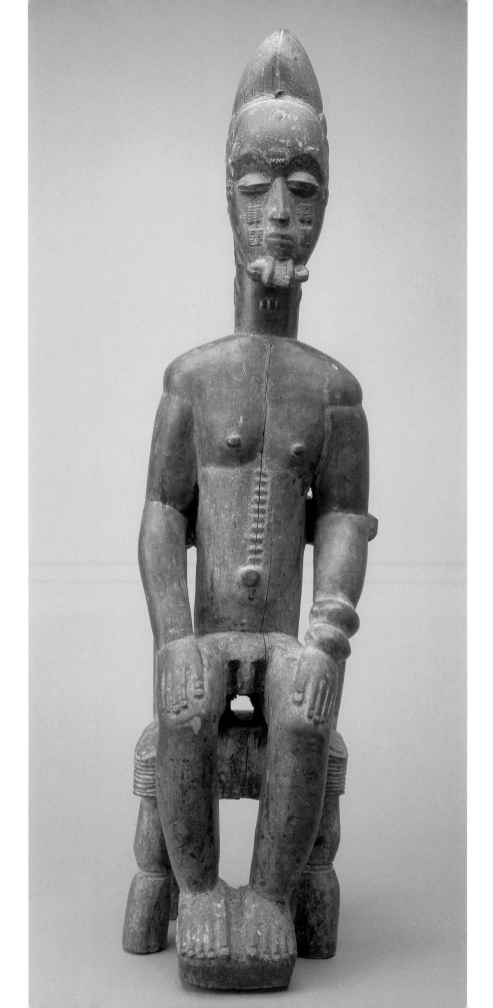

## Sitting

When an actual ruler dies, the incident is referred to as
"the stool has fallen" [*akonnwa ato*].    —Peter Sarpong, 1971[16]

The enthroned position in African art communicates a complex aura of cultural permanence and fineness of character. Calm emerges in the easing of standing; the privilege of enthronement provides a frame for concentration upon important matters. Permanence or important residence are idiomatic meanings embedded in African verbs of being seated. Thus in Yoruba the phrase for place of enthronement also means place of residence. Restlessness (*aijoko*) literally means lacking a place where one can sit down. The Efik of eastern Nigeria have an expression of permanence cognate with the Yoruba. They say "that town is seated by the river," as opposed to temporary settlements of farmers in the forest.[17] In faraway Suriname, among members of African-descended Saamaka civilization, the phrase *sidon muyee,* literally "a sit-down woman," honors a woman a man can trust. In tropical Africa, the seated person, conscious of the privilege of her position, must show awareness of herself as an object of perception. The seated dignitary, in other words, must present a fitting image to the world. One instructs by enthroned composure.

This ideal lights up Akan seated statuary. Their order of seating honors the old. It begins with the eldest person present and ends with the youngest. The Akan ideally sits on a chair or stool. Failing that, he sits on animal skins or mats. Failing that, he crouches. But he must never, ever sit on the ground, as if he were an animal.[18] In this civilization sitting completes the presentation of the self. The rules that govern this bodily position are strict. A person should not cross his legs.[19] Head and torso remain erect. The gaze is frontal. Looking down communicates sadness, evil, or heavy unwillingness. The person enthroned becomes an ideal frontal pattern of perfection, symmetrically disposed and focused. He embodies, ideally, the power of the throne to counter chaos and disorder. We sense all that, and more, in a noble image of a seated Baule male dignitary (pl. 11). His flesh is hard and muscular, denoting virility and strength. His luminous body exudes an ideal: "a state of well-being, bathed, shining with pomade."[20] Hands evenly rest on either thigh, fingers strictly parallel, in self-conscious precision. When we study this image in the flesh, we see how carefully the sculptor fused his royal subject with an upright axis. There is an incredible rightness to the way the center line of the coiffure is picked up by the beard, then continued by the line of cicatrization leading to the navel, then to the membrum, seal of manhood, and then straight on down to the earth. The canon of enthronement here unfolds in complexity and richness. With pursed lips and lidded eyes, the figure seems conscious of his impact on the people, of the imperative of communicating order, down to the smallest nuance of the fingers and the styling of his narrow beard.

Consider also a terracotta depicting an Akan queen mother with a child seated on either knee (pl. 12). This image, first of all, extends the idea of the main duties of

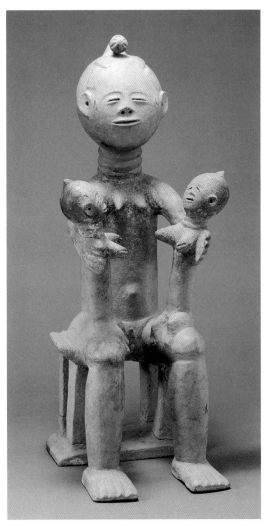

Pl. 12
**Seated figure with children**
Akan, Ghana
19th–20th century
Terracotta
H. 46.4 cm (18¼ in.)
Gift of Katherine White and the Boeing Company,
81.17.442

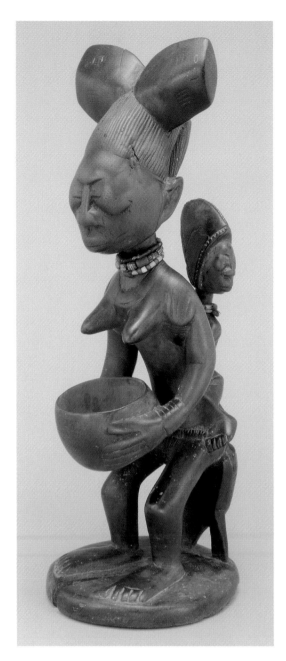

Pl. 13
**Mother and child figure for Sango**
Yoruba, Oshogbo, Nigeria
19th century
Wood, glass beads
H. 43 cm (17 in.)
Gift of Katherine White and the Boeing Company,
81.17.594

the queen mother: giving life, to clan or state, as its foundation and maintaining this vitality. Here queen mother and two children, wonderfully heraldic, transform being seated into a shorthand disclosure of character and continuity. Her spiritualized calm, magnified by enthronement, involves the children in a superior influence. Queen mother supports her children with consummate impartiality. More than that, she positions them on either thigh so that they must face one another, preparing the way for dialogue and acceptance. This is appropriate to a real life role as judge and counsel. In cases of minor offenses, women may rush into her presence, crying out, "Mother save me!"[21]

Very exciting, as an example of just how far the Yoruba master carver can take the theme of enthronement, is a mother-and-child ensemble for the thunder god, Sango Alado (pl. 13). A priestess sits upon a modified object, possibly a mudfish, alluding to the famed high voltage of that creature, which restates the presence of the lightning of Sango. A child sits upon the priestess. And, most dramatically, Sango's thunderstone is seated upon her head. All this rewards devotion—as instanced in the presentation of a bowl for sacrifice. And so she receives the ultimate seating, the descent of the lord in the form of his flaming meteorites, alighting upon her head. Fire, life, and continuity seal themselves within her bodily position. This complex presentation of truth and miracle intimates what happens when a person undergoes initiation into the service of the gods (*isin orisa*). When the postulant, like this carved woman, receives such protection, initiators paint upon her head powerful patterns, including the spots of the leopard, king of the forest, thereby exalting her by allusion to nobility. Seated on a throne, the initiate, as Drewal and Abiodun show, is "painted with substances, colors, and patterns to attract and direct the spirits that will be important in the life of the person."[22]

Finally, there is another beginning stated in this sitting—enthronement at the moment of initiation, as in the creolized Yoruba worship in Afro-Cuban New York and New Jersey. This gives rise to structures that rebuild a place for the descent of the spirit: cloth-emblazoned thrones, which express an ancient idea in a different way.

We turn now to the world of Bantu, starting with the Fang of Gabon. The *eyema bieri*, or reliquary guardian figure, sits to block passage to the place where the bones of the ancestors are gathered in honor (pl. 14). This is being seated to keep away the unauthorized. But the body of the guardian is so vertically poised and brilliantly muscled it is hard to perceive that he is sitting instead of standing. His face is a cryptic skull, his musculature reflects, it is said, not merely a healthy vitality and athleticism but a mysterious mirroring of the fatty passages on the body of an infant.[23] Skull, athlete, infant—a mysterious continuum is seated here to block the way to the ancestors and their resting place. The gist of the *eyema bieri* is therefore vigilant enthronement.

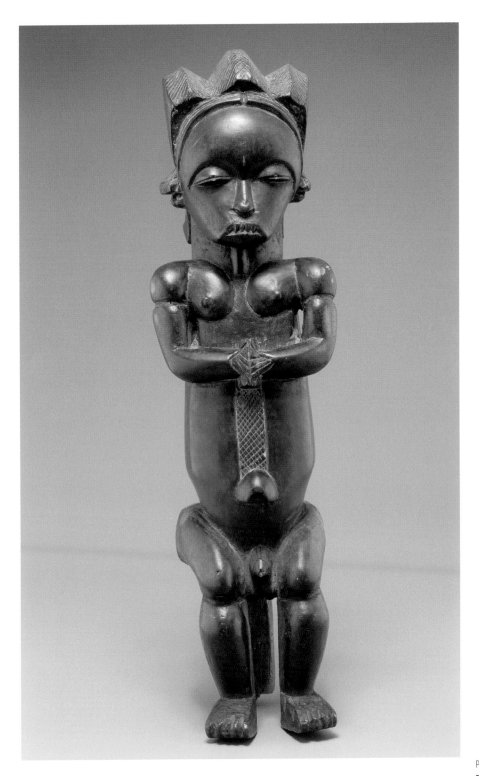

Pl. 14
**Reliquary guardian figure** *(eyema bieri)*
Fang, Gabon, Equatorial Guinea and Cameroon
Late 19th–early 20th century
Wood
H. 51.1 cm (20⅛ in.)
Gift of Katherine White and the Boeing Company,
81.17.783

## Riding

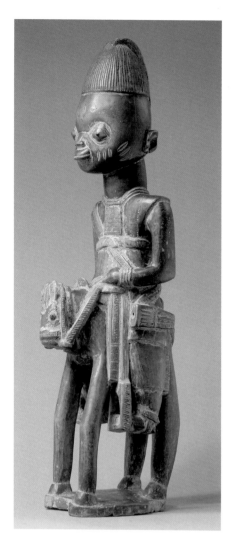

> In front of the great dais the Keke-Tigui, or war chiefs, made their
> horses perform dance steps under the eyes of the Mansa. The horses
> whinnied and reared, then, overmastered by the spurs, knelt, got up
> and cut little capers, or else scraped the ground with their hooves.
>
> —Djibril T. Niane, 1965[24]

Riding embodies arrogant enthronement. Speed, motion, and elevation combine
when one is seated on a horse. "You see [a rider]," a traditional leader once told
me in western Cameroon, "you think—war!"[25] In the West the image of the horse-
man similarly invoked a martial order, "so much so [that] in Rome during the reign
of Marcus Aurelius equestrian figures were the prerogative of the emperor."[26] The
mounted person in Africa acquires special power and resonance because the horse
is rare, expensively imported, and in some instances mystically associated with the
rider. The horse is not indigenous to Africa. It was not until the Hyksos invasion
of Egypt, circa mid-second millennium B.C., that the species was introduced to the
continent. Thereafter horses and horsemanship spread to the west of black Africa,
fully developed there by the rise of the Mali Empire in the Middle Ages. Yet the
cultivation of horsemanship remains problematic in tropical Africa. The climate,
areas of dense rainforest, and the bite of the tsetse fly are deadly to horses. Never-
theless, horsemen in Africa have exerted power and supremacy all out of proportion
to their numbers. It is said that certain states arose in West Africa on the backs
of horses and their intrepid riders: Mali, Bornu, Songhai, Hausa, Bariba, Gurman,
Gonja, Mossi-Dagomba.[27]

Africans south of the Sahara never used the horse for agricultural labor, but
reserved the animal for the transport of important persons. In addition, horseman-
ship was sometimes charged with mystical beliefs. Viewing a photograph of an
equestrian figure (pl. 15) triggered an immediate response from a priest of Egungun
near Ouidah: "That rider sits with force [*joko pelu agbara*], the force of the horse
[*agbara esin*]. He has the speed and the power of the horse within his body."[28] Some
riders are thus believed to absorb the physicality of their mount.

Reviewing other horse and rider figures, we sometimes note a blurring together
of animal and human, unlike the straightforward realism of the equestrian theme
within the West. Our first rider comes from the northern Senufo in southern Mali
(pl. 16). Frontally viewed, the horseman seems anchored in the flesh and muscle of
his mount. The legs of the beast are carved to resemble a metal apron protecting the
horseman's legs. Seen from the side, the highly stylized body of the rider is countered
by an enormous spear, as big as his body, held in his right hand. The vertical warrior
is brilliantly countered by the horizontal massing of the horse. The legs of the animal,
made human by reduction to two columns, complete the body of the rider as well
as the body of the mount. Strong and streamlined, this virtuoso piece of sculpture
brings alive its subject by interplay of diagonal and curve.

Still in the Sudan, we consider a Dogon horseman from Mali (pl. 17). The relaxed
legs of the rider reveal how lightly seated on his horse he is. It is as if the animal were

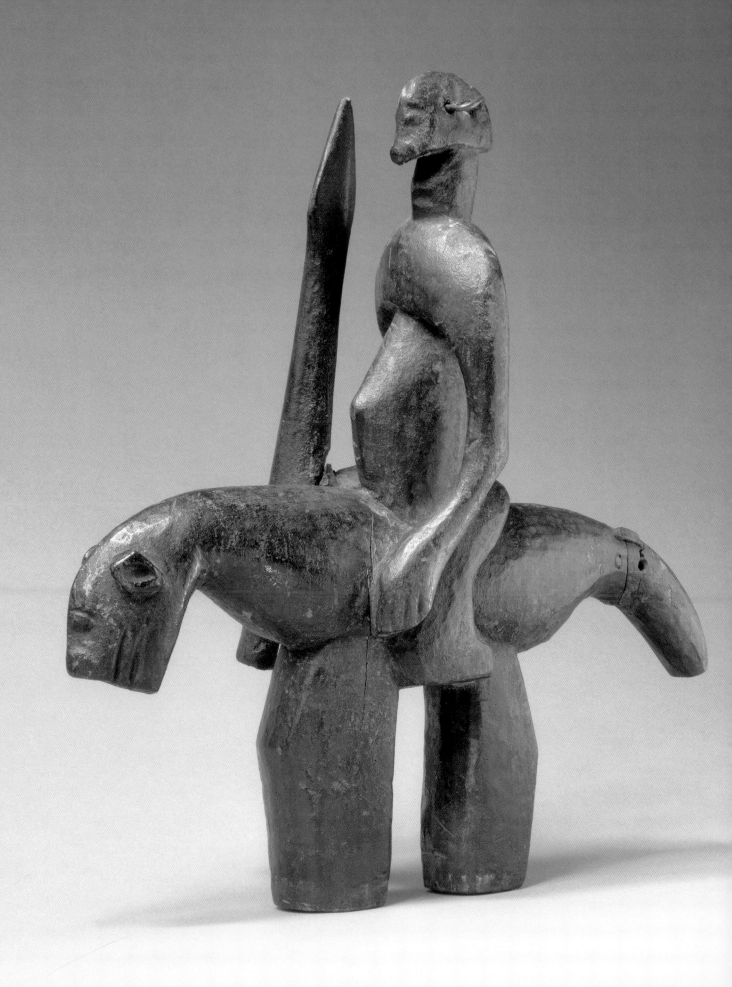

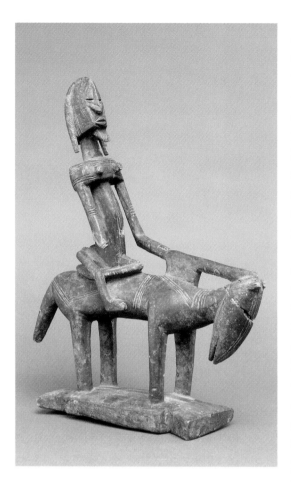

a figurated piece of furniture, a bench with head and tail both pointed down. The nonchalance of the position might mean that the rider cannot fall because his journey is mystically imbued. Griaule and Dieterlen argue that mounted figures in Dogon art symbolize the god Amma, and that in such cases the animal symbolizes one of the original eight genies of the Dogon, extraordinary water spirits.[29] The same scholars assert that the horse in Dogon lore associates with descent from the sky. Perhaps this is why the horseman's visage seems somnambulistic, eyes half-shut. The aura is quiet rather than alert. The gentle zigzag traversing the body of the animal could suggest the descent of the Dogon ark of creation, but this is far from certain.

Riding has been a theme in Nigerian art history since the Igbo-Ukwu culture, dated to around the ninth century. The image of the mounted warrior, god, or ruler is important in the world of Yoruba sculpture. Carved wooden figures of horsemen abound and usually honor, according to Robert Smith, an actual warrior.[30] Such images were kept in the house of a commander of the veteran warriors, or in the house of other military leaders in the last century. The commander kept them with his divination tray, thus linking past to future. In visual exposition, the mounted lord often becomes a master and entourage, as in a work attributed to the Alaga of Odo-Owa (pl. 18), the formal title by which the artist wished to be remembered (other art historians perversely persist in calling him by his prechiefly name of Bamgboye). Here, balance between man and beast is richly established. The leader is amazing. His towering headgear with frontal sash combines indications of knowledge of the Western helmet with the world of the square-sided phylacteries (*tira*) of Islam. He suavely pulls together sword and spear in his right hand while (again in Yoruba fashion) taking the reins in his left, but combining that gesture with the grasping, too, of a rifle. He calls with mastery of weapons and motions; his entourage responds with the sounding of flute and pressure drumming and, given other Muslim touches, perhaps even that ultimate Islamism in the field of sound—rifle music, the firing of a weapon for prestige and effect. Below the circular platform over which all this action unfolds there appears another level of drama and response. We witness the enormous eyes and exaggerated open mouth of an ancestor, so heightened as to remind us that in the earliest days the gods, the founding fathers, walked the earth as giants.

The richness of phrasing of the horseman theme can be sensed even in this modest survey. Riding is an activity that demands gestural asymmetry, sharply angled positionings of the arms and hands, as functions of an essential arrogance of action. Senufo and Yoruba riders take firm seats and maintain verticality, whereas the Dogon image rides with an air of dreamy detachment. This surely reflects a special expression of Dogon religious thought. And yet, at the end, the Yoruba submit this imperious icon to the social leavening of the call-and-response context. That forces all, leader and led, entourage and master, to recall the revelatory proverb: one tree cannot make a forest.

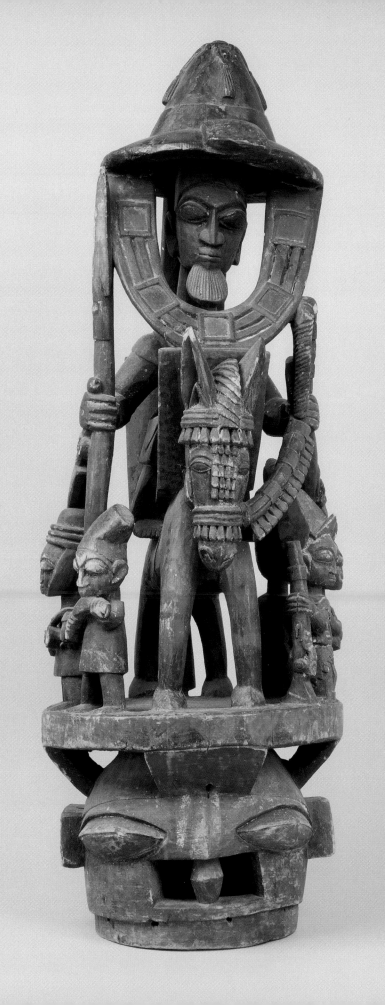

## Kneeling

> The kings are worshiped by their subjects, who believe that they come
> from heaven, at a distance and on bended knees.
>
> —G. B. Ramusio, *Navigazione e viaggi*, 1550[31]

To kneel relates the person to a higher force. Celine Baduel-Mathon enumerates some
of the enactments of the position in the cultures of West Africa: fiancé in the presence
of the father, plaintiff before the court, son approaching father, youths before elders,
the court before the king, person praying to the ancestors or the gods.[32] Such are the
public manifestations of resting on the knees in prayer or reverence. The king kneels
in private. In every instance, to fall upon one's knees indicates dependent relation-
ship. And that relationship triggers an ideal: the person only fully exists when set in
communication with a transcendental source of authority and action; otherwise one
wanders in a maze of endless subjectivity. But should a ruler before whom we kneel
turn evil or corrupt, submission can change to revolution and the followers of an
unworthy king can bring him to his knees. Myriad are the contexts of this act of sup-
plication. Among the Bamana of Mali, when a man accidentally ate food that was
tabooed, the woman who had served the repast in error asked forgiveness on her
knees, holding her hands at the back. The latter gesture signified humiliation. She
knelt to mend a ruined situation.[33]

Among the Agni, an Akan civilization of Côte d'Ivoire, a young man during a for-
mal occasion involving drinking untied his cloth, knelt before his father, and drank
from the goblet that the patriarch held carefully in the hollow of his hand. Farther east
along the coast, coreligionists of the traditional faith of the Ga people, in the region
of Accra, Ghana, knelt to offer to the spirits sacrificial fowls. These were given in twos,
held in both hands, in symbolically balanced double presentations.

Among Egba-Yoruba of the region of Abeokuta, every morning each member
of a traditional compound had to pay his or her respects to the head of the extended
family and his senior wife. A man would prostrate himself (*dobale*) before the leader.
A woman would kneel (*kunle*) or lie upon her right side (*yinrinka*).[34] All three gender-
coded gestures—*dobale, kunle, yinrinka*—traveled the Atlantic to the black Americas.
Here they remain vividly alive in Afro-Cuban *lucumi* worship and Afro-Brazilian
*candomble nago.*

Certain situations calling for kneeling were of such moment that they blasted
away the normal boundaries of gender and entourage, not unlike the amazing pith
helmet and Mande male robe worn by Wunkirle with her honorific spoon. Even the
king of the Oyo Yoruba, the *alafin*, was expected to kneel before a powerful, titled
woman known as *Iyamode:*

> The king looks upon her as his father, and addresses her as such, being the
> worshipper of the spirits of his ancestors. He kneels in saluting her, and she
> also returns the salutation kneeling, never reclining on her elbow as is the
> custom of the women in saluting their superiors. The king kneels for no one
> else but her, and prostrates before the god Sango, and before those possessed
> [with the spirit of] the deity, calling them father.[35]

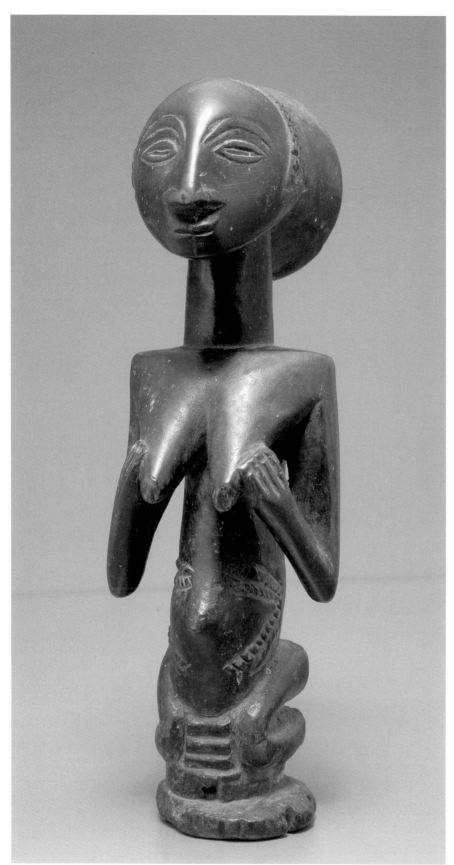

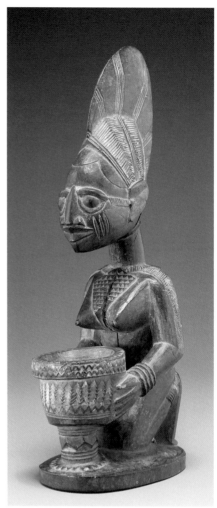

Pl. 19
**Kneeling figure**
Luba, Democratic Republic of the Congo
19th–20th century
Wood
H. 30.9 cm (12¼ in.)
Gift of Katherine White and the Boeing Company,
81.17.871

Pl. 20
**Female figure** *(olumeye)*
Yoruba, Nigeria
19th–20th century
Wood
H. 33.8 cm (14 in.)
Gift of Katherine White and the Boeing Company,
81.17.604

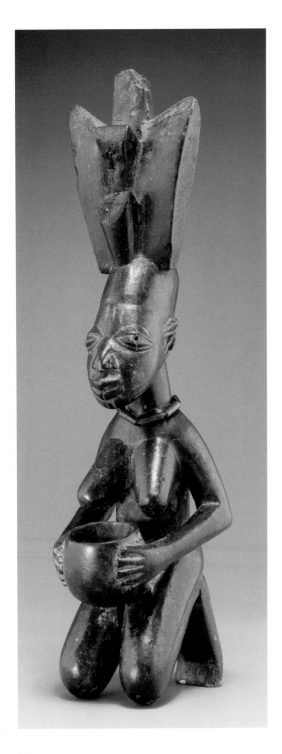

Pl. 21
**Female figure with bowl for Sango**
Yoruba, Nigeria
19th–20th century
Wood
H. 42.6 cm (16¾ in.)
Gift of Katherine White and the Boeing Company,
81.17.595

There is, moreover, a special manifestation of kneeling position that emerges in the Yoruba funeral ceremony known as *ikunle* (literally "the kneeling"). In this vigil members of a recently departed person's family were supposed to spend an entire evening on their knees.

Such exercises, in the greater black Atlantic world, become ritual ordeals or tests of commitment. I remember the night in August 1988 when I was initiated into Palo Mayombe, the strongly Kongo-influenced traditional religion of black Cuba. A young black fellow initiate and I were kept on our knees in an anteroom for more than an hour before being led into the shrine. The pain, after a while, for me at least, became severe. This was a passage of the initiation known as *penitencia* (penance). A priest explained the challenge inscribed within the kneeling: *ponte duro,* roughly, "hang tough"; that is, show you can endure discomfort, if you wish to be one of us. There were other tests that night, all in the kneeling position. At one point a heavy iron kettle with a load of sacred medicine was lowered onto my head while I was blindfolded, kneeling at the altar. As the great weight pressed against my skull, a priest standing somewhere near kept whispering "Aguantalo, Roberto, aguantalo" (Take it, Bob, take it), by way of encouragement.

So important is resting upon one's knees, or bowing low, as a sign of fully respecting the moral imperatives of Earth in Yoruba Ogboni ritual, that the doors in Ogboni shrine architecture are deliberately dwarfed. Everyone who enters is forced to bow to the spirits. A colleague reminds us that the roof to the Dogon *toguna,* or male meeting house, is similarly designed deliberately low, leveling everyone, keeping them seated and bent over. This is done so that "no one can stand up in anger." Saturating the field of African sculpture, kneeling icons are almost always idealized. The face is impassive. The limbs are strong but calmly disposed. Such icons not only impart to a shrine an aura of respect but, in the region of Djenne, Mali, indicate to the postulant what gestures to adopt within the shrine.

Turning to the Luba, we find the motif of the kneeling woman once again a sign of social allegiance and respect. The kneeling woman as icon among the Luba expresses moral rightness deepened with a timeless certainty. Consider as illustration a kneeling figure of a Luba woman with formal coiffure, holding both her breasts (pl. 19). From this stabilizing gesture of respect emerge powerful breasts and shoulders, quietude of mien, and crowning coiffure. Hauteur blends with reverence.

In further kneeling figures (pls. 20–24), we strongly sense how kneeling remains an icon of respect, a test of endurance, and above all, a seal of commitment to the way of the ancestors. To rest on one's knees is to voice with the body a prayerful ideal: every perfect gift is from above.

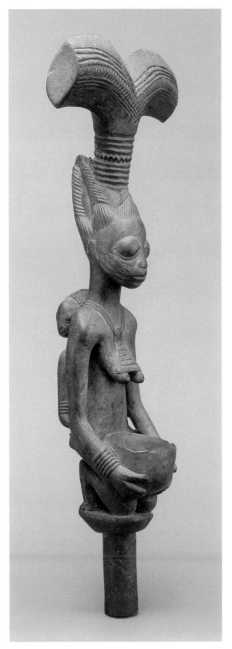

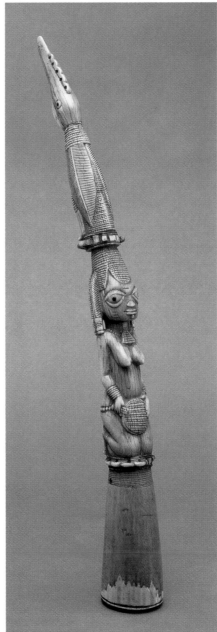

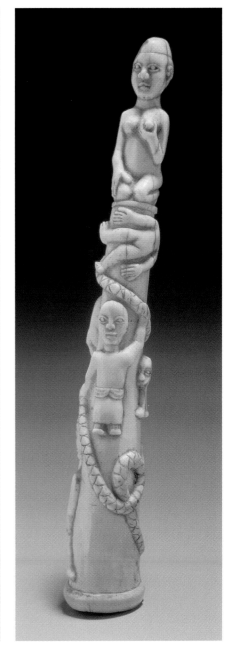

Pl. 22
**Thunder god dance wand** *(ose sango)*
Yoruba, Nigeria
19th–20th century
Wood
H. 50.5 cm (19⅞ in.)
Eugene Fuller Memorial Collection, 67.91

Pl. 23
**Divination tapper** *(iroke ifa)*
Yoruba, Nigeria
19th–20th century
Ivory
H. 39.3 cm (15½ in.)
Nasli and Alice Heermaneck Collection, 68.26

Pl. 24
**Tusk with relief carving**
Loango coast, Kongo, Democratic Republic of the Congo
and Angola
19th–20th century
Ivory
H. 15.6 cm (6⅛ in.)
Gift of Katherine White and the Boeing Company,
81.17.832

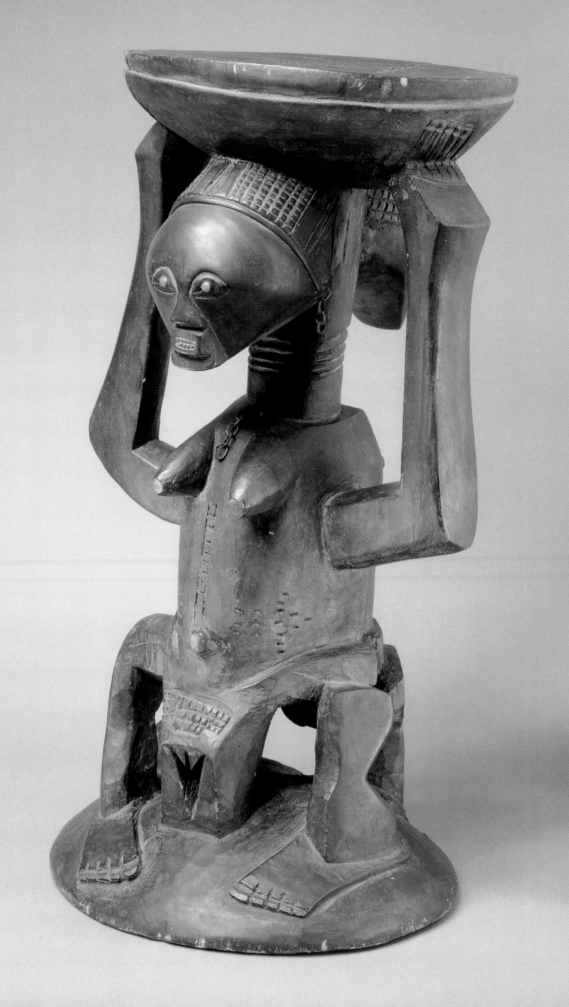

## Supporting

"Supporting" refers to carrying an object balanced on the head, steadied by both hands. The term also includes carrying a person on the shoulders or upon the back. Balancing requires more poise, for in this case the object rests upon the head of the person without the use of the hands. Supporting is often manifested in African statuary with a cold impassive stare, the seal of nonchalance or "cool." The canon of supporting bears various meanings according to place and culture. Different vernacular observers will see slightly different things even in a single piece of sculpture. Thus three Africans, from widely separated civilizations, were asked to comment on a double caryatid Luba-Songye stool for a leader (pl. 25):

> Ejagham (Nigeria and Cameroon): "They seem to carry something for an important person. The way they carry it is beautiful. They hold it with both hands. The load can never fall."
>
> Banyang (Cameroon): "This is a heavy load which cannot be carried without both hands, to reduce the weight."
>
> Suku (Democratic Republic of the Congo): "Our ancestors carried things like that. This pleases me because I have seen my own mother carry things like that, with both hands, taking care that the water in the vessel did not spill."[36]

These views from the inside are instructive, reminding us that weight and delicacy are involved in transporting and that there can be beauty to its unfolding, a beauty that ultimately resonates to the time of the ancestors. Africans also read into the theme of the person supporting a load with both hands upon his head a kind of stop-time rendering of the motion of the body traveling from one point to the next. This is not unlike the ancient Greek interpretation of the caryatid figures of the Erechthem on the Acropolis in Athens: processioneers, maidens who carried sacred objects in the Panathenaic celebration. Supporting is not only drenched with visions of the arrest of important motion but also displays, once again, the idealized flexibility of the human frame. Across tropical Africa women absorb the undulations of the earth in their springlike hips and knees to maintain the absolute stillness of their heads. In addition, the ability to rise with a heavy load on the head is yet another manifestation of the beauty that comes from the stronger power of the youth:

> Let us bend down to work
> We're only young once
> Old age will arrive
> Then when we place a burden on our heads
> We'll find that we cannot manage.
> It is muscular vitality that marks the youth.[37]

But supporting is not just athleticism. It can be a metaphor for responsibility and mind. In the Cameroon Grassfields we witness artistic phrasing of the mystic support of the king by his leopard counterpart in many forms of royal seating. Here the support is figurative and playful, not literal, for we are dealing with thrones that

Pl. 25
**Stool**
Luba-Songye, Democratic Republic of the Congo
19th–20th century
Wood, metal, pigment, glass
H. 50.6 cm (20 in.)
Gift of Katherine White and the Boeing Company,
81.17.907

Pl. 26
**Stool**
Babanki, Bamenda, Cameroon
19th–20th century
Wood
H. 30 cm (11⅞ in.)
Gift of Katherine White and the Boeing Company,
81.17.723

Pl. 27
**Throne**
Kom-Tikar area, Cameroon
19th–20th century
Wood
H. 82.6 cm (32½ in.)
Gift of Katherine White and the Boeing Company,
81.17.722

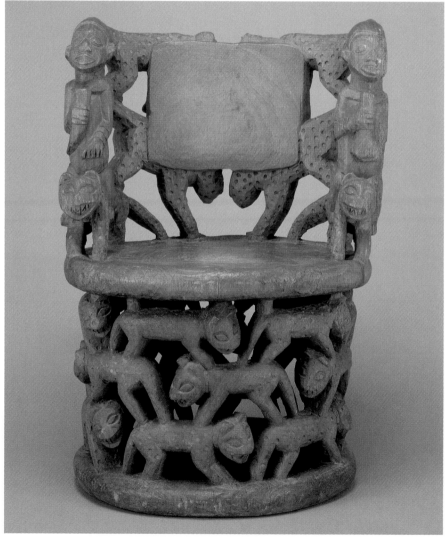

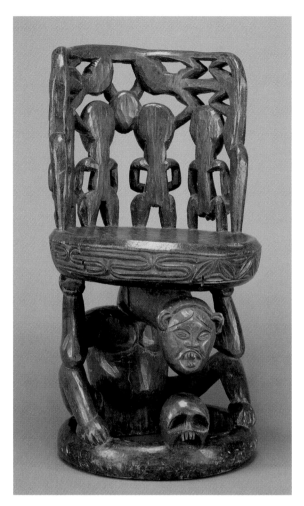 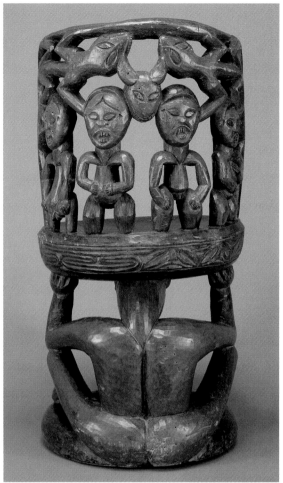

rest on the backs of moving royal leopards. How is this virtually pan-African icon of royalty locally nuanced in Cameroon? Among the chiefs of one western Grassfields culture, every leader of consequence is believed to be backed by a secret leopard counterpart. If the ruler dances brilliantly, with striking strength and grace, Bangwa people may say, "Oh ho, he takes his leopard out to dance!" Across the Grassfields and into the Cross River region the leopard connotes daring, physical prowess, impressive running, fighting or dancing. The crosscuts between the impressive athlete-ruler and the power of the leopard are quick and charming in a Babanki stool that is held up by the head of a human and, more playfully, by the ears of a dashing leopard (pl. 26).

Metaphorically resting the body of a seated king on the backs of moving leopards, themselves swarming playfully with their telltale spots, makes the seated king seem protected by countless numbers of the royal denizens of the forest (pl. 27). This is sculptural support by allusion to circles of mystic assistance. Flanking kings on leopardback, royal horns held in right hand, restate the resting of the king on untold reserves of mystic power (pl. 28).

A moving manifestation of literal and spiritual support is a figurated stool that once belonged to a Mambila patriarch in Cameroon (pl. 29). When women experienced difficulty in childbirth, they were brought to this stool and told to sit upon it

Pl. 28
**Throne**
Kom-Tikar area, Cameroon
19th–20th century
Wood
H. 92.7 cm (36½ in.)
Gift of Katherine White and the Boeing Company,
81.17.721

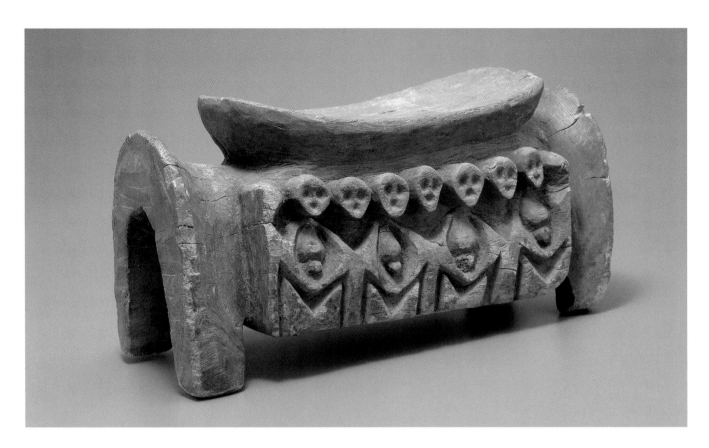

and confess whatever sins they might have committed. The release of tension after admission of guilt by this belief unlocks a difficult delivery.[38] When the woman in labor confesses and tells exactly what she has done, figurations on the stool support, in witnessing her action, the healing efficacy of the truth. Two figures, meanwhile—male and female—on one side of the stool physically support the person seated with upraised arms.

The carrying of weight and responsibility blends with the spirit in numerous gems of sculpture. A baby antelope carried on the body of its mother automatically identifies the female of a pair of Tyi Wara maskers among the Bamana (pl. 30). Whereas the victorious shouldering of a chief on the shoulders of a retainer on an Akye "linguist's staff" is nuanced by gestures to the heart and stomach—to inward sources of nobility of mind (pl. 31).

We close among masters of the theme of allegorical support, the Luba. Joseph Cornet compares Luba to Baule art in shared nobility and calm, with "no exaggerated attitude or awkward gestures break[ing] the inner serenity of the faces of the ancestor statues."[39] It is certainly true that the Baule chieftain being carried in triumph on the shoulders of his follower, the follower himself, and the Luba woman supporting a bowl become advocates for submission of self to authority (pl. 32). The Luba caryatid theme can be placed in perspective of time with a number of documents. An engraving from the end of the last century shows the king of the Luba seated on a large, handsomely carved caryatid stool while at the same time resting his feet on

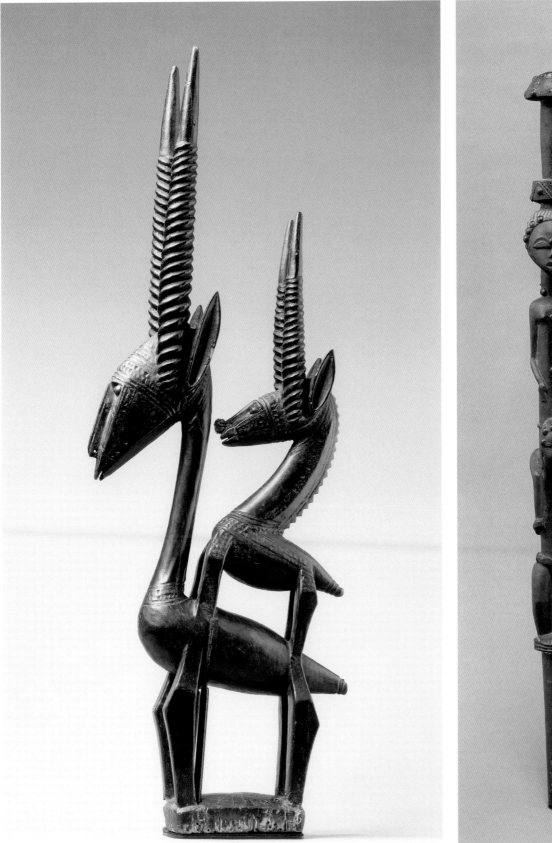
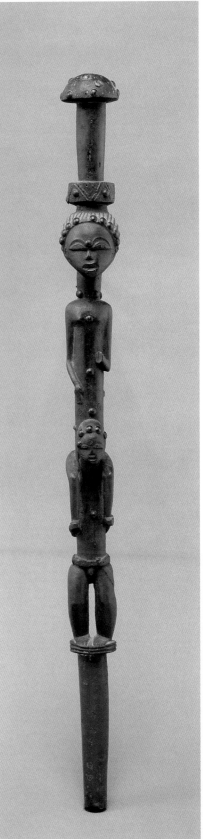

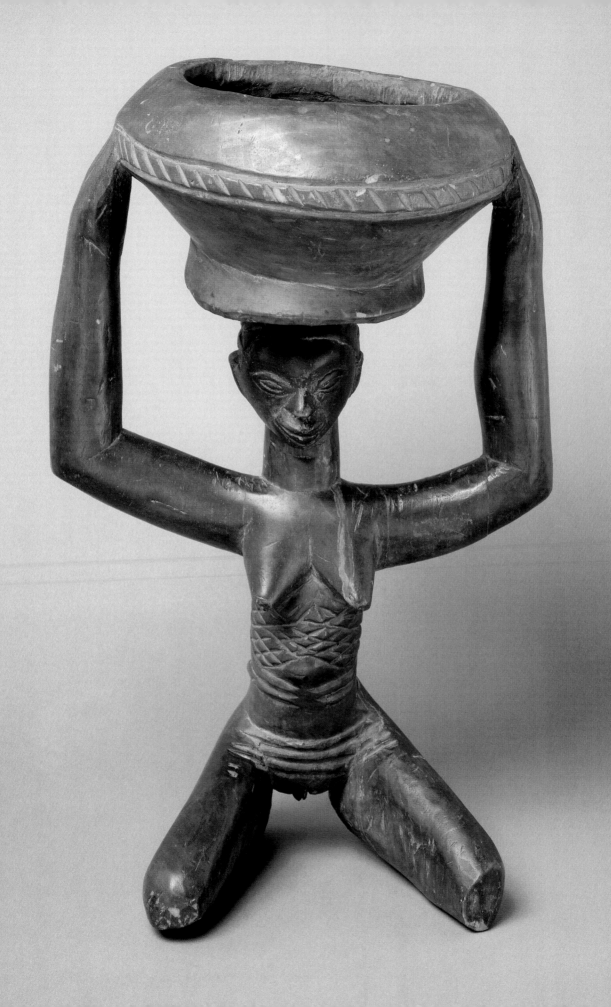

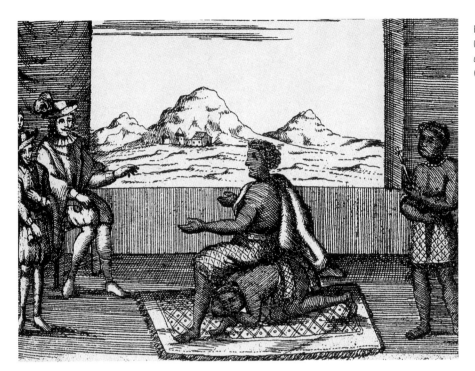

the thigh of his wife, thus supported by both statuary and a living person. Availing ourselves of the rich cultural cognation of the Bantu area, one can adduce an even earlier illustration of the living caryatid, dated 1687.[40] I refer to an illustration of Queen Djinga Bandi, received by the Portuguese governor of Angola (fig. 8). She rests upon the body of a follower, who serves as a living caryatid. Granting strength and meaning to the icon of support is the abiding presence of the spirit. Speaking of the Luba, but with insight of far wider application, Jack Flam, novelist and art historian, made this point forever clear:

> The effortless grace with which [the Luba images] carry their burden, the serenity of their countenance (so close to other Luba ancestor figures) and the hierarchy of importance in their body parts, all infer that the caryatid image is meant to be interpreted as a spiritual representation.[41]

Pl. 32
**Figure supporting bowl**
Luba, Democratic Republic of the Congo
19th–20th century
Wood
H. 49.5 cm (19½ in.)
Gift of Katherine White and the Boeing Company,
81.17.875

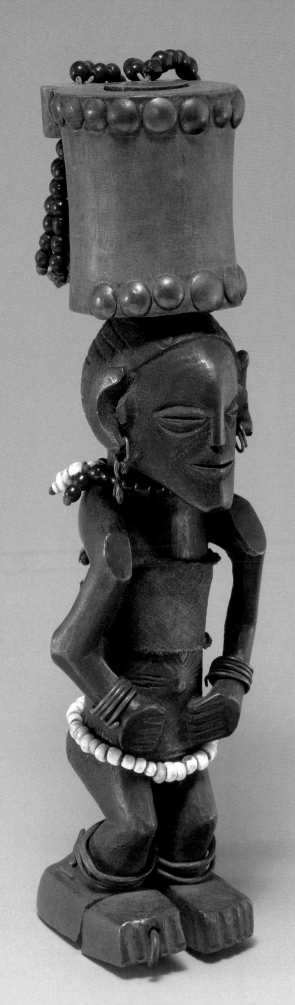

## Balancing

Pride resides in having the load rest easily on the head with an insouciant countenance that reveals no sign of pressure or strain, [while walking] smoothly with the arms swinging free.

—Sylvia Boone, 1986[42]

To move in utter confidence with an object balanced on the head is one of the accomplishments of traditional Africa. On my first trip to tropical Africa in 1961, I was amazed to see a young man bring sheets and pillowcases balanced on his head into a resthouse room. That summer I observed schoolchildren carrying ink and writing paper casually stashed atop their heads. I saw how balancing was a gift cultivated early in childhood and onward as part of the arsenal of African bodily grace into maturity.

Children in Benin master this talent as they learn to play games:

*Adigba,* "woman with the burden," is a game played by all small [Beninois]. The children fix twelve wooden sticks in a pile of sand. Then each child, by turns, carries on his knees, with his hands tied behind his back, a cushion balanced on his head, for a distance of about twelve meters....

As he approaches the area where sticks are, he is supposed to pick them up with his lips, never allowing the pillow on his head to fall. The game is very difficult, ventured only by children adept in carrying things on their heads.[43]

This is a beginning level of the skill. The highest levels refer to transcendental equilibrium, ultimately enabling a person to communicate mind itself by the quality of his composure and the importance of the object balanced on his head (pl. 33). Transporting objects on the head without using one's hands occurs with formalized repetitiveness in the sculpture of Africa. There is every reason therefore to sense iconic import.

As to the mystical dimensions involved, one might start off by mentioning that at Akan funerals women sometimes dance with a vessel filled with water balanced on their heads. If the vessel should fall, it is a sign that death was brought by witchcraft. In the same portion of West Africa, priests (*okomfo*) may dance with a shrine—a vessel filled with blessed substances—balanced upon their heads. The association of mind and balance is hinted at in the invocation by which they gloss this act: "Oh tree...we are calling on you that we place in this shrine the thoughts that are in our head."[44] The spiritual head, filled with fluid and symbolic objects, goes over the literal head. Mind emerges triumphantly redoubled.

Equally dramatic extensions of balancing objects on the head of a moving person occur in the worship of the *orisha,* the deities of the Yoruba people. Just as kneeling can become an ordeal, so transporting on the head without using hands becomes a test of spiritual training and aliveness. Followers of the thunder god, Sango, both in Nigerian Yorubaland and in certain Yoruba-oriented compounds in Bahia in Brazil, must dance upon initiation with a living flame balanced in a vessel on their heads. This logically leads into sculptural renderings of the balancing of the fiery

Pl. 33
**Tobacco mortar**
Chokwe, Angola
19th–20th century
Wood, brass, beads, string
H. 21.6 cm (8½ in.)
Gift of Katherine White and the Boeing Company,
81.17.913

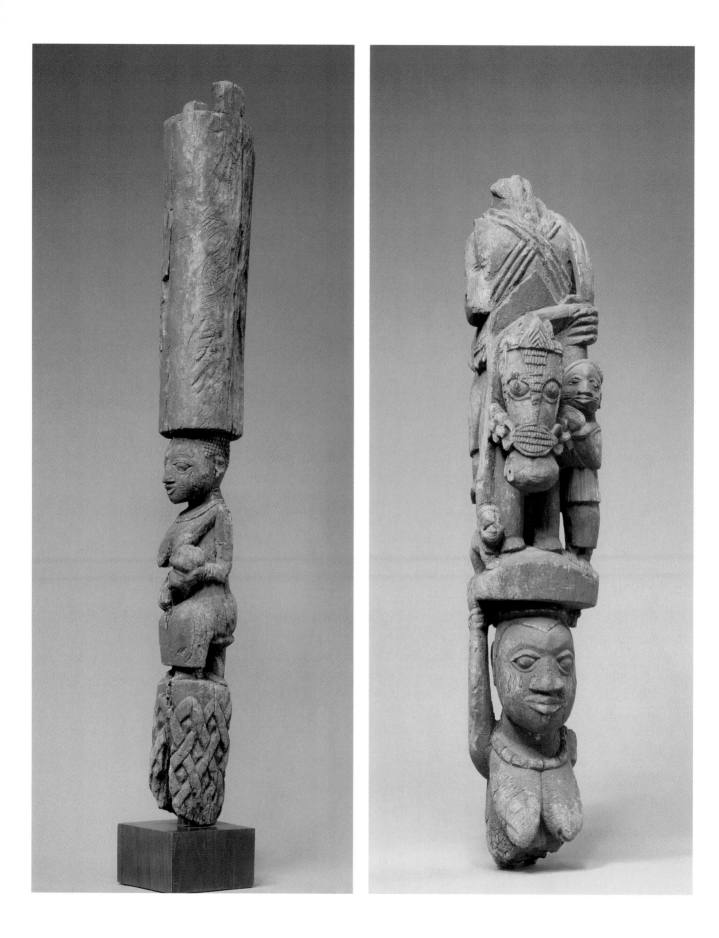

meteorites or thunderstones of Sango (*edun ara*) upon the brow or head of the devotee. The act of balancing puns on architectural support in the traditional Yoruba mind. This leads us to accomplished examples of figurated columns. Witness a carved housepost (*opo fie*) from Efon-Alaiye (pl. 34). It boasts a richly textured base, is covered with interlace, and a central portion depicts a seated wife of an important man (*iyawo oloye*), identified by the double strand of beads about her neck. A strong shaft of wood rests impressively upon her head. This is a senior woman who supports her compound with inherent goodness.

Another column enters into the realm of balancing (pl. 35). It is again from that splendid epicenter of style and grace in Yoruba carving, Efon-Alaiye. A woman with the specially lidded Efon eye supports with her head none other than a fully caparisoned warrior-chief with follower (now sadly reduced to a fragment). Because this striking column comes from Efon-Alaiye, where I did considerable fieldwork, I am able to match this piece to its meaning:

> The mounted figure represents a warrior who fought the enemies of Efon-Alaiye at the time of the Kiriji War [in 1880]. Under him [appears] his wife. This woman was brave too. When her husband went to war, she would be somewhere else, working magic to save him and bring him back alive.[45]

She keeps a world intact. The ruler of Agogo sleeps over his sword, so that his head is always supported by the throne. The legitimacy provided by the sword is here provided by the woman. This is iconic balancing. It is brought to a point of dramatized equilibrium. Yeats himself could be describing this woman who supported her husband and the world that they shared:

> Her eyes
> Gazed upon all things known, all things unknown
> In triumph of intellect
> With motionless head held erect.[46]

Pl. 34
**Housepost** *(opo)*
Efon-Alaiye, Nigeria
19th–20th century
Wood
H. 110 cm (43⅜ in.)
Gift of Katherine White and the Boeing Company,
81.17.625

Pl. 35
**Housepost** *(opo)*
Efon-Alaiye, Nigeria
19th–20th century
Wood
H. 56.5 cm (22¼ in.)
Gift of Katherine White and the Boeing Company,
81.17.624

# Notes

1. Richard Wright, *Black Power: A Record of Reactions in a Land of Pathos* (New York: Harper, 1954).

2. The late Araba Eko, Isale-Eko, Lagos, Nigeria, January 1972. It is believed that the gods established the correct manner of formal presentation in standing, sitting, and other activities. See G. Gosselin, "Pour une anthropologie du travail rural en Afrique noire," *CEA* 12 (1963), 521. Proper decorum in work gestures are sanctioned in West Africa frequently by reference to tradition and to the world of the sacred: "One thinks specially of the repetition of archetypal gestures mentioned in origin myths."

3. Alade Benhoufewe, Cotonou, Benin, June 4, 1973; Ako Nsemayu, Mamfe, Cameroon, June 8, 1973; Piluka Ladi, Kinshasa, Democratic Republic of the Congo, June 13, 1973.

4. *The American Heritage Dictionary,* 85, 554, 1256.

5. Marcel Griaule, *Folk Art of Black Africa* (New York: Tudor, 1950), 100.

6. Alade Banhoufewe, Cotonou, June 4, 1973; Ako Nsemayu, Mamfe, June 8, 1973; Piluka Ladi, Kinshasa, June 13, 1973.

7. Bruce Glaser, *Minimal Art: A Critical Anthology* (New York: E. P. Dutton, 1964), 155.

8. Kofi Antubam, *Ghana's Heritage of Culture* (Leipzig: Koehler and Amelang, 1963), 71.

9. Harris Memel-Fote, "The Perception of Beauty in Negro-African Culture," *Colloquium on Negro Art* (Paris: Presence Africain, 1968), 58.

10. Araba Eko, Lagos, January 1972.

11. Ibid.

12. F. J. J. Buytendijk, *Attitudes et mouvements* (Bruges: Desclee de Brouwer, 1957), 125.

13. Dejo Afolayan, Nigeria, 1988.

14. Ibid.

15. George Tabmen, Monrovia, Liberia, March 25, 1967.

16. Peter Sarpong, *The Sacred Stools of the Akan* (Accra: Ghana Publishing, 1971), 8.

17. Hugh Goldie, *Dictionary of the Efik Language* (Ridgewood, N.J.: The Gregg Press, 1964), 290.

18. "*Atenase:* The Manner of Sitting," in Antubam, *Ghana's Heritage of Culture,* 114.

19. Ibid.

20. Susan Vogel, "Yoruba and Baoule Art Criticism," unpublished paper, 1971, 5. Vogel cites Pierre Etienne, "Les Baoule et le temps," *Cahiers Orstom ser. sciences humaines* (Abidjan, Côte d'Ivoire), nos. 3, 5 (1968), 1–37. Etienne finds that Baule expend unusual time, labor, and money on bathing and rank this pleasure high among the good things of life.

21. Eva Meyerowitz, *The Akan of Ghana* (London: Faber and Faber, 1958), 31. In addition, Thomas Akyea, on behalf of the Agogohene, added the following information about the queen mother during fieldwork at Agogo, Ghana, on May 19, 1969: "The queen mother is either the sister, niece, or even mother of the king. She is a member of the court panel, and without her presence the court is not full. Any pronouncement or judgment given without her confirmation will not be binding. In her absence no authority can enstool a chief."

22. Henry Drewal, John Pemberton, and Roland Abiodun, *Yoruba: Nine Countries of African Art and Thought* (New York: Harry N. Abrams, 1989), 33.

23. James W. Fernandez, *Fang Architectories* (Philadelphia: Institute for the Study of Human Issues, 1977).

24. Djibril T. Niane, *Sundiata: An Epic of Old Mali* (London: Longman, 1965).

25. Ako Nsemayu, Mamfe, June 8, 1973.

26. From Babatunde Lawal, *Yoruba Sango Sculpture in Historical Retrospect* (Ann Arbor, Mich.: University Microfilms, 1971), 113.

27. Jochen Kohler, "Das Pferd in den Gur-sprachen," *Africa und Ubersee* 37 (1953–54), cited in Jack Goody, *Technology, Tradition and the State in Africa* (London: Oxford University Press, 1971), 71.

28. Alade Banhoufewe, Cotonou, June 4, 1973.

29. Marcel Griaule and Germaine Dieterlen, *Le Renard pâle* (Paris: Institut d'Ethnologie, 1965), 455–56.

30. Robert Smith, "Yoruba Armament," *Journal of African History* 8, no. 1 (1967), 88.

31. G. B. Ramusio, *Navigazione e viaggi* (1550), quoted by Thomas Hodgkin (1960), in *Nigerian Perspectives: An Historical Anthology,* 2nd ed. (London: Oxford University Press, 1975), 127.

32. Celine Baduel-Mathon, "Le Langage gestuel en Afrique occidentale: Recherches bibliographiques," *Journal de la société des africanists* 41, no. 2 (1971), 207, 209, 212, 213, 217, 218.

33. Human Relations Area File: Dieterlen, 118 E-5 (1946–49), FA8, Bambara; Dieterlen, 101 E-5 (1946–49, 1951).

34. E. A. Ajisafe Moore, *The Laws and Customs of the Yoruba People* (Abeokuta, Nigeria: Fola Bookshops), 7.

35. Samuel Johnson, *The History of the Yorubas* (Lagos, Nigeria: CMS Bookshops, 1921), 11.

36. Ako Nsemayu, Mamfe; Chief Defang, Cameroon; and Piluka Ladi, Kinshasa, June 1973.

37. Kwabena Nketia, "Yoruba Musicians in Accra," *Odu,* no. 6 (June 1958), 40, retranslation by author.

38. Gilbert Schneider, correspondence with author, Katherine White Archives, Seattle Art Museum.

39. Joseph Cornet, *Art of Africa* (London: Phaidon, 1971), 192.

40. Jack Flam, "The Symbolic Structure of Baluba Caryatid Stools," *African Arts* 4, no. 2 (winter 1971), 56.

41. Ibid., 57.

42. Sylvia Boone, *Radiance from the Waters* (New Haven, Conn.: Yale University Press, 1986), 126.

43. Charles Béart, *Jeux et jouets de l'ouest africain,* vol. 1 (Dakar, Senegal: IFAN, 1955), 264, "Equilibres avec object sur la tête," translation by author.

44. R. S. Rattray, *Ashanti* (Oxford: Clarendon Press, 1923), 148.

45. Iloro, December 21, 1963.

46. *The Collected Poems of W. B. Yeats* (New York: Macmillan, 1952), 168.

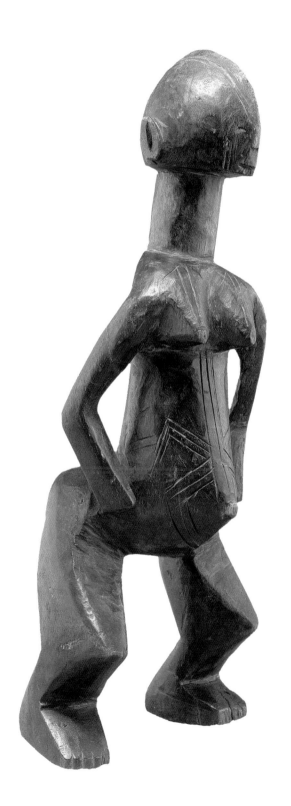

*Pamela McClusky*

# Case Histories

## Art Steps from Africa to America

# Heroes Go Solitary Walking: Hunters' Shirts

Salif Keita is about to perform in a crowded club in Vancouver, B.C. When his orchestra takes over, a precise complexity fills the air, mixing music from too many sources to identify at once. A spotlight is set on center stage. Someone rushes in and out of it, unleashing a sense of disquiet. Eyes strain through the smoke to sort out the vision. It's Salif Keita, swirling along an unpredictable path. When he does stop to allow his voice to explode, his agitated appearance comes into focus. He wears a bristling shirt and hat, activating a work of art with all the force it implies. No longer immobilized as it is in the museum, captive in a Plexiglas case, the shirt is where it once belonged. On stage, Salif Keita is showing what it's like to come from a line of epic tradition going back eight hundred years. Confidently overcoming the restraints of a largely foreign audience, he sings songs loaded with references from his past. The audience begin to wave their hands gently above their heads in a manner African friends have dubbed "kelp dancing." I wonder how many in the crowd are simply enjoying an unusual albino performer with a tight band, just as I wonder how many museum visitors see the shirt on display as a perplexing oddity. The audience sways while Salif Keita shudders, again and again, sending his shirt into turmoil.

A hunter's shirt visually defies its place in an art museum (pl. 36). Wild boar tusks, antelope horns, wads of dried mud, rusty stains, and bulging packets of leather bring a shadowy dose of forest ingredients into view. Such murky wilderness entered the art museum in stages. First, the shirts were featured in a major exhibition that introduced them as visual feasts but didn't say much about who originally wore them. Soon thereafter, studies began to reveal the original owners as members of a culture whose tenets will not fit into the usual classifications. The shirts brought into focus the strength of Mande people, who share "a space, in some way perhaps a time, and for many, an idea."[1] Among the lessons the shirts have unveiled are the Mande definition of heroes and their unique way of handling knowledge and discussing sorcery.

Pl. 36
**Hunter's vest**
Maninka, Guinea-Conakry
20th century
Cloth (strip weave), horns *(safele)*, cotton twine *(tafow)*, leather, amulets *(basi)*
L. 80 cm (31½ in.)
Gift of Katherine White and the Boeing Company, 81.17.70

Fig. 9. Left to right: Goats, meal preparation, market ingredients, Burkina Faso, 1969.

It was a greasy, aromatic mass of power.　　　–Katherine White, 1970

In 1969, Katherine White was made chairwoman of the African Subcommittee of the Museum of Modern Art in New York. She took it upon herself to convince the museum to host an exhibition about African design and collaborated with Roy Sieber, a professor who ably filled the role of curator. She relished being the catalyst: "I bought every juicy thing I could find to push them over the hump and get the enthusiasm going." She undertook a field trip to collect ammunition for her meetings at the museum. During her travels in Burkina Faso, she searched "for cloths among the cabbages, millet heads, woven mats, dainty Arab horses, agile steers with towering horns, sheep painted with blue stripes and magenta dots, even the side show of a python coiling himself around a tiny desert deer" (fig. 9). On the same trip, she traveled to Ghana and found an old man selling "a war dress, a dull strip-weave tunic cluttered with leather sewn amulets containing passages from the Koran, magic leopard's teeth, bells, a string heart, and shriveled sheep's vitals. The chicken blood had blackened stiff the chest and back. It was a greasy, aromatic mass of power. They say, dressed in such, a Ghanaian can face a machine gun in total safety."[1]

Upon her return, White packed a suitcase and went to the Modern. She showed slides and passed around samples of what might be in an exhibit. "I let them handle my enormous paper thin Pheul earrings, 5½ ounces of hammered red-gold elegance, each one packaged African fashion in a brown-and-white man's handkerchief. I showed them a huge Cameroon wall hanging sew-dyed with chameleons, houses, and water patterns.... They lifted an anklet weighing 16 pounds, thick with ornaments, and their hands turned blue from the black bronzy indigo of Nigerian batik. They liked what they saw. The show was on."[2]

In dividing the labor required to mount an exhibition and publish a catalogue, the organizers asked White to survey collections. Throwing herself into a year of

documentation, she covered "twenty major institutions, thirty-eight private collections, traveled fifty thousand miles and collected two thousand photographs." She photographed "aprons of porcupine quills from the Pygmies, engraved ostrich-eggshell bottles, and huge three-foot-around feather headdresses from the Cameroons. Necklaces of deer hooves, iridescent beetle wings, human teeth, bird bones, glass and tortoiseshell, anklets of huge flat brass sun discs, and fighting rings from Uganda."[3] She was especially attuned to emphasizing a range of media that would stand out in a museum like the Modern.[4]

A lovely sock in the teeth.     —John Canaday, 1972

*African Textiles and Decorative Arts* opened in fall 1972, following *Italian Design.* The two exhibitions exposed a stark contrast in what could be considered modern art. *Italian Design* featured specially designed rooms for living as well as objects for daily use such as furniture, ashtrays, and appliances. The curators attempted to bring together the broadest spectrum of divergent Italian design, but Robert Jenson in his review for *Artforum* pointed out one unifying element: "Plastic is the universal favorite of the Italian designers." He quoted one Italian designer who maintained that the material "allows an almost complete process of deconditioning from the interminable chain of psychoerotic self-indulgences about 'possession.'" Jenson followed, "He is right; plastic triggers few associations within us. It has no history and a malleable future.... The designers have created the furniture of an almost perfect human alienation and despair, designed for the forces controlling man, rather than the other way around." He ended by calling the designers "assassins of the human spirit."[5]

On the first floor of the museum, *African Textiles and Decorative Arts* displayed 240 objects to present a broad spectrum of African design. The galleries were darkened, music played, and a *New York Times* reporter wrote of a mixed feeling of well-being issuing from the exhibition, or "a lovely sock in the teeth."[6] In the gallery installations by Arthur Drexler, head of the Design Department

Fig. 10. Installation view from the exhibition *African Textiles and Decorative Arts,* The Museum of Modern Art, New York, 1973.

(fig. 10), visitors were led down meandering ramps from which floating textiles were suspended just out of reach. Jewelry, hats, combs, and skirts were housed in circling tubes that sent the eye moving in curves. Very little plastic appeared, but a multitude of other media were evident. Occupying an alcove, shirts were beacons of visual ferocity—sprouting projectiles and strips of hide, saturated in smoky colors, stained with sweat and caked with soil, never washed with soap. One can only ask: who would wear such a shirt with pride?

Ah, savage and solitary beast, we cannot finish praising you.

—Bamana salute

Just as the protrusions of the shirt keep people at bay, so the hunter broadcasts an approach to life that sets him apart. Mande explanations of human character distinguish between people who have the tendency to rebel and those who do not. Rebellious people are said to have ample *fadenya,* or "father-childness," with a need to strike out and transform the rules of society. Other people are said to be filled with *badenlu,* "mother-childness," which results in living as quiet, reliable citizens who put the group's needs before their own. Hunters are among the most willful, self-directed, and heedless of social orders. Hunters, warriors, leaders, and sorcerers are said to be like ferocious animals, an impression the hunters' shirts reinforce.

A hunter never gets his fill of solitary walking.

—Seydou Camara, 1976[7]

A hunter walks into a forest wearing a shirt of two distinctive colors: a lighter brown that blends into the early dry season when leaves are falling, and a darker brown for a later season when more earth is exposed. He gets the color from tree barks, and recites incantations as the shirt steeps in dye. The shirt is never washed, but absorbs wood smoke, sweat, soil, and stains, making it better able to hide a human's scent from the hunted prey. As the hunter sets out, the shirt helps him blend into the environment and shields him like protective armor. Active hunters are not the only men to wear such shirts—hunters' bards, warriors, and sorcerers also don them. Shirts loaded with added elements are not worn every day (or when hunting), but are put on when hunters assemble to accept new members into their association, join community celebrations, or attend funerals (fig. 11). A description of such a funeral, or "death diversion," for a fellow hunter takes us closer to the original "gallery" in which a hunter's shirt would be seen. Filling the air of the deceased's

compound, a praise singer plays his lute and sings in salute to the gathering hunters. By evening, the hunters settle into seven days of frenetic activity—they sing, dance, and drink, fire muskets, and blow whistles. The noises and songs scare off the spirits of the animals the hunters have killed over the years. Dancers encircle the hunter's widow to assure her of their protection. Late at night, long after other mourners have gone home to rest, a praise singer might begin. Depending on his skill and knowledge, the singer could deliver a one- or two-hour partial recitation of an epic or take two or three nights to deliver a fuller rendition. Songs praise the qualities of the deceased and recall the feats of great hunters throughout history. The mourning hunters will occasionally challenge each other to create extraordinary sights. One might strike the ground with his gun and cause water to flow. Another will swallow flames. As the all-night ceremony wears on, a mourner may boast that he is ready to stick knives into his cheeks, or remove his eyeballs. Audacious behavior goes with the attire. What culture pays tribute to this agent of disequilibrium?

> Give me a skull, man, I have no face-washing-pot,
> Give me a hide, I lack a covering cloth,
> He gave me huge intestines for I had no sleeping cloth,
> He gave me some blood for face-washing-water,
> He gave me small intestines as the belt for my waist.
> Put the big tail in front of me as a room-sweeping brush,
> Give me a leg bone to use as a toothpick,
> Famori, the hunter is coming.

> —Seydou Camara, 1977[8]

These two shirts (pls. 36, 37) are under the influence of a culture that resists classification. At the end of the twentieth century, Mande is known as a space, a time, and an idea. In spatial terms, Mande-speaking people are found in regions of West Africa reaching from the headwaters of the Niger River to a heartland in Mali, including sections of Gambia, Guinea-Conakry, Guinea-Bissau, Liberia, Sierra Leone, Senegal, Mali, Burkina Faso, Mauritania, and Côte d'Ivoire. The Mande were galvanized during the era of Sundiata Keita, who founded the Malian empire in 1235 and ruled it until 1255. His praises are continually recited in *The Epic of Sundiata*, perhaps Africa's best known heroic saga.

> Mande may stumble but it will never fall down.
> —Cheick Mahamadou Cherif Keita, 1995[9]

The legendary Lion King and founder of the Malian empire, Sundiata is credited with initiating behavior to which Mande people remain loyal. His life story is recounted again and again in many versions of an epic that evolved over hundreds of years. It is recited by musicians, who entertain but also act as historians and confidential advisers to leaders. Along with Sundiata's, other poems and songs specifically created for hunters make up a rich oral culture. Despite the towering influence of this oral tradition, Western scholars were slow to recognize its significance. The Sundiata epic was transferred to written form in the eighteenth and nineteenth centuries; then

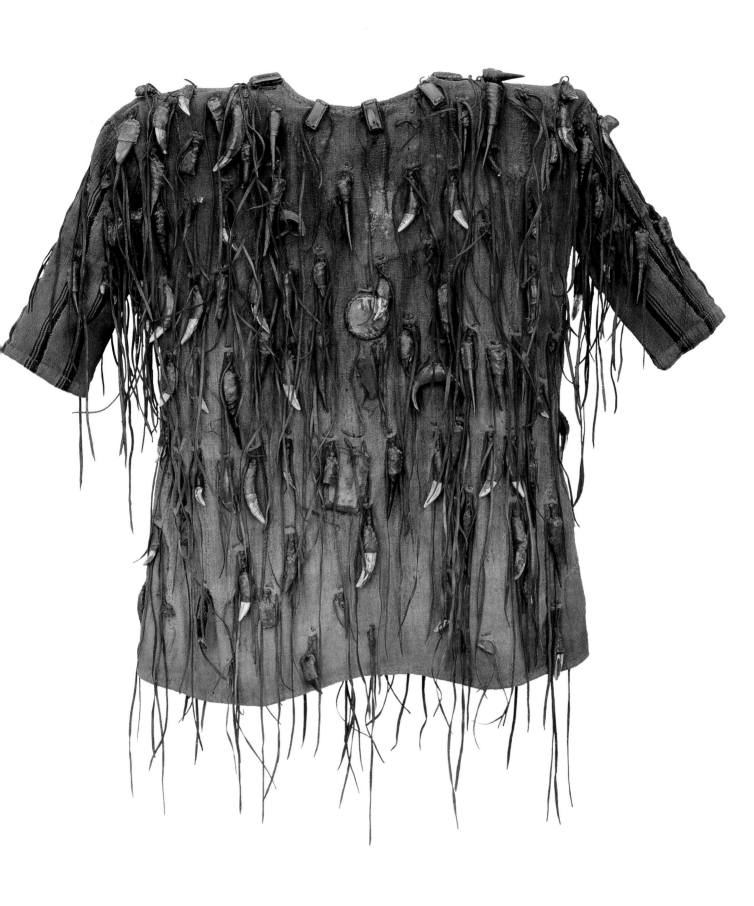

colonial writers tended to treat the saga as a source of history, editing out the mythic and supernatural details. When recitations were recorded and transcribed anew in the 1960s, awareness widened. Since then, a wave of studies devoted to Mande sculptors, blacksmiths, musicians, textiles, and epics has emerged. These studies continue to reveal the nature of the ideal Mande hero.

**The hero is the agent of disequilibrium.**

–Charles Bird and Martha Kendall, 1980[10]

Sundiata Keita defines Mande heroism. An extremely shortened episode from the epic reveals only partly the character of his heroism. Often related in a song called "Simbon," it tells how Sundiata is hexed at birth and remains a cripple, crawling like a reptile until the age of seven. Responding to his mother's despair, he asks for an iron staff that has been forged seven times, and tries to lift himself up. When the strong iron staff bends under his weight, he asks his mother to fetch a branch of a custard apple tree. He struggles to his feet and stands for the first time. Now filled with astonishing strength, he uproots an entire baobob tree with his bare hands and lays it at his mother's feet in tribute. He makes the bent staff into a bow, with which he hunts buffalo and elephants. For the rest of his life, Sundiata stands tall against every obstacle. He gains a reputation as an unequaled hunter, a king among kings, and the lion who possesses all the secrets of the wilderness.

Many nuances lace his sudden transformation from crawling boy to towering hunter. He combines the iron rod and the tree, symbolizing how man-made technology and natural powers must be fused to find strength.[11] After suffering from years of ridicule as a cripple, he rises up to confront his detractors and restore the honor of the deprived. Sundiata masters his difficulties to become the vehicle of collective will. In some situations, he triumphs by wielding medicines to dissolve adversity; in others, he is a ruthless rebel, or "adversity's-true-place."[12] In a gesture recalling Sundiata's initial frailty, the Mande greet a hunter by embracing his legs. Sundiata's legend doesn't dwell so much on his physical prowess as on his ability to overcome enemies with wisdom.

**Wisdom dictates amassing as much information about the natural environment as possible.** –Sedou Traore, 1988[13]

Creatures contribute tusks and claws (detail, pl. 36) to a shirt that speaks of a life largely spent in their wilderness, away from people. Hunters become acquainted with the habits of animals and reptiles after spending days, weeks, and months in their company. They learn to recognize ecological zones; use leaves, roots, and barks of plants; and discern the properties of bones, claws, skins, and organs of animals. More than one hundred years ago, the Manden plateau was home to wild boar, baboons, lions, anteaters, roan antelope, hartebeest, bushback, leopards, hippopotami, buffalo, elephants, giant eland, and giraffes. Each creature had to be tracked and treated differently. A delicately pointed horn that repeatedly stands out on one shirt came from the duiker antelope, called *sineri*. Prized as prey, the duiker lives in the forest but wanders alone onto farm plots to graze. Wary and shy, it can be coaxed

Pl. 37
**Hunter's shirt** *(donso duloki)*
Mande, Bamana, Mali
20th century
Cloth (strip weave), teeth, horns, leather, tin, amulets *(basi)*
L. 130.8 cm (51½ in.)
Gift of Katherine White and the Boeing Company, 81.17.70

Pl. 36 (detail)

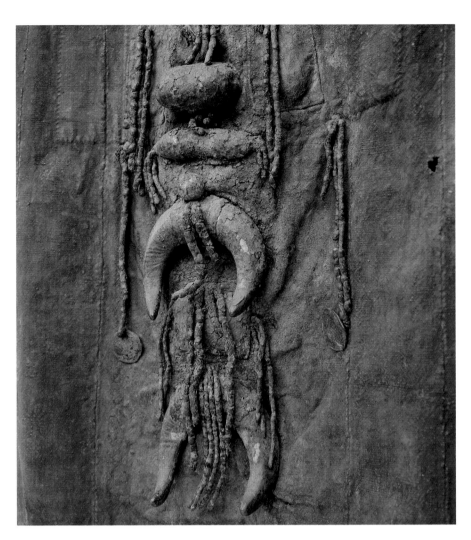

to stand still. Killing *sineri* requires preparation, caution, and subtle prowess. Buffalo horns on another shirt (detail, pl. 36) declare a different kind of hunting—tracking an animal known for its tendency to rampage and seek revenge.

Horns and teeth on shirts signal other hunter's skills as well (pl. 37). Inner cavities on both become chambers for storing medicines made of ingredients drawn from the forest. A hunter relies on medicines when confronting spirits who might attempt to sabotage his pursuit. Called *jinew*, wilderness spirits inhabit luxuriant pockets of the forest, and live in winds wafting over the savanna or in tall termite mounds. *Jinew* are not considered symbols of other worlds, but are members of this world to be reckoned with. When the hunter travels through their homeland, a spirit may contact him. Some are said to be insistent and adept at psychological torture. They must be engaged not just intellectually but through preparations called *daliluw.*

> The best way to know yourself is through your *daliluw.*
>
> —Mande proverb

To become successful, hunters master *jiridon,* or the "science of the trees." Their shirts catalogue the experience of searching for medicinal ingredients in the fertile

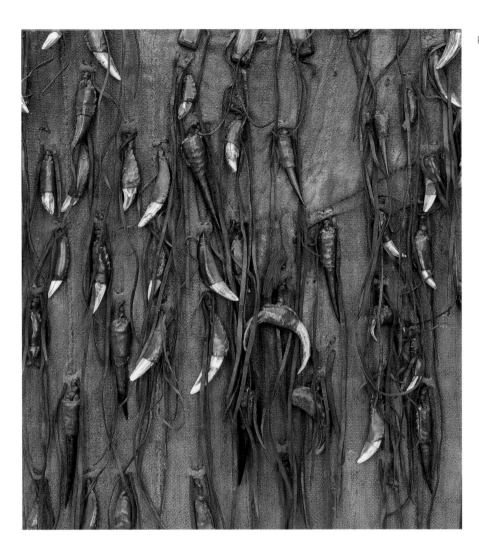

Pl. 37 (detail)

setting of the forest—finding plants, collecting venom from bees and snakes, and extracting tears from animals. *Jiridon* tells how to create medicines by combining parts of various living things. *Daliluw* are the recipes and techniques for mixing these elements. Many observe aspects of herbal chemistry, for example, pounding and boiling ingredients to produce a concentrated solution for curing fevers or bad breath. Other *daliluw* prescribe ritual preparations to activate or control energies said to animate the world. *Nyama*—an unpredictable energy of action—flows through all things and is ever present. *Nyama* can be helpful or hazardous, and hunters attempt to control it through their study of *daliluw*. They become known for their ability to prevent snakebites, cure stomachaches, and cause a person to fall in love.

> The ashes of what was deadly do not fill an oribi's horn
> (the smallest things are often the deadliest).
>
> —Seydou Camara, 1977[14]

A single amulet on a shirt can have a long process of creation. The tip of the horn (detail, pl. 37) of a bushback antelope is encased in leather. Such an amulet prompts many associations: first is that of the bushback itself, a small antelope with a large

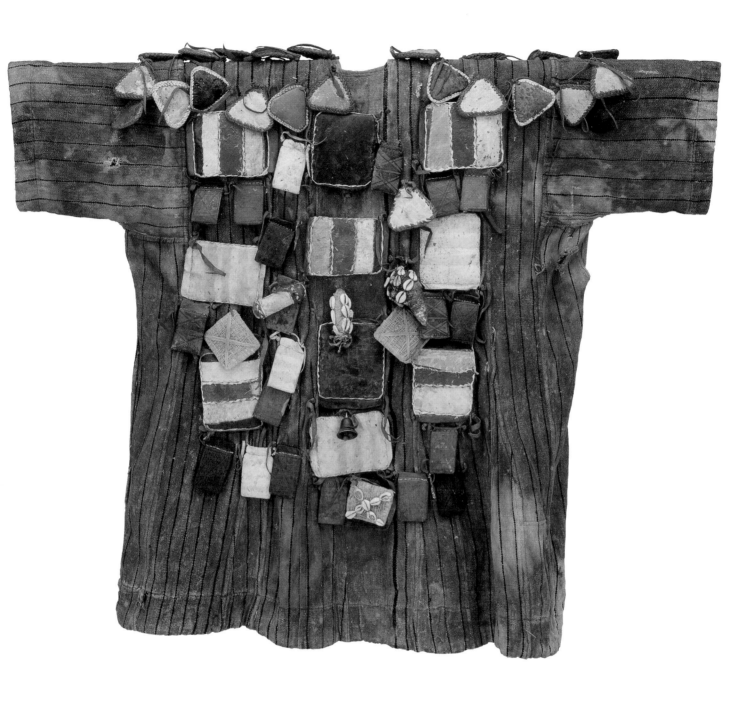

concentration of *nyama*. This energy can manifest itself in fragile creatures of such delicacy and solitude. Clever and intelligent, the bushback is believed to have been specially blessed by the Prophet Mohammed so that on some moonless nights its horns light up and shine in the forest. Tracking and killing the bushback requires respectful ritual steps, as the animal releases a large amount of *nyama* upon death. Praises are then sung for the antelope to redirect its life force.

One example of a recipe for the contents of an amulet shows the complicated steps required by *jiridon*. Putting together a *nyi-ji* (tears) amulet calls for mixing the roots of seven specific plants dug from seven different footpaths with a flower from a baobob tree, a large blossom from a tobacco plant, the cane or staff of a blind man, fiber from a hibiscus plant used to wash a medicine pot, and the washcloth of a woman. All these ingredients are burnt to ashes and then placed in the horn's cavity. A stopper is pierced with an iron staff, and the blood of a white rooster is poured over it. If a hunter wishes to activate the amulet, he withdraws the staff from the horn and points the amulet at an animal. The power forces the animal's tear ducts to flow, obscuring its vision and setting the stage for the kill. Once the animal is slain, the hunter waters the iron staff with its tears.[15]

> Amulets are, in short, prominent physical manifestations of Mande beliefs about the world's deep structures and the practical access that human beings have to them.     —Patrick McNaughton, 1988[16]

Bulging packets covered in leather are seen on shirts of the Mande and neighboring Asante (pl. 38). This form of amulet announces that a spiritual force has been harnessed and is at work. Most commonly a short prayer, verse from the Koran, or magic square is written on paper, folded, and packed inside the amulet. Blacksmiths and Muslim teachers (*mallam*) choose the inscription to be sealed in secrecy. The notion of writing as an act of recording words for others to consult openly is thereby reversed. Encased in leather, fur, or fiber, the amulet may also enclose the words and prayers uttered by the *mallam*. Asante chiefs and senior officials did not wear these shirts to hunt; instead, they wore them into battle as protection or during installations of leaders to announce that they were prepared for warfare.

> Fa-Jigi had a magic powder called "wasp sting" in his armpit,
> And this powder became a wasp.
> If it stings you,
> You will run in place.
> Jigi had a magic powder called "to-make-unconscious,"
> And this was given to the white men.
> Eeh!
> Fa-Jigi brought a powder called "beware,"
> And this became a bee that made excellent honey.
> Eeh!...
> He brought sorcery with him,
> Sorcery for saving people.
>
>                                    —Seydou Camara, 1975[17]

Pl. 38
**War shirt** *(batakari)*
Asante, Ghana
20th century
Cloth, leather, twine, cowry shells, amulets *(basi)*
L. 89 cm (35⅛ in.)
Gift of Katherine White and the Boeing Company,
81.17.454.1

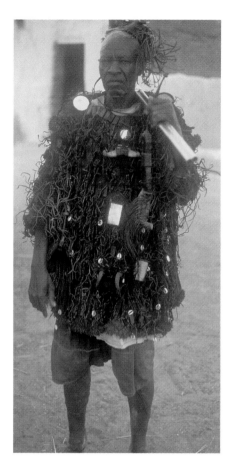

Fig. 12. Numu Tunkara wearing hunter's shirt, Fana, Mali, 1976.

Finding words to approximate Mande thinking is especially difficult when researchers approach the realm of the occult, sorcery, or magic. A fourteenth-century writer quoting an informant who lived in Mali for thirty-five years pointed out the prevalence of herbs for healing, making poisons, and settling disputes over sorcery.[18] European colonial accounts were read with distrust after later researchers discovered how Mande informants handle inquiries about sorcery. Public questioning violates the usual method of transmitting knowledge in restricted conversations. When outsiders delved into secret and potentially dangerous subjects, hunters launched terrifying descriptions of occult practices to intimidate and throw the strangers off track. As intensive studies of Mande art have evolved, researchers continue to caution readers about Mande perceptions of sorcery and the supernatural. Both are approached as neutral, common parts of the environment. To master their potential, and thereby become known as an accomplished sorcerer, is a desired goal.[19]

> To be a man is to have many secrets.     —Bamana proverb

Hunters travel far to learn from the wilderness and from others like them. A serious hunter builds a repertoire of *daliluw* during his apprenticeship and his long journeys in search of new information. All of his life is dedicated to acquiring new knowledge, which is reflected in the depth of accumulations on his shirt (fig. 12). Each *daliluw* is the result of a careful, highly private encounter. Unlike the Western notion that knowledge is enhanced if made public, this knowledge is closely guarded. Often the hunter may hear an incantation for a *daliluw* only once and be expected to retain it. Memories of such instruction are stored like documents and recalled with extreme fidelity.

> These dead heroes have done more for me than contemporary leaders.     —Banzumana Sissoko, 1979[20]

Epic performances and praise songs for hunters remind everyone of the need for heroic deeds. When hunters gather, their professional praise singer or bard (*donson jeli*) is present, often wearing a shirt laden with amulets. Songs may last one or two hours or take several evenings to unfold. Often playing a string harp-lute, the performer is called upon to teach, explain, and recall historical personalities and events that can motivate people in their current lives.

Shirts like those of the hunters are often worn by the *donson jeli.* Hunters would give singers amulets and trophies of horns, tusks, claws, and teeth to sew onto their shirts. One famous *donson jeli,* who made his living as a performer until his death in 1983, was Seydou Camara (fig. 13). Born into a family of blacksmiths, he was conscripted into the French army and served in Morocco and then Timbuktu from 1937 to 1945. After becoming an apprentice to another *jeli,* he won a hunters' bard competition in 1953. His fame spread in the late 1960s and 1970s as he was heard regularly on Radio Mali and performed at hunters' festivals, funerals, weddings, and baptisms all over southern Mali. Camara also offered his medicines and guidance to people who were ill or anxious about new journeys, marriages, businesses, and hunts.

# An Art of Persuasion:
# Regalia from the Asante Kingdom

Ananse the spider often creeps into Asante stories. In this one, his struggle with wisdom serves as a prelude to a kingdom that has a "great passion for persuasive public speech":[1]

One day, Ananse put all the wisdom in the world into a pot and decided to put it out of reach of all men. He would throw wisdom away so that the rest of mankind would be fools. With the wisdom pot on his back, he came across a fallen tree which had blocked the path except for a small gap beneath the tree. Ananse made several attempts to pass beneath the tree with the pot at his back, but to no avail. Kweku Tsen, his son, who was watching silently, at last volunteered a piece of advice to his father, "Put the load on the fallen tree, pass beneath the tree without the load, and pick up the load from the other side," he advised. Ananse complied and succeeded. Yet realizing wisdom was not his monopoly after all, Ananse in frustration smashed the wisdom pot. The pot broke and wisdom spread to all mankind.[2]

Spiders not only talk but dispense wisdom in Asante society. Ananse's son gives advice that deflates his father's greed to indirectly benefit everyone. The skilled use of such stories and proverbs is evident in Asante art, whether it be a ruler's dress or a drummer's refrain. Another hallmark of Asante creativity is its ability to take what looks familiar or ordinary and infuse it with extraordinary insights. Miniature brass sculpture looks merely entertaining but transforms business dealings into daily exhibitions of eloquence. A stool may look like a piece of furniture but be so endowed with sacred qualities that it embodies a nation. Wearing cloth can be a form of rhetoric.

To begin, five rings look like, and are, very common items created in gold. But they demonstrate how the Asante instill meaning in seemingly mundane objects. The first ring depicts a gold peanut (or groundnut, pl. 39)—not a foodstuff one would expect to inspire reflection, but in the Asante world it can refer to a proverb: "If you want to grow something for me, plant groundnuts, not corn" (a wish for a permanent relationship: groundnuts remain in the soil once planted, whereas corn is easily uprooted and destroyed).[3]

Pl. 39
**Peanut ring**
Asante, Ghana
20th century
Gold
H. 3.8 cm (1½ in.)
Gift of Katherine White and the Boeing Company,
81.17.400

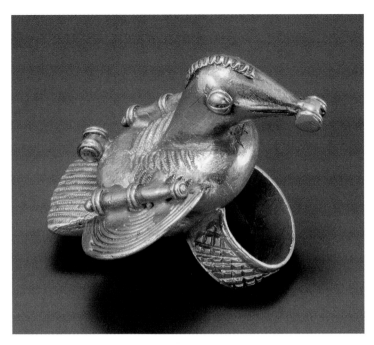

Pl. 40
**Bird ring**
Asante, Ghana
20th century
Gold
H. 4.5 cm (1¾ in.)
Gift of Katherine White and the Boeing Company,
81.17.429

Pl. 41
**Porcupine ring**
Asante, Ghana
20th century
Gold
H. 5 cm (2 in.)
Gift of Katherine White and the Boeing Company,
81.17.401

Ring two features a bird holding a keg of gunpowder in its beak and balancing a cannon on each wing (pl. 40). This represents a common proverb: "The courageous bird Adwetakyi sits on cannons" (a brave man faces all odds; he is always ready to face the enemy).

The third ring erupts in spikes that launch a range of associations (pl. 41). Some people read it as a cocoon; others see the bristling coat of a porcupine. Thus, an array of proverbs can be recounted: "The grub: it does not talk, but it breathes" (a stranger's character is not easily known). "You have become like the grub that has no mouth but it breathes" (said of a quiet but wicked person). "Kill a thousand and a thousand more will come" (remove a porcupine quill and others will fill in; the unified Asante are always armed and ready for action).

A tortoise's small head peeks out of its shell on the fourth ring (pl. 42). Tortoises bring forth a host of proverbs, including: "Tortoise, you are also suffering in your shell" (however secure a person seems, he has hidden troubles); and "When you go to the village of the tortoise and he eats earth, you eat some too" (when visiting another, respect his customs no matter how strange they may seem).

Finally, the fifth ring is a bulbous form best known as a wisdom knot that only a wise man can untie (pl. 43). Another reading, however, could ascribe this proverb: "If you are weaving and the thread gets tangled, use both hands to untie it" (even the wise man needs another's advice to solve a problem).

When worn as part of a complete royal regalia, this handful of rings is joined by bracelets, necklaces, sandals, hats, cloths, staffs, swords, stools, and umbrellas. Each item is selected for display by an Asante who seeks the proper words to enhance a given situation. In a museum's display, a collection of royal art proclaims the visual force of a prosperous kingdom, but doesn't reveal the eloquence that sustained the kingdom.

What the average museum goer sees is a gold peanut, bird, grub or porcupine, tortoise, and knot. But viewers attuned to the proverbs behind the rings begin to see the wisdom in the ordinary. On just one hand, a ruler is able to convey concepts for further discussion:

the longing for a lengthy relationship,
a readiness to use force when necessary,
suspicion about someone's duplicity,
compassion for another person's insecurity,
the need for leaders to consult others in making decisions.

While rings introduce the oratory of leadership, miniature sculptures show how metaphoric speech once fit into daily Asante life. Miniature sculptures cast in copper alloy served as goldweights, placed on scales as a counterbalance to piles of gold dust. Sales transactions thus became small-scale momentary exhibitions. The heads of families, chiefs, and wealthy traders curated these exhibitions as a constant part of doing business. In a special bag (*futuo*), each trader kept his own corpus of weights.

A small handful of weights illustrates the range of images and issues revealed by these everyday sculptures. One of the most common goldweights is one named Sankofa, a bird with a swirling, backward-twisting neck (pl. 44). These are four of its many interpretations: "Pick it up if it falls behind" (whatever mistakes one has made in the past can be corrected). "Go back and pick" (*san*, return; *ko*, go; *fa*, pick: any aspect of culture that doesn't draw from the past to replenish the present and cast a shadow into the future will die).[4] "When it lies behind you, take it" (use the wisdom of the past), or simply, "one foot should be in front of another."

Two men (pl. 45) lean back to greet each other in a weight that evokes another proverb: "They have ended up like Amoako and Adu" (an expression about wasted opportunities: Amoaku and Adu parted in their youth and meet again in old age to discover they are both as poor as when they started).

Pl. 42
**Tortoise ring**
Asante, Ghana
20th century
Gold
H. 4.1 cm (1⅝ in.)
Gift of Katherine White and the Boeing Company,
81.17.1684

Pl. 43
**Wisdom knot ring**
Asante, Ghana
20th century
Gold
H. 5.7 cm (2¼ in.)
Gift of Katherine White and the Boeing Company,
81.17.399

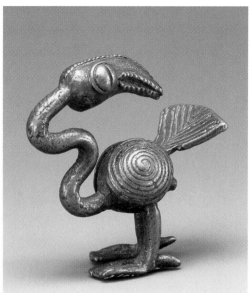

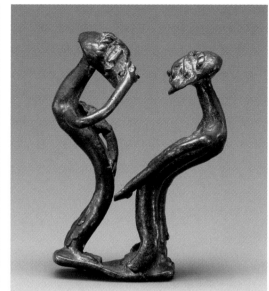

Pl. 44
**Figurative weight** *(abrammuo):* **Sankofa bird**
Asante, Ghana
19th century
Copper alloy
H. 3.5 cm (1⅜ in.)
Gift of Katherine White and the Boeing Company,
81.17.397

Pl. 45
**Figurative weight** *(abrammuo):* **Leaning men**
Asante, Ghana
19th century
Copper alloy
H. 3.5 cm (1⅜ in.)
Gift of Katherine White and the Boeing Company,
81.17.361

Pl. 46
**Figurative weight** *(abrammuo):* **Birds-on-tree**
Asante, Ghana
19th century
Copper alloy
H. 7 cm (2¾ in.)
Gift of Katherine White and the Boeing Company,
81.17.362

A mass of birds cover a tree (pl. 46) to suggest: "The woodpeckers hope the silk-cotton tree will die" (if the tree dies, grubs will fill the rotting wood and give the woodpeckers more food; one man's downfall is another man's gain).

The leopard with emphasized spots (pl. 47) conveys: "When the rain falls on the leopard it wets the spots on his skin but does not wash them off" (a man's nature is not changed by circumstances).

The scorpion (pl. 48) signifies: "The scorpion does not bite with his mouth but with his tail" (the enemy might not fight you openly but undermine you secretly).

A deer with long horns (pl. 49) means: "It is always too late to say, 'Had I known'" (a deer with horns so long they injured other animals asked his friends to push them in, but remembered too late that he needed horns to defend himself).

A shield (pl. 50) suggests: "Though the covering of a shield wears out, its framework still remains" (although the head of the family may die, the family endures).

A woman carrying a bowl on her head (pl. 51) is a reminder: "As long as the head remains, one cannot avoid carrying loads about" (as long as people live, they never stop worrying).

Gold fueled the Asante rise to prosperity, and goldweights were one outcome. Some of the richest gold deposits

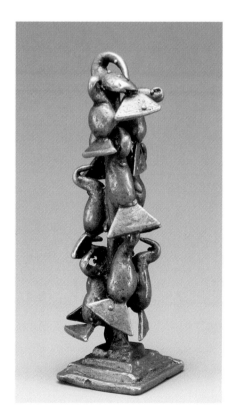

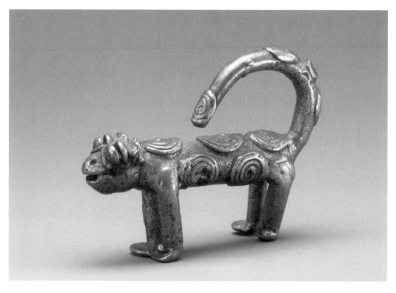

Pl. 47
**Figurative weight** *(abrammuo):* **Leopard**
Asante, Ghana
19th century
Copper alloy
H. 3.2 cm (1¼ in.)
Gift of Katherine White and the Boeing Company,
81.17.390

Pl. 48
**Figurative weight** *(abrammuo):* **Scorpion**
Asante, Ghana
19th century
Copper alloy
H. 2.9 cm (1⅛ in.)
Gift of Katherine White and the Boeing Company,
81.17.394

Pl. 49
**Figurative weight** *(abrammuo):* **Deer**
Asante, Ghana
19th century
Copper alloy
H. 3.5 cm (1⅜ in.)
Gift of Katherine White and the Boeing Company,
81.17.396

Pl. 50

**Figurative weight** *(abrammuo):* Shield

Asante, Ghana

19th century

Copper alloy

H. 6.8 cm (2¾ in.)

Gift of Katherine White and the Boeing Company, 81.17.370

in Africa launched a trading network that reached across the Sahara, south to the coast, and eventually to Europe and the Americas. By the fourteenth century, the Akan people of Ghana (from whom the Asante emerged) were making all the equipment necessary to trade gold—scales, weights, spoons, shovels, and gold-dust boxes. Abstract weights based on Islamic standards came first; they were followed by figurative weights as the Asante empire reached its peak of affluence in the seventeenth and eighteenth centuries with the trade in gold and slaves. In five centuries of goldweight production, there may have been as many as three million created to enhance daily business.[5] Weights could also be sent as a message:

> As a white man sends a letter, so do we send these weights to one another. The Crab's Claw. As you know, the crab is a very tenacious animal, and what he once holds with his claw he will never let go; even though it be severed from his body, it will still hold on, until crushed to atoms. If I were to send this to another chief who had done me an injury, he would at once know what I meant without a long palaver.[6]

Weights enhanced the bargaining process between buyer and seller. A Swiss missionary described how the weights worked in the Asante capital of Kumasi in 1875:

> The gold is weighed out amidst very noisy scenes. Each person carries his own weights with him, but those of the vendors would be found too heavy and those of the purchasers too light. Arguments go on for a long time until the correct weight is produced. Only now does the weighing take place....
>
> The weighing of gold can be as delightful as it is tiring, especially in the case of small purchases, for example, when you want to buy fruit or vegetables from the market woman ... a transaction worth a few pennies takes up as much time as one involving several ounces. This can teach a white man patience, but in my case I lost patience again and again.[7]

Such frustrations led the Swiss to introduce silver coinage in the 1860s, but it met with little success, and by 1868 a new proverb was created: "The white man has only one weight." However, soon after, the ancient gold trade fell into decline, and flat coins bearing European monarchs' faces were making inroads. By the 1890s, as the British stepped in to undermine Asante leadership, they brought with them large shipments of silver coins. Elderly Asante say that goldweights ceased to be made by 1905, yet the weights became such appealing collectibles that an industry of producing replicas blossomed and continues to the present.

The temporary exhibitions of proverbial sculpture that goldweights engendered are just one art form mastered by Asante culture. The other, more prominent vision is their royal panoplies, opulent combinations of art worn and carried in processions and festivals. One of the most vivid descriptions of a court panoply was published with color illustrations in 1819 by a young Englishman, Thomas Bowdich, in *A Mission from Cape Coast Castle to Ashantee*.[8] His account is loaded with details of a tumultuous three-month visit, and introduces a dilemma that plagued the next century of

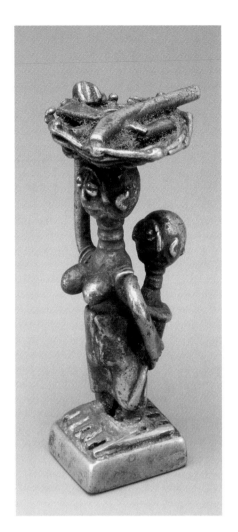

Pl. 51
**Figurative weight** *(abrammuo):* Woman carrying bowl
Asante, Ghana
19th century
Copper alloy
H. 6.1 cm (2⅜ in.)
Gift of Katherine White and the Boeing Company, 81.17.382

communication: the British might admire Asante visual art, but they were ill equipped to listen to the persuasive intentions it carried.

On May 19, 1817, four young Englishmen ended nearly a month's journey of 140 miles from the coast of Ghana to the Asante capital, Kumasi. Thomas Bowdich recorded the "magnificence and novelty" of the scene they were led into. A throng of people greeted them, producing a blinding glare as the sun reflected off masses of gold ornaments. While their eyes were dazzled, their ears were saluted by drums, horns, flutes, and instruments resembling bagpipes. Huge umbrellas, gently pulsing up and down, added bright streaks of scarlet and yellow to the arena. The visitors shook hands with men dressed in silk cloth draped over the left shoulder and layers of gold jewelry. A few wore so many ornaments on their wrists that young boys had to support their hands. After meeting a file of dignitaries, the Englishmen came upon the Asantehene (Asante king), who extended his hand.

Osei Bonsu, the Asantehene, was bedecked in silk cloth and abundant gold ornaments. Every item of his clothing was accented with gold and silver ornaments, from his white leather sandals to his hat. He greeted each of the Englishmen, as did the women of his court. A stool entirely encased in gold was visible under a nearby umbrella. As they were escorted to their quarters, dancers, dwarfs, and mimics entertained them. The Asantehene came to say good night and ask their names again. In the following days, the visitors met with Osei Bonsu and his councilors in a five-acre palace complex with a maze of inner courts, a judicial hall, and official residences. Later, the British mission also dined at the Asantehene's retreat, where they were offered roast pig, ducks, fowls, stews, pease pudding, oranges, and pineapples along with port and madeira, spirits, and Dutch cordials. Bowdich reported, "We never saw a dinner more handsomely served, and never ate better." His observations about Kumasi commended its organization of twenty-seven main streets, spoked to divide the city into seventy-seven wards. Streets that were cleaned daily served as stages for numerous ceremonial events. He admired how relief patterns on residential walls enlivened the surfaces of the city and indicated the rank of the person housed within. Bowdich's color depiction of Adoom Street features a woman seated beneath an umbrella, her produce scales ready to balance goldweights (fig. 15). He recorded his admiration for the work of potters, goldsmiths, weavers, and carvers living in the suburbs of Kumasi.

Bowdich indicates that life around the palace was not usually so quiet, but exuded a sense of intrigue as titled officials moved in and out of the palace, often late at night under torchlight. He also watched the Asantehene appear with his spokesmen, stool carriers, drummers, umbrella carriers, cooks, heralds, sword and elephant-tail bearers, ministers, and executioners. At several places around the city, the king would periodically sit to meet and greet people. He did so from eight-foot-tall platforms of polished clay, covered by a large umbrella and attended by fifty to one hundred courtiers sitting below him.

Bowdich watched the Odwira festival in early September and deemed it to be a harvest "yam festival" (fig. 16). Processions of chiefs and military leaders paraded by the Asantehene with their entourages, accompanied by musicians playing horns and

Lady Hodgson were led through an arch as missionary school children sang "God Save the Queen." They reached the British stone fort, which stood in the middle of an open space, to find Asante royalty and chiefs waiting under large twirling umbrellas. Drums and horns sounded. As the governor passed by, each leader rose from his stool to salute.

Sir Frederick met the assembly again on March 28. The Asante leaders formed a semicircle with their stools, arranging themselves in order of seniority. Facing the assembly, Governor Hodgson amazed his audience by demanding that they pay interest on an old war indemnity. His final words delivered so strong an insult that the chiefs fell silent:

> Let me tell you once and for all that Prempeh will never again rule over this country of Ashanti.... The paramount authority of Ashanti is now the great Queen of England whose representative I am at the moment.... Where is the golden stool? Why am I not sitting on the golden stool at this moment? I am the representative of the paramount power, why have you relegated me to this chair? Why did you not take the opportunity of my coming to Kumase to bring the golden stool and give it to me to sit upon?[17]

No one responded. Without speaking, the Asante all stood up, shook the governor's hand, and filed past him. In the solemn departure, British officials noticed one woman who reached out and touched the medals of the order of St. Michael and St. George around the governor's neck. The woman was Yaa Asantewaa. Four years earlier, her son, chief of the state of Edweso, had been deported with Asantehene Prempeh I. In his absence, she had assumed the rule over Edweso, while constantly arguing for the restoration of the Asante monarchy. After the encounter with the British governor, the Asante called a secret meeting. The sixty-year-old Yaa Asantewaa recounted all the grievances the Asante had against the British and swore never to pay interest. As the men, concerned about their depleted resources, debated the wisdom of going to battle with the British, Yaa Asantewaa stood and declared:

> How can a proud and brave people like the Asante sit back and look while whitemen took away their king and chiefs, and humiliated them with a demand for the Golden Stool? The Golden Stool only means money to the whitemen; they have searched and dug everywhere for it.... If you, the chiefs of Asante, are going to behave like cowards and not fight, you should exchange your loin cloths for my undergarments.[18]

To emphasize her point, she fired a gun in front of the chiefs. They responded by planning a war, to be led by Yaa Asantewaa. The conflict officially began three days later, after Sir Hodgson sent a detachment of men to search for the Golden Stool. When the men came back empty-handed, Hodgson realized he was in a dangerous position. The Yaa Asantewaa War, a guerrilla campaign lasting from April to November 1900, is acknowledged to be one of the most determined resistance movements of the colonial era. The British contingent was trapped in the fort and remained there for two months. British relief troops armed with new weapons eventually overcame the

Asante, but it took them many months to capture Yaa Asantewaa. She was sent to join Prempeh and her son in the Seychelles, and lived there in exile until her death in 1921.

The British annexed the Gold Coast as a British colony in 1901 and ruled it until 1957. Two more decades were to pass before the English began to realize why a stool inspired rebellion. Mistaken for a coronation seat, the Golden Stool became a target for British officials, who thought it was a prize to capture and own. But the Golden Stool remains an object of devotion at the core of the collective Asante identity.

To the Asante, the Golden Stool is known as Sika Dwa Kofi, "Born on Friday." Oral tradition traces its origin to a Friday in 1701, when the founder of the Asante nation, Osei Tutu, received the stool. Suddenly, in the midst of a thunder and lightning storm, a golden stool floated down from the heavens, ruled by the Sky God Nyame, and came to rest in Osei Tutu's lap. He turned to his priest, Okomfo Anokye, who interpreted it as the soul or spirit (*sunsum*) of the Asante nation. The gold material was equated with the enduring and vital life force of the sun, which would bless the unity of the Asante nation. Together, these two men formulated the foundation of Asante identity, shifting its focus from a military state to one of an effective government thriving on the trade of the precious metal. A set of seventy-seven laws became associated with the Golden Stool, the most essential being a sense of "common citizenship," which requires every person of the Asante union to place their loyalty in the stool. A cylinder support at the core of the Golden Stool may symbolize the tree planted by every Asantehene to serve as the center of his dynasty. Inside the core cylinder, the priest Anokye placed hair and nails collected from the leaders brought together by Osei Tutu. Brass bells were added to the stool to enable contact with ancestors. Fetters implied a vigilance in keeping the nation secure.

Since it carries the soul of a nation, the Golden Stool is treated extremely carefully. Never permitted to touch the ground, it is always seated on its own European-style chair with an elephant-skin mat. This position signifies that the ruler presides over both human and natural forces. In the course of two centuries, the Golden Stool also became known as a sign of confirmed leadership. When an Asantehene passed away, the stool and other regalia were held in trust until a new leader could be chosen. The new Asantehene could gain access to the treasury and the royal regalia only after being enstooled. Keeping the Golden Stool was the final affirmation of a new leader's position. He did not sit upon the stool, but kept it by his side to embody all the laws and government processes that he would honor.

After King Prempeh's deportation in 1896, the Golden Stool disappeared from sight. It was not seen again in public until 1921, when it was accidentally unearthed and the bells were removed to be sold. When this news circulated, Asante chiefs became concerned that the British might assume control of the Golden Stool. Signs of national mourning—red clay smeared on faces and arms—appeared widely. But this time, the British consulted their new anthropological department in Ghana, led by R. S. Rattray, who would publish many studies in the next decade. He launched his written reports with an attempt to correct "misconceptions, if not total ignorance in the past concerning this object." As a result of Rattray's counseling, the British permitted the Kumasi council of chiefs to try the thieves according to Asante law, and

announced that the government considered the Golden Stool to be the property of the Asante nation. Soon thereafter, the queen mother of Mampong sent a replica of her silver stool to Princess Mary of England as a wedding gift with the words, "It may be that the King's child has heard of the Golden Stool of the Ashanti. That is the stool which contains the soul of the Ashanti nation. All we women of Ashanti thank the governor exceedingly because he has declared to us that the English will never again ask us to hand over that Stool."[19]

Despite many similar attempts to let bygones be bygones, the Golden Stool's rightful occupant remained in exile in the Seychelles for twenty-eight years. During his captivity, Asantehene Prempeh I balanced accommodation with efforts to maintain Asante traditions. He learned English and wrote numerous letters and documents, became baptized, and attended the Anglican church. Simultaneously, he directed the affairs of his subjects in a manner true to the Asante judicial system. Every twenty-one days, he celebrated the Adae festival—a day of rest set aside for communication with ancestors who were fed their favorite food and drink. Normally, this observance would take place in a special room where the ancestors' blackened stools were kept as a locus for their spirits. In the Seychelles, no stools had been allowed to accompany the exiled Asante, so Prempeh I improvised a libation ceremony that relied on the same invocations. Although his correspondence was heavily censored, petitions like this one of 1918 state how painful the separation from his home had become:

> It is now 23 years since we are made prisoners. I the Ex-king Prempeh being taken prisoner together with father, mother, brother and ex-chiefs; and now my father, mother and brother are all dead leaving me alone and about ¾ of my chiefs are dead and the remainder ¼ few are either invalid or ill. We are now very miserable, so we could not express any wish but entrust all our wishes in thy hands to allow us to go to Kumasi.[20]

Six years later, King Prempeh I was finally allowed to return to Kumasi. He was installed as paramount chief of Kumasi in 1926 (fig. 18), but was never allowed to reclaim the title of Asantehene. The British did help to complete a new residential palace at a site known as Manhyia ("all nations should come together"). His return inspired a new wave of Asante art production as leaders became confident that they could revive their ceremonial lives without colonial interference. Goldsmiths and weavers were hired to create new regalia. Secretly, Prempeh I obtained the Golden Stool, replenished it, and had it carried openly in a 1931 procession that set a model for religious inclusiveness. The Golden Stool was publicly seen (for the first time since 1895) at a thanksgiving service at St. Cyprian's Anglican Church in Kumasi. Inside the church, it was placed in front of the altar. "Then Prempeh and the Queen Mother stripping themselves of all their ornaments went and knelt by the altar and gave thanks for all his liberation and restoration to his people. Was Prempeh

Fig. 18. Asantehene Agyeman Prempeh I after his return from exile, Kumasi, Ghana, 1926. Basel Mission Archive D-30.6200.3.

supplicating the Christian altar, the Golden Stool that was strategically positioned in front of the altar, or both? Prempeh's experience with modernity was an ambiguous adventure."[21]

Prempeh I passed away two years later and was buried as an Asantehene now immortalized in a blackened stool. On January 1, 1935, his nephew was installed with the title of Nana Osei Tutu Agyeman Prempeh II. As the new protector of the Golden Stool, he began reasserting the essential elements of Asante identity. To this day, the Golden Stool remains a seat that is occupied, not owned. In an unbroken line, Asantehenes have been enstooled and continue to sit in state with the stool at their sides. On April 26, 1999, Otumfuo Osei Tutu II became the sixteenth occupant of the Golden Stool. He succeeded his uncle Otumfuo Opoku Ware II, who ruled from 1970 to 1999 (fig. 19).

A stool that is not for sitting but is a national shrine, the Golden Stool demonstrates how a literal reading of Asante art is far from complete. On a heroic scale, the Golden Stool narrates the founding of a kingdom and broadcasts epic messages at every appearance. It serves as a reminder of the laws of common citizenship and of the permanence of the Asante confederacy, and is honored as a sacred emblem that no other nation has ever been able to touch. On an everyday level, personal stools also function as more than furniture.

Fig. 19. Asantehene Otumfuo Opoku Ware II seated in state next to the Golden Stool "Born on Friday" (Sika Dwa Kofi), Kumasi, Ghana, 1992.

From mere seats to near gods, stools permeate the social, political and religious life of the Akan.    —Herbert Cole and Doran Ross, 1977[22]

Stools indicate special times in a person's life. A child beginning to crawl is given a stool to mark the passage through the dangers of infancy. A girl is seated upon a stool when she is leaving puberty to become an adult woman. A groom will present a stool to his bride to honor their marriage. Day to day, stools are used for household chores like bathing and eating. Each time a person sits on the stool, it absorbs more of the *sunsum*, or spirit, of the owner and becomes linked to the owner's personality and spiritual state. Upon the person's death, the stool becomes a locus for the individual's memory and will be set on its side so that no stray disruption may enter it.

If a leader rises to greatness and is deemed worthy of commemoration, his stool becomes consecrated. After the funeral, the stool is blackened with soot mixed with raw egg, animal blood, and fat, and then placed in a windowless room that is *kronkron,* holy and pure. In this room, an incumbent leader pays respects to his predecessor, offering prayers and libations in return for guidance. Not for sitting, the stool contains the soul of a significant individual. One explanation emphasizes the

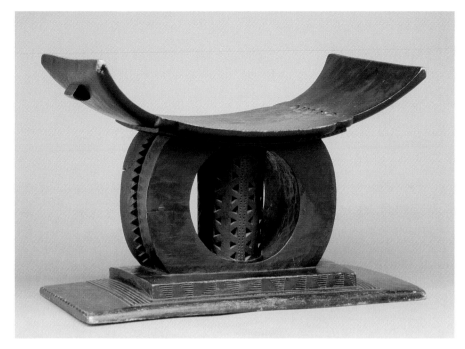

Pl. 52
**Stool**
Asante, Ghana
20th century
Wood
H. 38.7 cm (15¼ in.)
Gift of Katherine White and the Boeing Company,
81.17.338

need to remain in contact with those individuals: "You have your black telephones. You can pick one up and talk to your father in Europe. We have our black stools. We can stand one up, and talk to our grandfather (*nana*) in the Asaman. When you have finished you put the phone down, and when we have finished we lay the stool down. But your father is not inside the telephone, and our grandfather is not inside the stool."[23]

Just as the Golden Stool established the unity of the Asante kingdom, so the stool is a prominent symbol for all political positions. Leaders are not put in office; they are "enstooled." When a leader passes away, "the stool has fallen." On certain occasions, a stool could be appealed to for support. Bantamahene (commander of Asante troops) Awua II in an 1874 battle with the British is recounted as having stood on his stool to cheer his men. Such an act was meant to be "an insult to his ancestral ghosts, to fire their anger and make them fight more vigorously."[24] Certain stool types were once reserved for use by leaders of a particular rank. The Asantehene at one time had exclusive control of many designs, which were not allowed to be sold or used without his permission, but such limitations were relaxed in the twentieth century.

Of the stools in the Seattle Art Museum collection, two stand out as examples of the range in form these objects can take. A circular form is featured on the first example (pl. 52). A proverb, "The halo of the moon circles every human being" (*Kontonkurowi eda amansan kon mu*), is visually apparent in this design. It can be seen as a reminder that the Asante confederacy has the power to control and unite all its people. Or it may signify, as the curving sides frame the central core, that the head of any one person is always surrounded by higher powers. Peter Sarpong also sees the circle as a reminder to a leader that death comes to everyone, even the most powerful king. In response, he should remain humble even though he may have achieved high status.[25]

A roaring lion with a key on his side is featured beneath the second stool (pl. 53). Contrary to Western misconceptions, lions do not roam most of the African continent. They are more common to a savanna than the forests of the Asante environment. Akan proverbs and prayers often refer to the leopard as the "king of the forest," but rarely mention the lion. The sources for the image on this stool thus require investigation.[27] The profile head, the posture, and S-curving tail suggest a non-African source for the depiction. A rampant lion convention comes from the heraldic designs employed by European monarchies. This motif was among the most prominent visual metaphors the Europeans offered. Asante carvers were likely to have noticed the lion on Dutch, Danish, and British sailing ships plying the coast during the gold and slave trades. In addition, to designate alliances, the British and Dutch gave chiefs messenger canes on which the lion could appear. Another, more common source still seen today is the lion, used as a corporate emblem for a commercial trading company. Heraldic crests and trademarks served as symbols to identify the companies selling goods such as cloth and tea.

Two chairs now in the National Museum of Ghana connect the lion with state furniture. Belonging to the Dutch and English governors, both feature lions with crowns guarding royal arms. Sitting in those chairs, the foreign governors would have presided over court hearings that affected many Ghanaians. The bright yellow and silver enamel lion on the Asante stool sets up a role reversal—upholding an indigenous leader rather than a foreign one. Indeed, the lion overtakes the leopard as an Asante symbol of leadership in the twentieth century and underlines the change in power. Asante proverbs regarding the two animals reinforce the lion's prominence: "Only the lion drinks from the palm-wine pot of the leopard" (some chiefs are more powerful than others). "A dead lion is greater than a living leopard" (the lion at its worst is still more powerful than the leopard at its best). "Before the lion, the leopard ruled the forest."

Above all, however, the key placed prominently in the middle of the lion's body puts him in a position of control. Keys and locks as signs of wealth were displayed early in Asante history. Locked chests were said to be "numberless" when the British sacked Kumasi in 1874. The main reserves of the Kumasi treasury were kept in a Great Chest under the direct care of a head treasurer, who was entrusted with a gold key as his badge of office, while the assistant treasurer carried a silver key. Every morning, the Asantehene's bath was accompanied by the rattling of the treasury keys.[28] A stool with a roaring lion and silver key bolsters its occupant with two eminent symbols of power and wealth.

While stools are a basis of Asante heritage, they are less well known than other public art forms of the kingdom: jewelry and textiles. The fame of their textiles in particular inspired Katherine White to visit Kumasi in 1973. The Kennedy Center in Washington, D.C., had asked her to find a *kente*—the distinctive Asante cloth made famous internationally—for the building's lobby, and she agreed to go to the source.[29] As her slides show, Kumasi at that time was home to a royal presence that

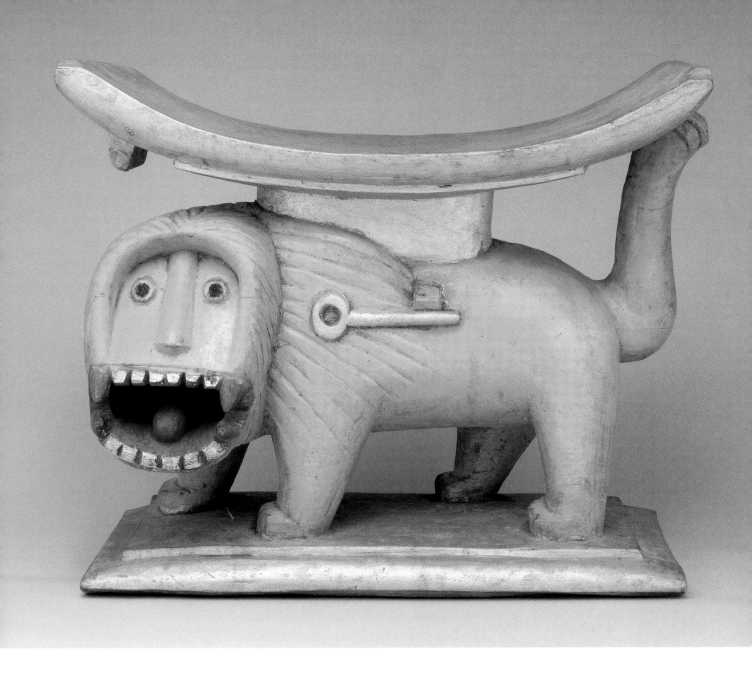

PI. 53
**Lion stool**
Asante, Ghana
20th century (after 1957)
Wood, enamel paint
H. 42.1 cm (16⅝ in.)
Gift of Katherine White and the Boeing Company,
81.17.545

*Regalia from the Asante Kingdom*    97

Fig. 20. Record booth with painting of Tina Turner, Kumasi, Ghana, 1969.

continued to thrive, side by side with pop royalty like Tina Turner, whose portrait is seen on the side of a record vendor's booth (fig. 20). Throughout many changes in the twentieth century, the Asantehene, Otumfuo Opoku Ware II, maintained a distinguished history of royal patronage. He had succeeded Asantehene Prempeh II in 1970 and presided over a full court and complex agenda as a traditional leader in Kumasi. White put in a request for an audience.

On the morning of April 24, a messenger from the palace arrived with word that the Asantehene could meet with her delegation:

We changed and eased our way through traffic across town to the palace. Big gates, four soldiers, a driveway of crushed red stone. We walked in, were greeted by a tense man in a business suit—the Asantehene's secretary. We waited outside on the porch. Suddenly a movement from within told us to rise. The Asantehene was there. A very tall man—over six feet, imposing, smiling. Dressed in a white *adinkra*, the cleanest printing job, the finest whipped thread I had ever seen. On both hands were huge gold rings in the shape of a sitting bird with wings spread. His sandals were black leather, the straps of which had triangles of alternating gold and silver, with an ornament on the end. We were so nervous we told our mission before we had been presented with a drink. I managed to remember not to cross my legs. We made (I mean *made*—we were both so flustered we couldn't think) conversation for about twenty-five minutes, after which we minded our manners, signed the guest book, shook all the hands all over again, and departed.[30]

The same dress that rendered White speechless would have an opposite effect in an Asante royal gathering. An audience attuned to looking carefully at the Asantehene's dress would have been able to refer to a number of proverbs, sayings, and allusions provoked by his choices. Gold jewelry and *kente* and *adinkra* cloth were just a few of the many art forms typically owned by an Asante chief. Swords, umbrellas, linguist staffs, caps, helmets, crowns, sandals were also part of royal regalia. As Katherine White set out to create her own set of regalia, she focused on cloth first. She coordinated her visit with a researcher living in Ghana, Brigitte Menzel, who led her to the best sources for *kente*. They traveled twelve miles east of Kumasi to Bonwire, the center for royal weaving established in the seventeenth century. There, the weavers challenged her sense of how collecting should proceed:

April 23, 1973, Bonwire, Ghana
At the turnabout we got out, headed for the shop of James Antobreh. Suddenly he was there behind us and we introduced ourselves. He took us away, down a side street to a compound, where we were put in a bare room, in which stood a cupboard, a battered modern desk, and four chairs. We were seated. Obviously there was a routine ahead of us. Two huge bottles of beer

Pl. 54
*Kente* cloth (Nkontompo Ntama, "liar's cloth")
Asante, Ghana
20th century
Cotton
L. 316.9 cm (124⅞ in.)
Gift of Katherine White and the Boeing Company,
81.17.466

were brought, opened, poured. I mentioned how interested I was in perhaps finding some old *kente*. "First we do other things, after which you say what you want," I was told. In came a lovely old man, the chief Nana Okai Ababio II, of Bonwire. They chatted between them until Brigitte arrived and we could begin. James was the chief's linguist. Then I suddenly had to make a speech. So I gave a little talk on the Kennedy Center, how beautiful we wanted it to be, how beautiful we thought *kente* cloth from Ghana was, and how happy we were to be there, etc. etc. This was translated to the Chief although I suspected (confirmed later) that he understood it all.[31]

Choosing a cloth was not a direct purchase but an indirect negotiation. White had to follow Asante protocol—stating your purpose comes after proper introductions and time to talk. Eventually, Bonwire weavers did bring inspection samples of many different *kente* strips, each with a distinctive name, according to custom. Their

names were reviewed with White, and then she was taken on a tour to see the weavers at work. She debated with several people about which *kente* was appropriate and returned the next day to negotiate. On the same trip, White also spent time seeking out *adinkra* cloth in the town of Ntonso, the center for its production. There she photographed men stamping black dye with a multitude of symbols cut from a gourd, and embroidering the finished cloth strips together. In making her choices, White evaluated the colors, design qualities, look, and feel of the cloths, but remained aloof to their rhetoric.

Both types of cloth have a vocabulary that was once controlled by royalty. *Kente* cloths speak of authority and rank through their carefully inserted patterns, of which over three hundred warp-and-weft variations have been documented. *Adinkra* cloths relay messages through the proverbs and sayings associated with the symbols stamped on them. Dressing as a strategic form of communication requires an encyclopedic memory of symbols and their attendant proverbs and allusions to Asante history. The Asantehene relies on a retainer in charge of his wardrobe to maintain and select clothes for his public appearances. The scope of this encyclopedia is hinted at by just a few textiles from the museum's collection. They have accrued a wealth of messages through the course of the last century.

Not all people read signs and symbols.    —Abena P. A. Busia, 1999[32]

Sharp turns in a pattern on a blue and white cloth signal a *kente* known as "liar's cloth" (Nkontompo Ntama, pl. 54). It was said to have been worn by a king as a means of questioning the veracity of people who came before him. Another cloth is known as Mmaaban, a mixture of warp patterns implying a unity in strength (pl. 55). Within the variety of patterns are a host of less obvious images assigned names such as ficus tree, donkey's ears, tail of the colobus monkey, lion, vine climber, and belly of the crocodile. A cloth with a strong vertical warp stripe is named Aberewa Bene, "wise old lady" (pl. 56). The name refers both to an exceptional elderly woman of the Asensie clan and to the constant role older women have in matters of traditional jurisprudence. Brief explanations of *kente* only hint at the number of signs and symbols that one cloth can carry. Mmeeda patterns convey a notion of how cloth is used to mark history (pl. 57).

A dictionary translates *mmeeda* as "something unheard of, unprecedented, extraordinary."[33] Other sources rephrase this to mean "something that has not happened before." The British researcher R. S. Rattray recorded it as *asonawa mmada* and said it originated from the name of the first clan to father an Asante king. On this historic basis, the Mmeeda pattern was worn by the person who activated *kente* for an international audience. Kwame Nkrumah was a force in world politics as he led the first successful transition from colonial to independent government in twentieth-century Africa. A goldsmith's son from an Akan group called Nzima located on the coast, Nkrumah drew on Asante visual and verbal arts for his style of leadership.

Nkrumah wore a Mmeeda *kente* cloth on February 12, 1951, the day he was released from a year's prison term for sedition against the colonial government. His party had won overwhelmingly in elections held four days before his release. At the

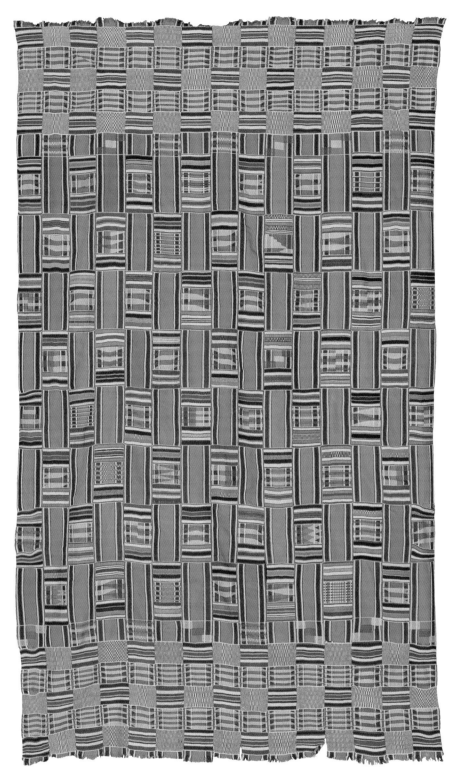

Pl. 55
*Kente* cloth (Mmaaban, "unity is strength")
Asante, Ghana
20th century
Cotton and silk
L. 194 cm (76⅜ in.)
Gift of Katherine White and the Boeing Company,
81.17.459

Pl. 56
*Kente* cloth (Aberewa Bene, "wise old lady")
Asante, Ghana
20th century
Cotton, rayon
L. 198.1 cm (78 in.)
Gift of Katherine White and the Boeing Company,
81.17.433

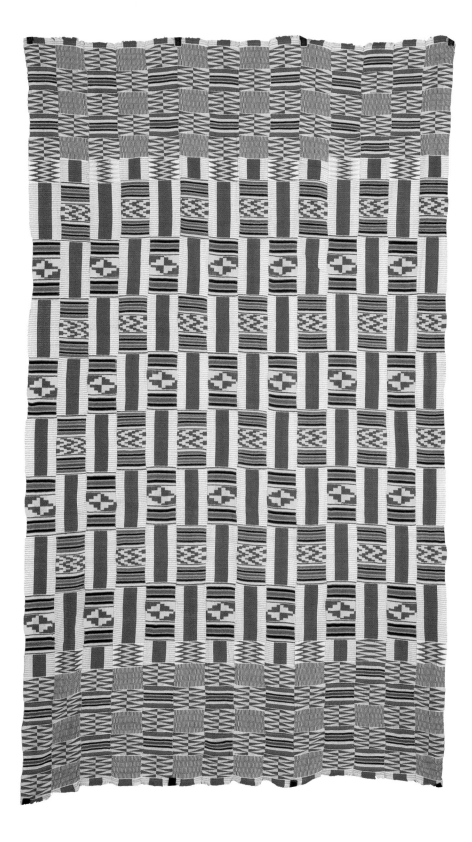

# Notes

1. Kwesi Yankah, *Speaking for the Chief* (Bloomington: Indiana University Press, 1995), 1.

2. Ibid., 45.

3. The proverbs cited here have been drawn from Peggy Appiah, *Why the Hyena Does Not Care for Fish and Other Tales from the Ashanti Gold Weights* (London: Andre Deutsch, 1977); Timothy Garrard, *Akan Weights and the Gold Trade* (London: Longman Group, 1980), chap. 6; R. Sutherland Rattray, *Ashanti Proverbs: The Primitive Ethics of a Savage People* (1916; reprint, Oxford: Clarendon Press, 1969). Additional readings have been enriched by many conversations with Daniel "Koo Nimo" Amponsah, 2000–2001.

4. Interpretation by Koo Nimo, presentation, Seattle Art Museum, March 1999.

5. Garrard, *Akan Weights*.

6. Yaw Atwereboanna, 1903 document in Liverpool Museum, cited in ibid., 301.

7. Johann Gottlieb Christaller, cited in Garrard, *Akan Weights*, 273.

8. Thomas E. Bowdich, *A Mission from Cape Coast Castle to Ashantee* (London: John Murray, 1819).

9. For a discussion of the fuller dimensions of the yam festival, see Agnes Aidoo, "Political Crisis and Social Change in the Asante Kingdom, 1867–1901" (Ph.D. diss., University of California, Los Angeles, 1975), and T. D. McCaskie, "Asante Odwira: Experience Interpreted, History Constructed," in *State and Society in Pre-Colonial Asante* (Cambridge: Cambridge University Press, 1995).

10. Cited in Enid Schildkrout, ed., *Notes from the Golden Stool: Studies of the Asante Center and Periphery*, 1987).

11. Cited in ibid.

12. Winwood Reade, *The Story of the Ashantee Campaign* (1874), 357–58, cited in Aidoo, "Political Crisis and Social Change," 183.

13. The exact date of Prempeh's birth is debated.

14. Ivor Wilks, *Forests of Gold* (Athens: Ohio University Press, 1993), 225.

15. Letter from Asantehene Prempeh I to Governor Branford Griffith, June 28, 1894, cited in Aidoo, "Political Crisis and Social Change," 616.

16. Letter from Governor Branford Griffith to J. R. Holmes, District Commissioner of the Cape Coast, 1890, cited in ibid., 580.

17. Cited in *The Golden Stool: An Account of the Ashanti War of 1900* (London: Kimber, 1966), 33.

18. Cited in Agnes Aidoo, "Asante Queen Mothers in Government and Politics in the Nineteenth Century," *Journal of the Historical Society of Nigeria* 55, no. 2 (December 1977), 12.

19. R. S. Rattray, *Ashanti* (London: Oxford University Press, 1923), 295.

20. Petition by Prempeh I to Governor Gordon Guggisberg, October 13, 1918, cited in Joseph K. Adjaye, "Asantehene Agyeman Prempeh I and British Colonization of Asante: A Reassessment," *The International Journal of African Historical Studies*, 1989.

21. Emmanuel Akyeampong, "Christianity, Modernity and the Weight of Tradition in the Life of Asantehene Agyeman Prempeh I, c. 1888–1931," *Africa* 69, no. 2 (1999), 304–5.

22. Herbert Cole and Doran Ross, *The Arts of Ghana* (Los Angeles: UCLA Fowler Museum of Cultural History, 1977), 140.

23. Informants cited in Wilks, *Forests of Gold*, "Political Crisis and Social Change," 233–34.

24. Aidoo, "Political Crisis and Social Change," 273.

25. Peter Sarpong, *The Sacred Stools of the Akan* (Accra: Ghana Publishing Corporation, 1971).

26. Obo Addy, conversation with author, Seattle, May 2000.

27. See Doran Ross, "The Heraldic Lion in Akan Art: A Study of Motif Assimilation in Southern Ghana," *Metropolitan Museum Journal* 16 (1982), 165–78.

28. Malcolm McLeod, *The Asante* (London: British Museum Publications, 1981), 78.

29. *Kente* as a term has a sequence of evolving translations. It first appeared in print in 1847 when a "cotton blanket (*kintee*)" was acquired from an Ewe town and taken to Denmark. Three possible meanings:

  1. a term honoring a seventeenth-century Asantehene named Oti Akenten;

  2. a combination of two Ewe words, *ke* and *te*, meaning "open" and "close";

  3. "that which will not tear under any condition."

30. Katherine White Journals, Seattle Art Museum.

31. Ibid.

32. Quoted in "Maternal Legacies: A Weave of Stories," Doran Ross, ed., *Wrapped in Pride: Ghanaian Kente and African American Identity* (Los Angeles: UCLA Fowler Museum of Cultural History, 1999).

33. Johann Gottlieb Christaller, *Dictionary of the Asante and Fante Language Called Tshi* [Twi] (Basel: Basel Evangelical Missionary Society, 1933), 303.

34. Kwaku Ofori-Ansa, *Kente Is More Than a Cloth: History and Significance of Ghana's Kente Cloth* (Maryland: Sankofa Publications, 1993).

35. Kwesi Yankah, "The Making and Breaking of Kwame Nkrumah: The Role of Oral Poetry," *Journal of African Studies* 12, no. 2 (1985), 86–92.

36. Ross, *Wrapped in Pride*.

37. Nii O. Quarcoopone, quoted in "Pride and Avarice: Kente and Advertising," in Ross, *Wrapped in Pride*.

38. Ibid.

39. Joseph K. Adjaye, "The Discourse of Kente Cloth: From Haute Couture to Mass Culture," Joseph K. Adjaye and Adrianne R. Andrews, eds., *Language, Rhythm, and Sound: Black Popular Cultures into the 21st Century* (Pittsburgh: University of Pittsburgh Press, 1997), 29.

40. Nimo, presentation, 2000.

41. Asantehene Prempeh I's *adinkra* is in the collection of the National Museum of African Art; see Leasa Fortune, *Adinkra: The Cloth That Speaks* (Washington, D.C.: Smithsonian Institution, 1997).

42. See Rattray, *Ashanti Proverbs*, 264–68.

43. Martha Ehrlich, "Early Akan Gold from the Wreck of the Whydah," *African Arts* 22, no. 4 (1989), 56.

44. White purchased a group of rings, bracelets, and necklaces from Karl Merz, who had married the granddaughter of Bantamahene Kwame Kyem. The Bantamahene died in November 1944, and Merz's wife moved to Switzerland in 1949, taking with her from Kumasi this group of jewelry, among many other items. Correspondence indicates that he was selling the jewelry and wanted the previous owners to be known as Nana Kwame Kyem, Bantamahene; James Adjaye-Kyem; and the Kyem family. Listing the owner as an individual and his family does deviate from Asante ownership law. Most goldwork would properly be described as being the stool property of the Bantamahene, not his personal property. Ownership of gold regalia belonged to the office, not to the individual occupying the stool. Research into this ownership question is now ongoing.

45. For an in-depth discussion of Asante gold, see Timothy Garrard, *Gold of Africa*, (Geneva: Barbier-Mueller Museum, 1989).

46. Kwesi Yankah, "Proverbs: The Aesthetics of Traditional Communication," *Research in African Literature* 20, no. 3 (fall 1989), 325–46.

47. Nimo, presentation, 2000.

48. Gilda Sheppard, interview by author, Seattle, 1998.

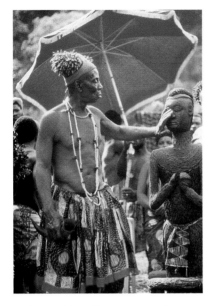

# Assembling a Royal Stage: Art from the Kom Kingdom

The original owners of the nearly four thousand African objects in the Seattle Art Museum are rarely known by name.[1] Art from one kingdom in Cameroon offers an exception and introduces five owners whose interactions with collectors span the twentieth century. Archival notes and files are full of details about kings who surrounded themselves with artistry. These records offer a perplexing view of royalty—of men who had commanding agendas but were dependent on others, who maintained a private distance from their subjects but allowed outsiders to become confidants. One note embodies these contradictions:

> *Royal Scepter* [see pl. 70]
> total length ca. 46"; length of handle ca. 6½"—
> wood, copper plate, trade beads, horsetail—
> finest example of transformation of the simple fly whisk and its use into a royal insignia of authority—: commemorating the tribal victory of the people of Bekom over the Fulani invaders around 1830—
> history: presented by Fon Ndi of the Bekom [Kom] nation in 1933 to Paul Gebauer for dental services, the making of an upper plate and lower bridge, which lasted the old boy until his death but did not restore to him the power of youth he had expected. . . . He had been told beforehand that no miracle would occur beyond the pleasure of chewing kola nuts once more.[2]

It seems an improbable exchange: a royal scepter (or flywhisk) for dental services, a symbol of victory over invaders for the chance to chew kola (not to diminish the stimulating pleasure it provides). The museum's records indicate other occasions when the Fon (king) gave away art—a figure was offered in return for help provided to a king's eighty-eight wives; a throne was given because it was admired in a discard pile. Such accounts introduce the close associations between foreigners and the Fons. This closeness creates a puzzle of references: private details, public records, changing governments, two thorough photographic archives, rumors and newspaper accounts—all merge to form a faceted picture of the Kom kings and their art. Anchoring this inquiry are figures designed to sustain a dynasty.

Pl. 70 (detail)

Fig. 23. Preparations for the appearance of Kom royal art, Laikom, Cameroon, 1974.

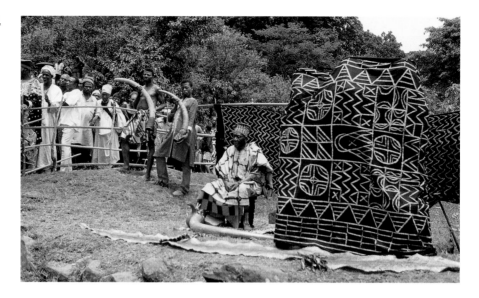

Over the course of a decade, Katherine White acquired objects that all came from the same closely guarded royal sanctuary high on a mountaintop in Cameroon. To do so, she relied upon alliances with Americans living in the vicinity of the Kom kingdom for up to thirty years. Their accounts of collecting from the hands of the original owner, the king himself, reveal the level of access they enjoyed. Visiting the royal palace on a frequent basis, they built a photographic record that enhances their descriptions of royal life. In the final assembly of objects, White established a ceremonial setting, a stage fit for a king (fig. 23).

A complete array of the symbols known as *ufwu-a-Kom* ("things belonging to the Kom people") would have been seen only at the palace in the Kom capital of Laikom. There, atop a mountain slope at 6,300 feet elevation, on a long volcanic spur known for drenching tropical rains and severe lightning, a dynasty established a dramatic site from which to rule.

> Laikom was worth the stiff climb and the exposure to its bitter cold nights, for it was a jewel of architecture. Artistic rulers made it into a showcase of towering buildings and a maze of courtyards.
>
> —Paul Gebauer, 1930[3]

No producer could ask for a more spectacular setting for an auspicious public event. Often shrouded in mist, Laikom was perched high above all other settlements on the Grassfields plateau (fig. 24). Entering the palace was equated with walking into a human body—the main gate was the mouth; the central square, the stomach; and the Fon's quarters, the buttocks or foundation of the palace.[4] At the turn of the century, as many as three hundred wives lived in compounds considered the limbs of the palace body (fig. 25). The innermost square was reserved for the sacred core of the Kom—an altar defined by a basalt pillar, a cactus tree, and a stone throne. The tallest building in the complex was an audience hall, into which only a select portion of the Kom people would be ushered on their way to a ceremonial occasion. As they entered, palace retainers monitored their every step, and kept royal art apart from the commoners. Just as the Fon was aloof from contact, so his

Fig. 24. Laikom, 1950s. The Metropolitan Museum of Art, Department of the Arts of Africa, Oceania, and the Americas. The Photograph Study Collection. Bequest of Paul Gebauer, 1977, G-76.

Fig. 25. Quarter of Fon's wives, Laikom, 1953.

possessions were not to be touched by anyone without special authority. Before dawn, officials would be sent to the sanctuary that housed an entire set of royal family portraits. No one saw them emerge and install the assembly in a corner of the large square.

> Symbolism captures their minds and maintains their interest.
> —Paul Nchoji Nkwi[5]

One of the most prominent portraits is composed of a life-size female figure standing with clasped hands over a stool adjoining her knees (pl. 67). This memorial figure of a queen mother underwent a drastic change of context at the beginning of the twentieth century. In Laikom, the figure was kept in a repository guarded by palace retainers who permitted only the king's closest councilors to enter. Commoners

Pl. 67
**Memorial figure of queen mother**
Laikom, Kom Kingdom, Cameroon
Mid-19th century
Wood, glass beads, brass, human hair, redwood powder
H. 175.3 cm (69 in.)
Gift of Katherine White and the Boeing Company,
81.17.718

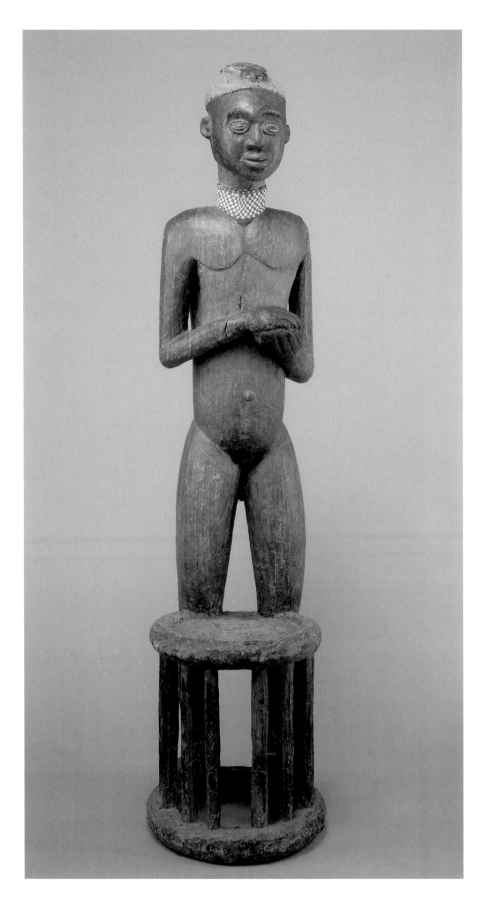

could view the mother only once or twice in a lifetime as part of the installation of a new king, when the queen mother joined a line of portraits dedicated to ancestors whose rule remained unbroken since the founding of Laikom. Her presence was an essential reminder of the female line of descent, which set Kom rulers apart from all neighboring kingdoms.

Kom eyes would read her features with appreciation. Not young or alluring, she is a middle-aged woman of unshakable stability and dignity. Her hair is shaved in a manner common to women of the nineteenth century (fig. 26). Traces of red powder show that she was properly rubbed and coated with camwood as a protective measure. She cups her hands just as royal women do when they clap to greet the king. No sharp features or angles appear in her face, in accordance with a Kom preference for rounded curves. The only exaggerated feature is her ears, which protrude perhaps to signify her role as a woman who listens for ancestral communication. A coating of copper riddled with slight dents becomes a metal sheath over her face. Beauty for the Kom is embodied less in the face than in the body.[6] The figure fulfills an ideal body type, with an ample physique of broad shoulders and long limbs that suggest a woman able to work and provide for her family. The stool at her knees extends to remind viewers of the lineage of rulers whose enstoolment or enthronement she presides over. Around her neck, a beaded necklace in checkerboard blue and white hints at the beading that once covered her body.

In the public setting, the Kom portraits invited ancestors of the past to participate and sanction events in the present. Endowed with impressive composure, the portraits were regarded as capable of controlling behavior. Women, in particular, were believed to have close communication with ancestors. Their covert power could produce reactions in people, while men had to rely on overt power. Figures commemorating the mothers and wives of the Fon had to be present. This queen mother has been identified by the name of Naya, the great-grandmother of Fon Yu.[7] Her strength was imparted to him, the most powerful of all Kom Fons, whose influence on the reputation and extent of the Kom kingdom is legendary.

Just two photographs of Fon Yu are known to exist (fig. 27).[8] Taken between 1905 and 1910, they are the only direct evidence of a remarkable ruler, then nearing the end of his life. Born in 1830, he was known to be ambitious at an early age, and his older brother exiled him for two years to a neighboring kingdom. While in exile, Fon Yu learned to carve. He returned to establish his reign at the age of thirty-five and ruled over the Kom for forty-seven years until his death in 1912—an unprecedented stretch of time (from before the American Civil War until the eve of World War I). In both his photographic portraits, Fon Yu holds sculptor's tools and poses with a memorial female figure whose size suggests that Yu was relatively tall. Lines on his brow mark many years of leadership.

Memories of Fon Yu, the seventh Kom king, loom large. A forceful innovator, he is credited with making bold moves and focusing increasing attention on himself as the main actor in the prestige system. Forty-five villages came under his control for ritual and secular affairs. Laikom became his showcase for architecture as he established how court compounds were to be distributed over the landscape. Known as

Fig. 26. Babungo wife with shaved coiffure rubbed with camwood, ca. 1930–1960. The Metropolitan Museum of Art, Department of the Arts of Africa, Oceania, and the Americas. The Photograph Study Collection. Bequest of Paul Gebauer, 1977, J-26.

Fig. 27. Fon Yu (reigned 1865–1912) posing as carver, with the female figure of the Afo-a-Kom ensemble, ca. 1905–1910.

the king who began and ended wars, he invited noted warriors to drink with him weekly at his palace. Fon Yu is also remembered for swiftly punishing by death those who failed to be hospitable to strangers.[9] To enhance his stature, he surrounded himself with art as symbolic support. A school of carvers produced royal sculpture, implements, and doorposts that set him apart. Portraits of his family sanctioned his right to rule: they underlined the notion that the Fon might be the supreme force in the nation, but he still depended on his family for support. Admiration for Fon Yu's restless enterprise is tempered by memories of his severe tactics of law enforcement, including experimentation with slow poisons.

In 1900, Fon Yu was firmly positioned in Laikom. He aggressively fended off a German explorer in 1889, but by 1904–1905, German expeditions were making the ascent to Laikom. During 1904, a German missionary named Reinhold Rhode acquired a pair of memorial figures—one of them the queen mother—and several other items from the palace. It is not known whether these items were obtained by gift or by coercion. In August 1905, German forces ended a punitive expedition by signing a treaty and enacting a gift exchange with the Fon. Sculptures and masks were taken back to museums in Berlin and Frankfurt. By that year, the Rhode figures were installed in the newly established Museum für Völkerkunde in Frankfurt.

Fig. 30. Mourning the death of Fon Ndi (reigned 1926–1954), with Paul Gebauer (center) taking photographs, Laikom, 1954.

during his reign was the active presence of missionaries. Roman Catholic and Baptist missions had been established in the Bamenda division years before (1838 and 1919), but during Fon Ndi's era, Christians set up schools and hospitals and began to exert new influence, especially on the young men commemorated in this figure.

Not a portrait of an individual, this sculpture is a memorial to a whole system of service that the Fon relied upon. Young men known as *chisendo*s formed an elite group of attendants who assisted with many aspects of palace life.[15] A candidate was chosen between the ages of ten and fifteen if he had an aptitude for learning, regardless of his family's position. At the palace, he underwent at least ten years of intensive training, including instruction in diplomacy, trade, security, and ceremonial and ritual preparations. The trainees were supervised by officers of an organization known as Kwifon, or "voice of the Fon" (fig. 31), an intricate system of government common throughout the Cameroon Grassfields. It was said that Kwifon supported the Fon as a taproot supports a tree.[16] Not seen, but ever present, Kwifon members heard everything going on and could exert unlimited power when necessary. They announced orders, enacted regulations, settled domestic disputes, and inflicted penalties as warranted. Outside the palace, whenever acting in the public eye, Kwifon officers veiled themselves in masquerade so as not to be identified as individuals. Behind the scenes, they acted as a democratic decision-making forum. After being trained by Kwifon officers, *chisendo*s eventually became Kwifon members themselves.

Pl. 68
**Retainer figure**
Laikom, Kom, Cameroon
19th century
Wood, nails, fiber fragments
H. 77.3 cm (30½ in.)
Gift of Katherine White and the Boeing Company, 81.17.719

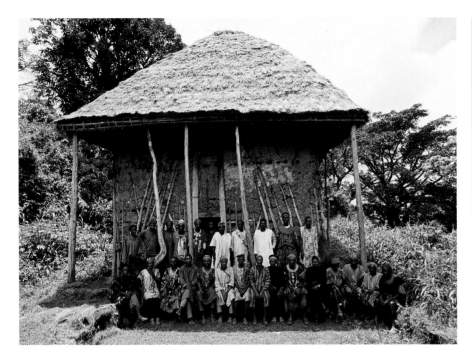

Fig. 31. Kwifon group portrait in front of the royal storage house, Laikom, 1970.

Fig. 32. Royal storage house interior, Laikom, 1966.

The sculpture (pl. 68) represents a *chisendo* of high status. As a signal of how extremely close he is to the Fon, he is seated on a leopard stool, a royal prerogative symbolizing the cunning and stealth with which royalty operates. The *chisendo*'s cap also signifies rank. Small holes and nails indicate that his body was originally covered with a beaded coating. Beyond these references, the relaxed display of authority combined with service makes this figure stand out. Symbols of strength are matched by a body that would assume gigantic proportions if he stood. Long arms curve up and end in hands that expand to hold two containers—a gourd and a large bowl. Long legs splay over the seat. In contrast to the endless facets that flicker across the surface of his limbs, his face remains a study in calm, smooth composure. Serenely juggling two vessels while sitting atop a leopard is testimony to the dignity of the *chisendo.*

Photographs record this figure placed on the ground next to other memorial figures, as well as stored in the royal sanctuary guarded by the Kwifon (fig. 32).[17] It would likely have been the task of a *chisendo* to bring out the figure and fill the vessels with palm wine and kola nuts—two essential ingredients for a ceremony, to lubricate and heighten awareness of events as they unfold. This figure has sat through many years of royal ceremonies and testifies to the unique position of the *chisendo* in Laikom.

Fon Law-aw's removal of the figure is a portent of personnel shifts in his palace. Hundreds of *chisendo*s were once in residence, enabling the Fon to guard the cultural center of the kingdom and learn the running of Kwifon government. By the end of his father's reign, missionary schools and national government policies were giving parents new choices for their children's education. While becoming a *chisendo* was desirable in the 1940s and 1950s, by the 1960s formal education was one of the changes forging a path through the kingdom. Steadily, recruitment of *chisendo*s

Fig. 33. Paul Gebauer saluting subchiefs, Laikom, 1954.

dropped off, until by 1990 only five were left in the palace.[18] Fon Law-aw gave the *chisendo* portrait to a foreigner whose tenure in Cameroon overlapped this period of change.

Henry VIII would have been envious.     —Paul Gebauer, 1979[19]

Paul Gebauer and his wife, Clara, arrived to work at the American Baptist Mission in 1931 and stayed until 1961 (fig. 33). Their legacy of Cameroonian art is embodied in thousands of photographs and hundreds of documented objects now housed in several museums. Katherine White corresponded with Paul Gebauer for years to seek advice about assembling her own selection. She began by buying the male retainer figure from him in 1964. Paul Gebauer speaks of himself as being "prematurely bald, prematurely blunt, and prematurely initiated into the secrets of missionary-politicians."[20] He and Clara became known for sending home candid reports and participating in studies of local art and landscape. Paul's descriptions of Fon Ndi's palace—the Fon seated near the fireplace with attendants nearby, ruling over a kingdom punctuated with ceremony and architectural artistry—are filled with ad-miration. He launched a study of spider divination that led to a master's thesis, an endeavor that did not sit well with some of his Baptist brothers. His statement of purpose set a course of acceptance that must have been noticed by the Fons he came into contact with:

> We shall not take our culture to them, for they have one of their own. We shall
> not burden them with our American civilization, because theirs is one of their
> own.... We shall not laugh at their arts and crafts but encourage them to carry
> on and to perfect their expression of their appreciation of the beautiful. We

shall not denounce their social and political institutions as sinful and ugly and out of date, for we of the west lack the wisdom to discriminate, nor do we have the right to do so.[21]

The Gebauers backed up this manifesto by establishing a school that was "as informal and individual as possible." They earned a reputation for hiring artists to adorn building projects with sculpture and for being attentive to a succession of leaders throughout the region.

Kom art and ethics were treated differently by Roman Catholic missions. In the 1920s, Kom Catholics were known to unmask Kwifon masqueraders and spit upon them—an opposition that was to reverse later in the century.[22] More pointedly for Fon Ndi, however, Catholic missionaries began encouraging his wives to leave their compounds and marry mission converts. This campaign lasted into the 1940s, and in 1947 reached a crescendo. A Catholic newspaper made a scandal of the issue by publishing "Just Cargo," a nun's description of what she counted as Fon Ndi's six hundred wives. The article included her account of witnessing a girl being thrown on the ground and stepped on by the Fon. This article became the basis for a United Nations investigation, which determined that for the sake of vividness the writer had dramatized Kom custom and made it appear she was describing an actual incident.[23]

Although the United Nations and the Catholic bishop backed off from trying to influence the Fon's private life, a journalist named Rebecca Reyher set out to witness the "heartbreak of polygamy." Her account, entitled *The Fon and His Hundred Wives,* was published in 1952.[24] As part of her journey, she visited Paul Gebauer, who puzzled her with his clear opinions regarding the issue. He commended Fon Ndi's intelligence and his system of governance, and condemned Catholic baptism for its shortsightedness. Reyher proceeded to Laikom, was invited by the Fon to stay at his guesthouse, and talked with him on numerous occasions. Her focus rarely wavered from the plight of runaway wives or from skeptical disapproval, but her account does provide details about the crosscurrents of Fon Ndi's time. Reyher left Africa after two weeks at Laikom and several months in Cameroon and Nigeria, while Paul and Clara Gebauer stayed thirty years. And Paul Gebauer was given a sculpture in thanks for his service to Fon Ndi's eighty-eight widows.

Endowed with two major Kom sculptures, Katherine White continued to look for others. In 1968, she purchased a throne that left Laikom after another long-term American alliance (pl. 69). Gilbert and Mildred Schneider had gone to Cameroon in 1947 as part of the American Baptist Missionary Society and stayed for sixteen years. Stationed for many years fifteen miles from Laikom, they were instrumental in setting up a facility for the housing and treatment of lepers. Gilbert established an extensive archive of photographs and notes of his observations, which led to a doctorate in anthropology upon his return to the United States. His documentary work was carried on by his son Evan, born and raised in Cameroon. Their joint efforts comprise a remarkably thorough record of cultural evolution from the 1940s to the present. During their initial tenure, the Schneiders became close to Fon Lo-oh (ruler from 1955 to 1964) (fig. 34). Gilbert worked so closely with Lo-oh and a Kom adviser and former *chisendo,* Johnson Mbeng, that he was permitted to move around the palace without

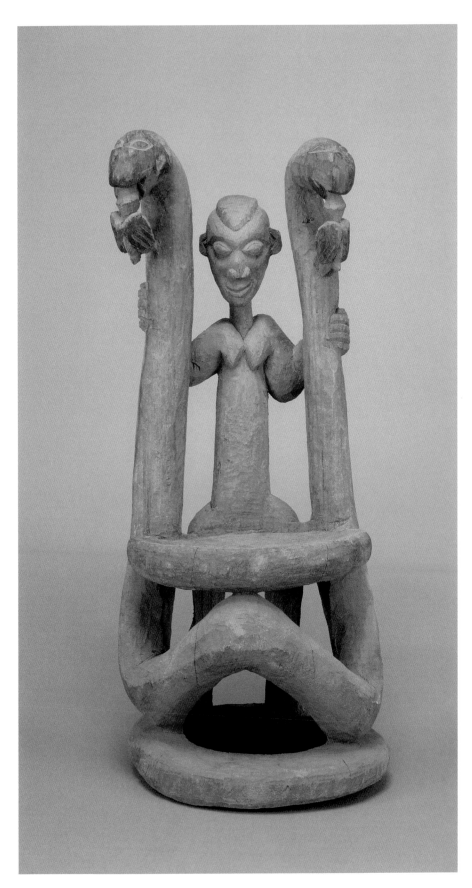

Pl. 69
**Coronation throne**
Laikom, Kom, Cameroon
20th century
Wood
H. 99.7 cm (39¼ in.)
Gift of Katherine White and the Boeing Company,
81.17.720

escort and to take pictures of royal objects. During one visit, Schneider noticed a figure piled up with other items in a passageway. In a letter to Katherine White, Schneider explains:

> The figure which you now have was in the "discard" category. I voiced concern about the piece and other such items and the Fon immediately gave me permission to take a few items. He gave me that particular piece without any strings attached. He was glad that two people took interest in documenting the royal palace. We should be grateful to have the Kom throne in the States. The royal palace burned in the early 1960s and all the "discard" pieces that remained were destroyed by fire.[25]

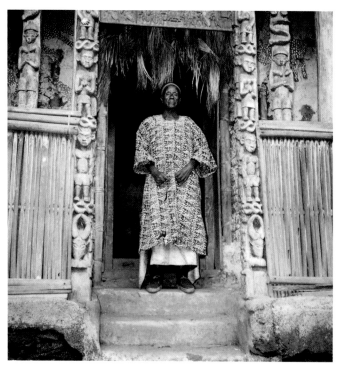

Fig. 34. Fon Lo-oh (reigned 1955–1964) in front of main gathering house, Laikom.

This "discard" visualizes the origin of Laikom. It is a stool whose back is formed by a woman grasping a two-headed snake in her hands; each snake head holds a bird in its mouth. Just as this woman is steadfast in holding this large swirling creature about her, so the story behind the stool unites the Kom as the "people of the snake." Kom people tell and retell the story as their foundation myth.[26] The tale begins in a time when the Kom were settled and thriving in Bamessi. The Fon of Bamessi, however, became upset by the growing population and suggested to the Kom Fon, named Muni, that they each build a house for troublemakers and set the houses afire. Muni agreed and built his house in good faith, but the Bamessi Fon built a house with two doors so that his people could escape the fire, while the Kom people burned. Deeply disturbed by this trick, Muni was ashamed and decided to hang himself, but he also wanted revenge. He told his sister to lead the Kom people away and to look for a new lake that would form from the bodily fluids of his rotting corpse. She was to wait and watch the lake sink and disappear, leaving traces of a python's track. Once the track was sighted, she was to gather the Kom people together and follow the python until it disappeared. The sister carried out this plan, and the snake led the people to the highest mountain peak, where they founded Laikom.

Laikom's perch sets it apart as a capital. Colonial administrators often suggested moving it to a lower, more accessible position in the valley. Fueled by a story of betrayal and survival through allegiance to a female, the Kom maintained the position of their capital. The story is reenacted and reinforced whenever a new Fon is installed. In the process of an installation, a man must acquire new powers that elevate him above all others. Unlike ordinary men, he learns to foresee the future, communicate with ancestors, and triumph over evildoers. He acquires sacred powers and changes his character to prepare for leadership.

During the 1960s and 1970s, one corner of Katherine White's living room was being filled with Kom royal art, rich with significant associations. She continued to

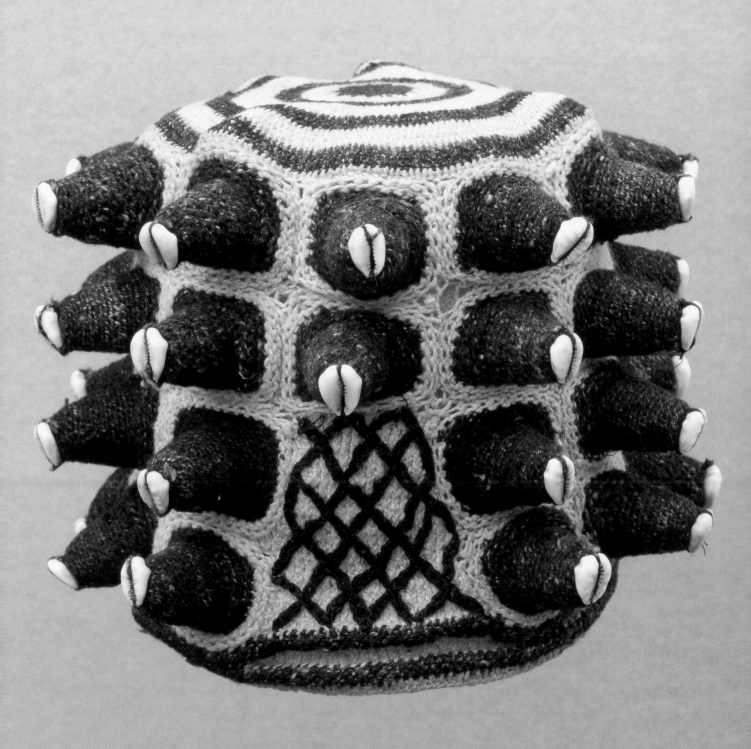

The Kom version begins with a letter from an American asking the Kom adviser Johnson Mbeng to steal two statues from the sanctuary where the Afo-a-Kom had been kept. Mbeng, not pleased by this suggestion, showed the letter to Fon Nsom, who proposed that they, a tiny kingdom, try to trick the giant American nation into returning what was rightly theirs. Mbeng wrote letters to Americans inventing a story of famine, impotence, and mourning caused by the removal of the Afo-a-Kom. In fact, when the statue disappeared, the Fon did not express concern about it. And because only a privileged few ever saw the statue, and then only once a year, the Kom people as a whole did not miss it—there was no widespread mourning.

When the American delegation returned the statue, the Fon was put to a test of his diplomatic abilities. The Minister of Information stepped in to claim it for the nation of Cameroon (established as a united republic in 1972). He announced that the government would make the statue a symbol of national unity and send it around the country until the proper home could be determined. The minister placed it on view in the window of the Office of Tourism with a sign saying "This statue is worth 15 million francs in America." Fon Nsom challenged the government's claim to ownership with his own ingenious response to the situation:

> The Fon had done one funny thing when we entered the office. He was shown a chair at the side of the room and he refused it, saying he wanted to be directly in front of the Minister. So he sat there while we interpreted all the things that had been said for him. Then he said, yes, thank the Minister and tell him that he was glad this thing is for the whole of Cameroon. Then he insisted that we ask the Minister this question: "If I cut off my ear or pluck out my eye, would it belong to Cameroon or to me?" The Minister said, "If you remove your eye, it is still your eye, it does not belong to Cameroon." And the Fon said, "Yes, exactly so, and the Afo-a-Kom is still my Afo-a-Kom." The Minister said the Fon should not be comparing the eyes, the ears, with the Afo-a-Kom.[32]

When the minister spoke of sending the Afo-a-Kom on a tour around Cameroon, the Fon stated he would have to stay with it wherever it went. The minister asked, "What are you talking about? You want to stay here?" In reply, the Fon said he had been living in Yaounde in a hotel for three days with free food and a free bed. He would stay. Soon thereafter, the minister placed a few calls. By the next day, the Afo-a-Kom was on its way back to Laikom, where it was greeted with jubilation (fig. 36).

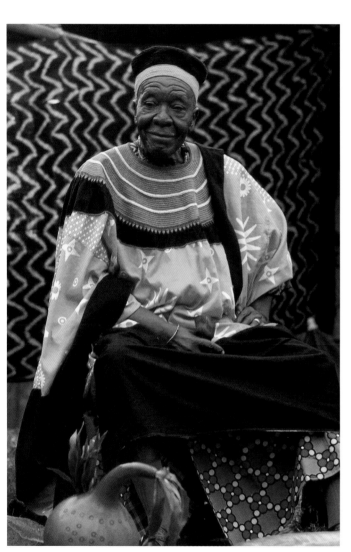

Fig. 35. Fon Nsom (reigned 1967–1974) with *ndop* cloth in background, 1974.

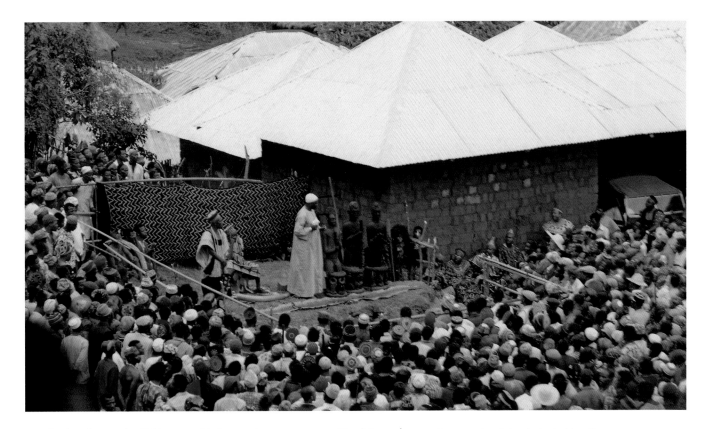

Fig. 36. Crowds viewing Afo-a-Kom, 1974.

In the aftermath of this two-sided story, lessons emerge. Fon Nsom, known in Kom for his fondness for intrigue, was able to assess an American weakness for sensational news. He and Johnson Mbeng adopted the stereotype of a poor kingdom unable to cope without its sacred statue. Jumping on an opportunity to save the situation, Americans responded with amazing swiftness. They were less aware of the complex Kom realities: that a theft from palace storage indicated there were not enough retainers to maintain security; that a Fon is required to negotiate his status in a modern nation state; that a sculpture like the Afo-a-Kom is seen differently by various Kom audiences—as a familiar portrait of Fon Yu by palace officials, and as an awesome reminder of royal power by commoners, but not a sacred god able to cause famine.

In turn, Kom people learned how much Americans value royal sculpture and began making as many copies as possible. Local rumors commended the cleverness of the Fon. Among commoners, the Afo-a-Kom was said to have caused havoc in America by walking around at night and destroying other objects placed near it. The return of the sculpture, in this rendition, was not a gesture of generosity, but was provoked by the need to export the destructive figure.

Fewer than ten years later, the Smithsonian Institution decided to mount another exhibition of Cameroonian objects, *The Art of Cameroon*. Once again, Katherine White's collection was prominently placed on view along with the Afo-a-Kom. Fon Jina Bo II (ruler from 1975 to 1989) had agreed to the loan and relied upon his retainers to carry it out.

Afo-a-Kom toured the United States but again became a beacon for misunderstanding. When the figure was returned by a Smithsonian representative, it was

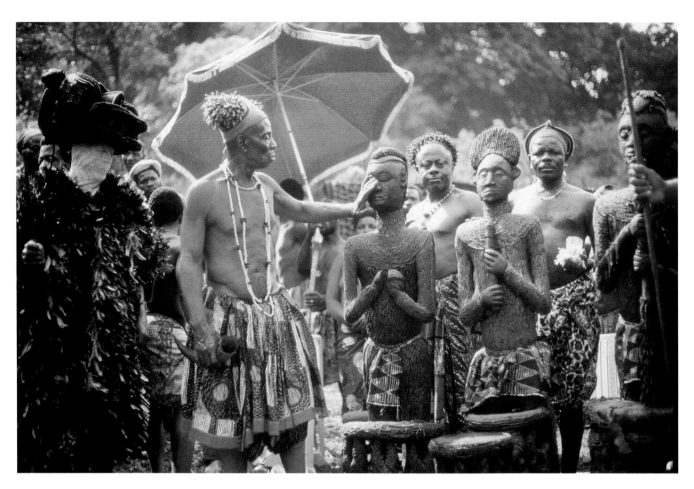

Fig. 37. Fon Jina Bo II (reigned 1975–1989) at his
enthronement with the royal figures, October 1, 1979.

greeted with disappointment. It seems an American impostor, acting as an agent for
the Smithsonian, had already been to Laikom. He had promised the Fon a sum of
money, a trip to the United States, and the seven vehicles that would bring the sculp-
ture back to Laikom. The Fon, pleased with these plans, had given the man carvings
as gifts to take back to the United States. When the true Smithsonian representative
arrived, bringing the Afo-a-Kom in a crate and a $300 loan fee, the reality fell far
short of the Fon's falsely raised expectations of what was possible from America.

> I have since realized that I am like a wor m since I became Fon of Kom.
> —Fon Jina Bo II

Negotiating with museums is just one of the difficulties a Fon faces. Jina Bo II,
the first Fon to be quoted in publications, began his rule with a test of confidence in
the process of "becoming Fon" (fig. 37). One Kom scholar, Paul Nchoji Nkwi, describes
a situation in late 1974 when contradictory forces were pulling at the kingdom.[33] On
December 13, the previous Fon, Nsom Ngwe, brought a case against his heir, Michael
Mbain. Mbain was tried for selling three masks from the royal compound. He was
brought before the Fon, and the police threatened to imprison him, but he insisted
on his innocence. Senior palace retainers led the charges against him, insulting and
jeering him for his misdeeds and rudeness toward the Fon. Three days later, however,
Fon Nsom Ngwe died unexpectedly. Michael Mbain underwent the initiation process,

much of it privately enacted, which stressed his new functions and responsibilities. He emerged as a man transformed seven days later. Those same retainers who had denounced him earlier now called out his praise names as he took the identity of a Fon named Jina Bo II. As Nkwi reports, "The entire enstoolment process was believed to transform an ordinary mortal into an immortal being having power over life and death."[34]

Fon Jina Bo II is one of many leaders presiding over kingdoms that have survived, but not thrived, in the late twentieth century. Ongoing conversions to Christianity and Islam erode his base of spiritual authority. State government agents strive to dismantle the powers of the Fon in order to obtain access to lands under his authority. Customary Kom laws disregard political agendas and have led the Fon to question:

> What makes my land my land? Is it that piece of paper or the fact that I am Fon of Kom? . . . I have since realized that I am like a worm since I became Fon of Kom. I am like a worm in the midst of ants. On my right, the "tiny chiefdoms" are biting me, on my left the Senior Prefect and his gendarmes. Everywhere around me, there are pressures. The land is no longer mine.[35]

Kom royal sculptures have been removed from their original owners over the course of this century. In an art museum, the intricacies of the Fon's role are a remote consideration. On the streets of Cameroonian cities and kingdoms today, the reality of the legacies left by such kings have a far greater impact.

Chiefs, more chiefs, always chiefs.     —Jean-Marie Teno, 1999[36]

The documentary film *Chef!* by Jean-Marie Teno concludes the century with a startling look at a ruler within the context of his own family. Teno narrates his changing expectations as a past chief is honored while his own great-uncle is installed as a chief. Two art forms punctuate the film. First is the cement statue commemorating King Kanga Joseph II, who was born in 1900 and ruled for fifty years. Teno observes that this king sought to develop his community by "straddling two traditions with no preparation and no training." His concrete image presides over a busy intersection. "All alone at the end of the street, he will watch the concrete and beer ads invade his kingdom." A great chief, he is saluted by masquerades whose importance he preserved. But, Teno says, the masks are symbols that "fewer and fewer understand." The masquerades fade away as images of urban distress pervade the film. Questioning the role of such leaders in contemporary culture, Teno stresses the need to ask "Who comes first, the people or the chief?"[37]

The Seattle Art Museum's stage for a Fon of the Kom kingdom is fairly complete. Most of the objects were gifts from Fons to Americans who worked for years in Cameroon. Memories and photographs provide a record of close associations and meanings, but the stage is still missing the key actor—the patron who inspired the art and the only person ritually prepared to use it. In Laikom recently, the Fon remains the lead curator and principal guard of his own ongoing collection (fig. 38). In this role, he extends the kingdom's art in new directions. As part of a visitors center, a pole has

Fig. 38. Fon Yibain (reign 1989– ) at the palace, Laikom, 1999.

been erected to honor the past kings. Paintings of the succession of kings appear on the palace walls. Just as the Fons adapt their collections to remember the past and attract new visitors, so does the museum. Fon Yibain, the current ruler, was consulted as the museum planned its display of a stage fit for a Kom king. He designated Gilbert Mbeng Lo-oh, named for an American and Kom ancestor, to act as his emissary and conduct interviews with retainers and current members of the Kwifon (defined by Lo-oh as the sacred and administrative arm of the palace). Before bringing the results of his work to Seattle, Mbeng Lo-oh promised "startling revelations about customs and especially myths surrounding Kom art." Thus, the museum will learn from this venerable kingdom as it guides a royal past into the present.

# Notes

1. This circumstance changed with a collection of Maasai art in January 2000.

2. Paul Gebauer, note attached to an accession card created by Katherine White.

3. Paul Gebauer, "Architecture of Cameroon," *African Arts* 5, no. 1 (1971), 46.

4. Eugenia Shanklin, "The Path to Laikom: Kom Royal Court Architecture," *Paideuma* 31 (1985), 111–50.

5. Paul Nchoji Nkwi, "A Conservation Dilemma over African Royal Art in Cameroon," in *Plundering Africa's Past,* ed. Peter Schmidt and Roderick J. MacIntosh (Bloomington: Indiana University Press, 1996), 108.

6. Eugenia Shanklin, "The Odyssey of the Afo-a-Kom," *African Arts* (1990), 62–69.

7. Christraud Geary, *Africa: The Art of a Continent* (New York, Guggenheim Museum, 1996), 155.

8. The two photographs of Fon Yu, both taken by Adolf Diehl, are given an approximate date of 1905–10.

9. Eugenia Shanklin, "Missionaries and Witchcraft Beliefs in Kom, Cameroon," in *The Message in the Missionary: Local Interpretations of Religious Ideology and Missionary Personality,* Studies in Third World Societies, no. 50 (Williamsburg, Va.: College of William and Mary, 1994), 56.

10. Reproduced in Tamara Northern, *Royal Art of Cameroon* (Hanover, N.H.: Dartmouth College, 1973), 10.

11. Reproduced in ibid., 12.

12. Katherine White Journals, Seattle Art Museum.

13. Katherine White's summary, based on Paul Gebauer's undated letter to her, Katherine White Archives.

14. E. M. Chilver and P. M. Kaberry, "The Kingdom of Kom in West Cameroon," in *West African Kingdoms in the 19th Century,* ed. Darrel Forde and Phyllis Kaberry (London: International African Institute, 1967), 142–43.

15. Phyllis M. Kaberry, "Retainers and Royal Households in the Cameroon Grassfields," *Cahiers d'études africaines* 3, no. 10 (1962), 282–98.

16. Hans-Joachim Koloss, "Kwifon and Fon in Oku on Kingship in the Cameroon Grasslands," in *Kings of Africa* (Utrecht: Foundation Kings of Africa, 1992), 40.

17. Photograph by Gilbert Schneider of Ngumba House, published in Fred Ferreti, *Afo-a-Kom: Sacred Art of Cameroon* (New York: The Third Press, 1975), 63.

18. Nkwi, "A Conservation Dilemma," 108.

19. Paul Gebauer, *Art of Cameroon* (Portland: The Portland Art Museum; New York: Metropolitan Museum of Art, 1979), 78.

20. Charles Weber III, "The Educational Policy and Mission Schools of the Baptists in British Mandated Cameroon 1922–1945: The Policy and Education Work of Carl Bender, Paul Gebauer, and George Dunger," dissertation on microfiche (1982), Metropolitan Museum of Art, New York.

21. Ibid.

22. Shanklin, "Missionaries and Witchcraft Beliefs," 58.

23. M. D. W. Jeffreys, "Some Notes on the Fon of Bikom," *African Affairs* 50, no. 200 (1950), 241–49.

24. Rebecca Reyher, *The Fon and His Hundred Wives* (New York: Doubleday, 1952).

25. Gilbert Schneider, letter to Katherine White, November 5, 1973, Katherine White Archives.

26. Eugenia Shanklin, "The Track of the Python: A West African Origin Story," in *Signifying Animals, Human Meaning in the Natural World,* ed. Roy Willis (London: Allen and Unwin, 1990).

27. Catalogue card, Katherine White Archives, Seattle Art Museum.

28. Alastair Lamb and Venice Lamb, *Au Cameroon: Weaving/Tissage* (Hertingsfordury, England: Roxford Books, 1981).

29. Shanklin, "The Odyssey of the Afo-a-Kom," 62–69.

30. Ferretti, *Afo-a-kom.*

31. George Spicely, quoted in ibid., 122.

32. Fon Nsom's words were recited by Bobe Chia Fuinkuin, a high-ranking member of the Kom entourage; quoted in Shanklin, "The Odyssey of the Afo-a-Kom," 66.

33. Paul Nchoji Nkwi, "Becoming Foyn: Among the Kom of the Cameroon Western Grassfield," *Paideuma* 36 (1990), 235–43.

34. Ibid.

35. Quoted in Cyprian Frisiy, "Chieftaincy in the Modern State: An Institution at the Crossroads of Democratic Change," *Paideuma* 41 (1995), 56–57.

36. Jean-Marie Teno, *Chef!* California Newsreel, 1999.

37. Ibid.

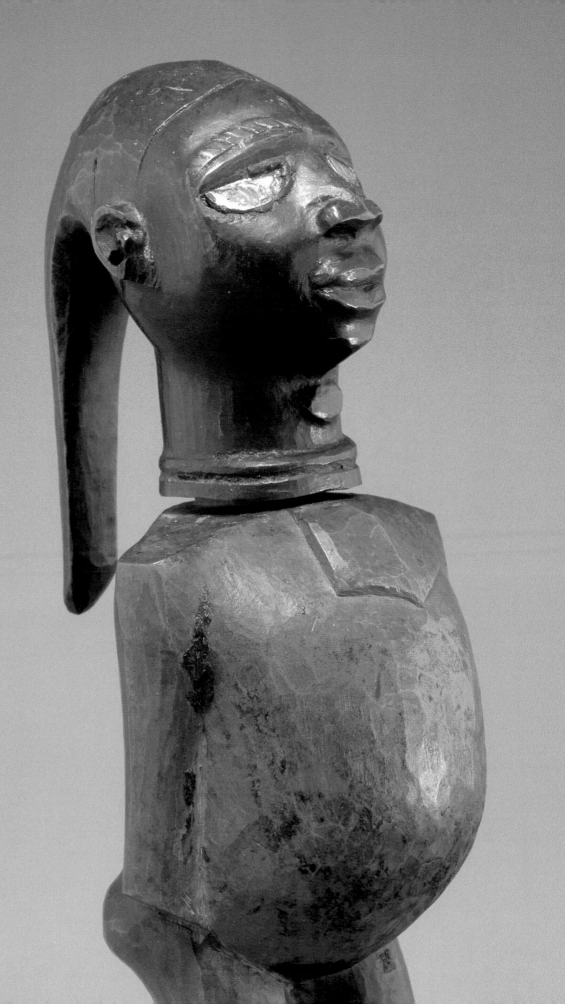

# The Fetish and the Imagination of Europe: Sacred Medicines of the Kongo

The word "fetish" can be a gauntlet, thrown down with unsettling force. Europeans came to use the one word to cover a wide range of objects from all over the African continent. Fetishes were everything from necklaces to sculptures valued by Africans for—in Western terms—their power of "enchantment," provocation of "superstitious dread," or capacity to be "animated by a spirit."[1] Outside Africa, fetish assignments have extended to complex issues of value. Karl Marx used the term to call attention to economic fixations. Sigmund Freud adopted it in describing sexual perversion. Recently, fetishism has been applied to Dutch still lifes as well as Hollywood cinema.

As a curator of African art, I receive at least one "fetish" call every other month. I keep track of them in a phone log that started as a way to contain my frustrations over the imaginary diabolical powers that African art inspires. The conversations follow a pattern: "I have a fetish from Africa. My grandfather/uncle collected it when he was working over there and he said it was supposed to give people head-aches and my family doesn't want it around the house anymore. When can you come and get it?"

This basic statement is followed by long digressions about the errant uncle or adventuresome grandfather, but then we close in on what makes the owner uncom-fortable about the fetish. One contained "slave tears." Another was "evil and nasty" and "too scary for anyone else to handle." Usually, the object comes from an un-known country, and the caller can only describe it as a standing statue. Along the way, my official capacity shifts from art museum curator to exorcist. Just as I am unsuited for this role, so is the sculpture whose job description has been typecast with one word. The exorcism should be redirected, against the process that created a blanket term for images of belief—against the fetishizing of African art.

> It is we who have constructed the world of the fetish, not the original makers, priests or clients of such figures in Central Africa.

> —John Mack, 1995[2]   Pl. 77 (detail)

Standing as an anchor image for fetishes is a male figure holding his hands on his hips, most of his body covered with nails and blades (pl. 75). This sculpture is of the type held up as the epitome of the negative, violent model of vengeance that is still a baseline for fetishism. His body has been pounded with nails, poked with needles, splattered with blood, and incantations are uttered over him to provoke illness and disruption in someone's life. As this caricature steps aside, it is replaced with a figure whose personality and job description are shaped over the centuries of an evolving kingdom. First discovered over five hundred years ago, this kingdom tested European leaders' willingness to exchange goods and knowledge. Within the lifetime of one African king, however, trade took on new and terrible dimensions. The fetish was created as Europe closed off the exploration of African thought and chose instead the exploitation of its people.

> **Faith is as fragile as glass.**
>
> —King Mvemba Nzinga, who became Afonso I,
> letter to King Joao III of Portugal, 1526[3]

A Portuguese explorer in 1483 was the first to notice water rushing from the Congo River into the Atlantic. Diogo Cão sailed into the mouth of the river but could not continue. He returned to Lisbon in 1484, taking with him four men from the Kongo kingdom. After meeting these ambassadors, the Portuguese king, Joao II, sent a fleet of three caravels to investigate their reports of a royal capital ruled by an African king. By December 1490, a group of priests, stonemasons, carpenters, and women set out with gifts and building materials to establish diplomacy and a settlement. The caravels arrived at the port city of Mpinda on March 29, 1491, to be greeted by the chief of the province, who was quickly baptized and renamed Don Manuel. Within days, the Portuguese began their walk inland to the capital city of Mbanza Kongo, perched atop a plateau in the Crystal Mountains. Escorts led them into the large city and through a maze of densely planted trees surrounding the approach to the king's quarters.

The expedition found King Nzinga a Nkuwa seated on a raised wood throne with ivory inlay, while around him were assembled his queen, wives, nobles of the court, and chiefs of the provinces (fig. 39). Leopard and civet furs were draped around the king; his arms were laden with bracelets of copper; and his garments were woven of raffia. The leading Portuguese emissary approached him, knelt, and kissed his hand. King Nzinga responded by taking a handful of earth, pressing it against his heart and then against the Portuguese. Porters brought forth gifts from the king of Portugal— brocade, velvet, satin, silk and linen, silver and gold jewelry, trinkets, plate, and a flock of red pigeons. Kongo musicians played ivory trumpets, "producing a sound so melancholy that its like has never been heard."[4] They repeated their song twelve times to honor the twelve generations of kings since the kingdom's beginnings. The next day, the king sent privately for the Portuguese to devise a plan for his baptism, which required the swift construction of a church. Two months later, before a huge gathering of onlookers, Nzinga took the baptismal name Joao I, and his son became Afonso I. A rush of other title holders followed their lead.

PI. 75
**Standing figure** *(nkondi)*
Kongo, Democratic Republic of the Congo
Late 19th–early 20th century
Wood, iron, imported nails, fiber, beads, glass, feathers, chalk
H. 80.5 cm (31¾ in.)
Gift of Katherine White and the Boeing Company, 81.17.836

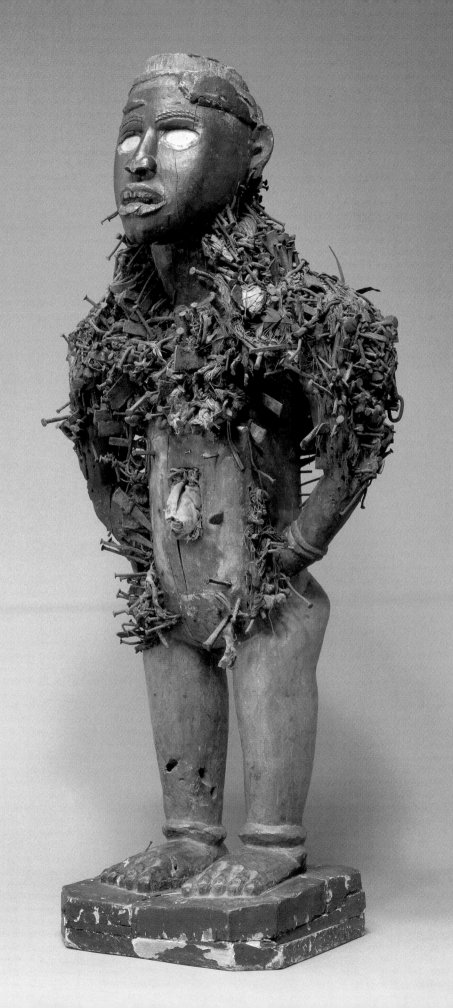

Fig. 39. The arrival of the Portuguese before the king of Kongo in 1491, from Filippo Pigafetta, *A Report of the Kingdom of Congo and of the Surrounding Countries . . .* (1591).

When members of the Portuguese expedition returned to Lisbon, young Kongo nobles went along to carry gifts of ivory and raffia cloth for the king. They also brought the news of a vast country with a distinguished government in place for nearly 150 years.[5] The founder of the kingdom, Ntinu Lukeni, had gained renown as a judge whose fairness in establishing laws and dispensing justice formed a central identity for the people. Portuguese observers noted the presence of regional governors and ranks of civil servants convening in numerous courts within the palace. Most chroniclers also described a large open plaza known as the court of justice, where an enormous wild fig tree shaded the king as he heard disputes and reviewed his troops.

More Portuguese emissaries came to Mbanza Kongo in 1493 and 1504, bringing ample supplies of vestments, crosses, and religious books. Undoubtedly, one of the first to handle them was a member of the court who took extreme notice of all things Portuguese. His curiosity was a major force in an era of remarkable leadership. Mvemba Nzinga Afonso I assumed the throne after his father's death in 1506 and ruled until 1543. Not long after his coronation, he loaded a ship bound for Lisbon with gifts. He sent along his son and several nobles and requested that King Manuel put them in schools and dispatch more missionaries and technicians.

Indeed, Afonso I became famous for his commitment to Christianity and education—he studied theological texts with Portuguese priests and made Catholicism the state religion. Reports to the king of Portugal describe him as "the apostle of the Congo," commending his skills in preaching, his exercise of justice, and his punishment of those who worshiped idols. Despite the fact that only his household firmly supported the move, he destroyed a "great house of the nkisi-fetishes" in Mbanza Kongo.[6] A rendering of Afonso's destruction of the idols depicts a fire consuming a bundle of fantastic creatures with curling tails and fearsome faces (fig. 40).[7]

once have rested atop the head of this *nkondi* (pl. 75) with a blaze of jagged color.

*Mooyo:* the belly/life.

The belly of this *nkondi* has been emptied; only a scrap of cloth is left as a hint of what originally covered the navel. A pack of medicines composed by the *nganga* would have filled this hole and been sealed in place with resin, and then a mirror placed in the center. Such medicines gave the figure life, or as Robert Farris Thompson says, a vitality "like a live radio with a working antenna." Without the medicines, the figure has lost its compass and is unable to act. *Minkisi* were portable shrines for the souls or spirits they referred to.

Four other figures illustrate how the mooyo could be configured. The first is seated, with medicines projecting from his navel and the shoulders of his jacket (pl. 76). His gun, uniform, and pith helmet may signal the presence of a European soldier. Sealed behind glass are a host of ingredients that float in a foggy enclosure just out of view. A standing figure whose arms are absorbed into a swollen belly clearly displays his role as a container for medicines—the head twists off (pl. 77). Sitting cross-legged, another holds his hand to his chin in a pose suggesting a person of reflection, lost in thought about how to guide others with his mind (pl. 78). The Kongo phrase "we leave this matter in your lap" refers to the person who is seen listening and thinking on behalf of others.[33] Holding his belly with his left hand and a cane of authority with his right, another Kongo man stands attentively (pl. 79). Medicines coat his face and helmet, but not his body.

*Dikenga:* the turning.

Fu Kiau Bunseki in 1969 first wrote about underlying principles of Kongo art. He clarified a notion that had flourished beneath the surface, beyond European understanding, for more than four hundred years: "The sign of the cross was not introduced into this country and into the minds of its people by foreigners. The cross was known to the Kongo before the arrival of Europeans, and corresponds to the understanding in their minds of their relationship to their world."[34] Bunseki introduced the notion of the *dikenga,* a sign or cosmogram for seeing the progress of a man's soul as akin to the path of the sun (fig. 45). Four moments of the sun are equated with four end points of a cross in a circle. He names the four moments: (1) *kala,* rising, beginning, birth, or regrowth; (2) *tukula,* ascendancy, maturity, responsibility; (3) *luvemba,* setting,

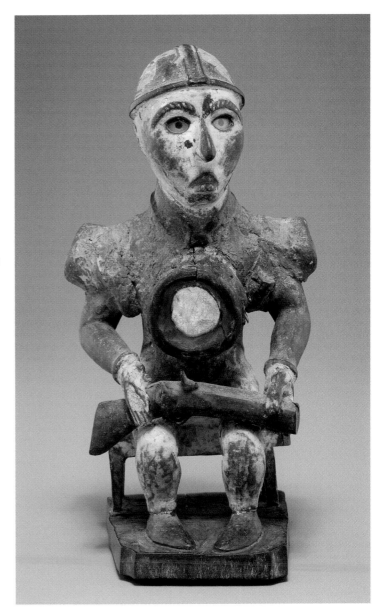

Pl. 76
**Seated officer**
Kongo, Democratic Republic of the Congo
Late 19th–early 20th century
Wood, mirror, glass, chalk, camwood powder, clay, labels
H. 24.2 cm (9½ in.)
Gift of Katherine White and the Boeing Company,
81.17.835

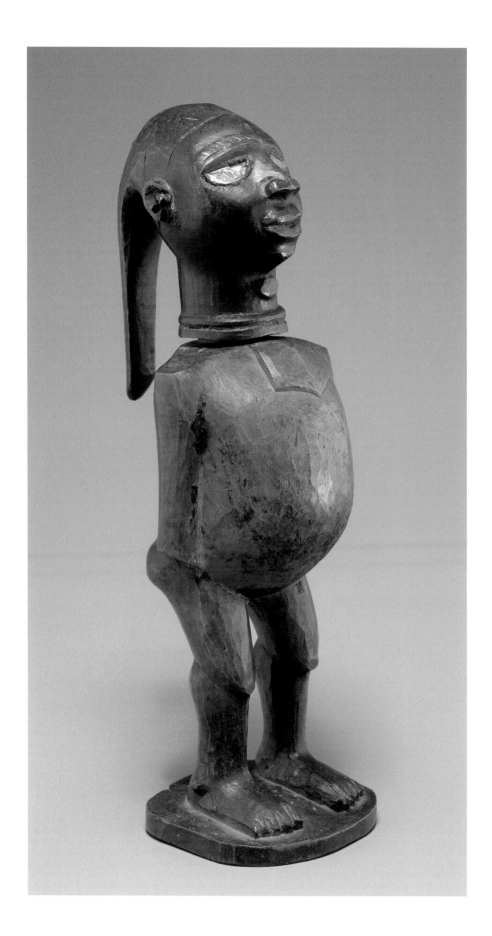

Pl. 77
**Standing figure**
Kongo, Democratic Republic of the Congo
20th century
Wood, glass, metal
H. 30.1 cm (11⅞ in.)
Gift of Katherine White and the Boeing Company,
81.17.841

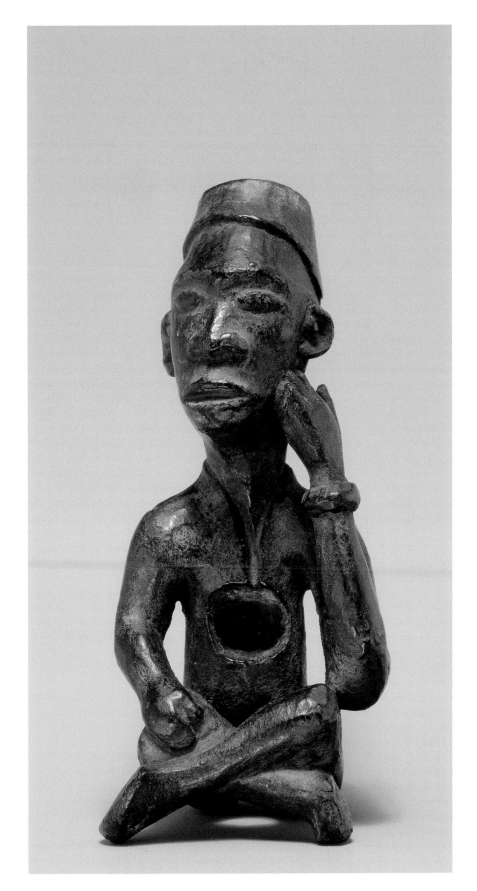

Pl. 78
**Seated man**
Kongo, Democratic Republic of the Congo
20th century
Wood
H. 13.8 cm (5½ in.)
W. 6.0 cm (2⅜ in.)
Nasli and Alice Heermaneck Collection, 68.54

Pl. 79
**Standing figure**
Kongo, Democratic Republic of the Congo
20th century
Wood
H. 19.7 cm (7¾ in.)
Gift of Katherine White and the Boeing Company,
81.17.839

TUKULA

KU NSEKE

LUVÈMBA      KALUNGA      KALA

KU MPEMBA

MUSONI

Fig. 45. Diagram of *dikenga,* four moments of the sun, after the writing of Fu Kiau Bunseki.

handing on, death, transformation; and (4) *musoni,* midnight, existence in the other world, eventual rebirth.[35] All souls are constantly cycling through these four stages, just as each day goes through its stages. Early morning mists are the dying embers of the cooking fires of the dead, who pass away just before the dawn of the living. The *dikenga* sign can also be read as a map: the world of the living and dead meet in the middle horizontal line called *kalunga.*

Turning and circling are found in a woman with child (pl. 80). She sits on an honorary platform incised with pinwheel images that rotate. Her legs form a circle to suggest the cycle of one's life and the revolution of the day from one world to the next.

A *dikenga* sign is a potent document. An *nkondi* figure was likely to witness its impact as a cross was marked on the ground to create a ritual space for oath taking. "The person taking the oath stands upon the cross, situating himself between life and death, and invokes the judgement of God and the dead upon himself."[36] In other circumstances, the *dikenga* declared abilities to lead: "To stand upon this sign meant that a person was fully capable of governing people, that he knew the nature of the world, that he had mastered the meaning of life and death."[37]

*Kalunga:* ocean, door, and wall between two worlds.

The *nkondi's* eyes shine, reflecting light from mirrors placed above them. Mirrors, in their shimmering qualities, are reminders of *kalunga,* the shining water that forms a thin barrier between the living and dead. That barrier is crossed by souls and the sun each day. To move into the world below is to enter a time of regeneration, when one's soul can purge itself of the impurities acquired in life and emerge ready to be born into the next existence, washed clean. Looking at the water, or into the *nkondi's* eyes, we glimpse a miraculous world waiting to welcome the tired soul (detail, pl. 75).

Out of humiliation can stem grandeur.     —Fu Kiau Bunseki[38]

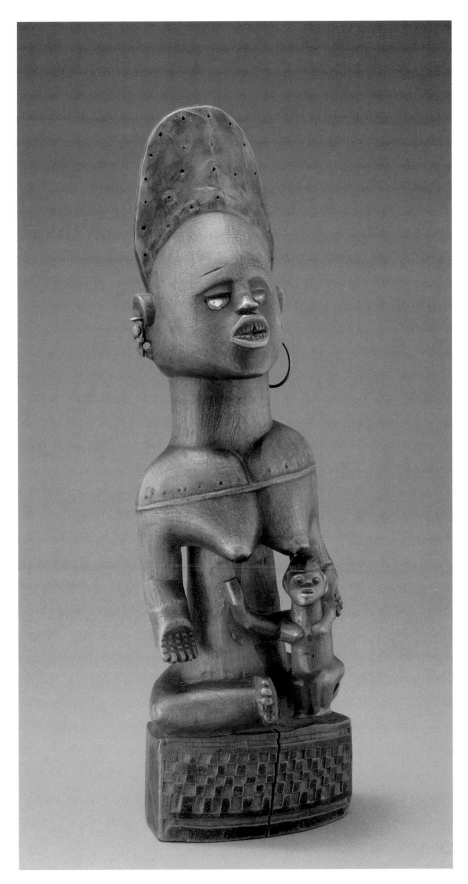

Pl. 80
**Mother and child**
Yombe, Kongo, Democratic Republic of the Congo
Late 19th–early 20th century
Wood, glass, metal
H. 9.9 cm (3⅞ in.)
Gift of Katherine White and the Boeing Company,
81.17.838

Most Kongo sculpture was collected at the turn of the twentieth century, when the prospects for understanding by outsiders were bleak. One European observer sets the tone of the time: "Kongos have no religion or system of worship; vague superstition takes the place of the former; and the arrangement of charms of the latter. There is no idolatry or attempt to communicate with a Divine Being."[39] The European writers were partly blinded by the need, in the colonial mind, to step in and establish religion where there was none. Another reason is described by Wyatt MacGaffey, scholar of the Kongo, who points out that writers then thought of culture as a collection of traits, not as a system of thought. They were not encouraged or inclined toward abstract thinking themselves, so they deemed the native populations incapable of it.[40] The

blinders were so firmly fixed that the Kongo explanations of their own ways of composing the world went unseen. Meanwhile, for centuries, the Kongo maintained a system of *minkisi,* a religion of medicines, common principles of moral conduct, and an orientation to the relations between the land of the dead and the houses of the living.

The large thunder of people's icons.

–Robert Farris Thompson, 1992[41]

Kongo-derived sights and sounds have been an inspiration for African American creativity for centuries. Listen to the samba in Brazil, watch the rumba in Cuba, or tune into the jazz of North America and you are immersed in art forms with Kikongo names and elements. Travel around Cuba, where "underground Kongo practices wired the island," and go to Havana, known as Kuna Mbanza, "to town over there." As cosmograms are drawn in chalk on the earth, priests restate the Kongo *dikenga,* a site where "spirits seat themselves on the center of the sign as the source of firmness."[42] In Haiti, watch for *paquets congo,* bundles containing references to visual codes, puns, and spirits from the Kongo. Attend a ceremony in Rio de Janeiro and you may see Kongo influences mix with Roman Catholic notions of the Latin cross. Examine an Umbanda altar in Uruguay or Brazil for Kongo traces in the mixture of images. Peer inside a large three-legged iron cooking pot in Cuba, Miami, or New York—the assembled ingredients can constitute an *nkisi* much as they would in Kinshasa (fig. 46).

Fig. 46. *Futu nkisi mbuki* (bundle of medicine for a healer), Kinshasa, Democratic Republic of the Congo, 1972.

Like a tornado hidden in an egg.

–Fu Kiau Bunseki, 1978

A walk through African American communities reveals one of the most enduring points of connection to a Kongo aesthetic. Yards and graves display an organic link in a host of choices people make. Considered an opening remark to the person passing by, a yard can itself be transformed into an *nkisi* governed by a concern for protection and completion of the soul's journey. The circles, crosses, diamonds, and spirals of

the cosmogram are reconfigured in pinwheels, tires, things that roll on and on. Bottles hanging from trees flash in the sun, luring provocateurs inside to be captured. Tinfoil, mirrors, and lightbulbs reflect light, hinting at the charge of the spirits who wait beneath the shiny surface of the water's edge. Commonplace objects grow empowered by associations. A snail shell placed in the yard or on the grave is a punning reminder that immortality is in evidence—the Kikongo word for snail shell, *zinga,* also means "to live long." Outward simplicity but inner complexity became a hallmark of African American spiritual expression by necessity, but also finds inspiration in Kongo precedents. Bunseki recounts that the first *nkisi* given to Man was Funza, incarnated in unusual twisted root formations. "When you see a twisted root within a charm you know, like a tornado hidden in an egg, that this nkisi is very, very strong—you cannot touch it, only nganga can touch it."[43] African American healers were known as "root persons," respected for their recipes of earth, feathers, forest woods, and many other things, but most significant was a root known as High John the Conqueror.

Fig. 47. David Hammons, *Money Tree,* 1992, gelatin silver print, H. 41.9 cm (16½ in.). Gift of Greg Kucera and Larry Yocom, Seattle Art Museum, 97.77.

> Let me be the bad guy.     —David Hammons, 1986

Kongo impulses have been taken into the streets of New York by the artist David Hammons, whose work conjures many obsessions of the art world. After moving to New York, Hammons found that "everybody was just groveling and Tomming; anything to be in the room with somebody with some money. There were no bad guys here, so I said, Let me be the bad guy, or attempt to be a bad guy, or play with the bad areas and see what happens."[44] He often worked outside galleries, turning his attention to vacant lots in Harlem. Empty Night Train and Thunderbird bottles started appearing on the tips of branches, and metal rings were seen adorning trees like necklaces. Finding tornadoes of meaning in the dirt and discards of life, he created installations using human hair collected from local barber-shop floors, chicken wings found on the street, and bottle caps salvaged from barrooms (fig. 47). On a landfill in lower Manhattan, he constructed *Delta Spirit* out of discarded sheets of metal and surrounded it with an enlarged yard show of doll shoes, bottle caps, feathers, cowbells, wind chimes, and old wheels. The installation was situated by the Hudson River, near the edge of the water's shiny surface, and was a gathering place until it mysteriously disappeared in a fire. In a move made famous by another artist, he collected enormous elephant droppings from the circus and offered the resulting elephant dung sculptures for sale on the streets. Then he sold snowballs. Like the Kongo king who used dirt to signify greeting, David Hammons finds significance in elements that seem simply made but carry complex associations.

> Colonel Frank called this one fetish no. 3.     —Renée Stout, 1989[45]

Fig. 48. Renée Stout, *Fetish no. 3*, 1989, mixed media, H. 24.1 cm (9½ in.). Private collection. © 2001 Renée Stout.

Fig. 49. Page from Renée Stout's notebook for *Fetish no. 3*, 1989, ink on paper, H. 28 cm (11 in.). Collection of the artist. © 2001 Renée Stout.

When Renée Stout was ten years old, she saw her first *nkondi* at the Carnegie Museum of Art in Pittsburgh. Kongo imagery and medicines led the artist to create a sequence of sculptures and installations that immerse the viewer in *minkisi* placed in an American context. Her studies guide her work, but she gains admiration for reclaiming African aesthetics and doubling their power through invented realities and personal experiences. In *Fetish no. 3*, Stout takes the image of a doll/child, inspired by her work with three-year-old children (fig. 48). "In working with them for the past four years I've seen a lot of innocence, which, to me, seems to ward off evil."[46] Her dolls imply a role reversal, as they deviate far from the convention of miniature people to play with, and instead project strong personalities with layers of Kongoized identity. In a posture much like that of the woman and child seen in pl. 80, the figure in *Fetish no. 3* sits with her legs in a circle. Stout attaches bundles of her own hair to the head and covers the features with kaolin chalk. She is also known to place inside her works grave dirt, powdered High John the Conqueror root, and other ingredients to ensure that the figure is imbued with the presence of her ancestors and her own being. In another role reversal, Stout plays on the old version of the fetish as a memento brought back from trips to exotic lands by the invented Colonel Frank. In a report about his observations, the fetish is described according to old ethnographic style,

# A Sculpture Hungry for Aggression:
## *Ivwri* Figure

The *ivwri* figure commands a step back, with its rotted mouth, gaping fangs, and human torso blending into a four-legged creature (pl. 81). The surface is pitted and covered with splotches of red and white. Forcefully, it defies a convention evident in most sculptures from West and Central Africa. Humans and animals, while depicted separately in sculpture, do not often mix. To join bodies with a beast is to make a sculptural statement with unnerving potential.

That potential is expressed in Ben Okri's novel *The Famished Road.* In a vivid description of this kind of union, a hybrid character attacks all senses:

> I saw before me in that new spirit world a creature ugly and magnificent like a prehistoric dragon, with the body of an elephant and the face of a warthog. It towered before me. It was more graceful and less heavy than an elephant, but its tread more resounding. Its face was incredibly ugly. A devourer of humans, of lost souls, of spirits, of all things wonderful, this creature opened its dreadful mouth and roared. Beneath me the tree began to change. Suddenly it seemed the tree was no longer a thing of wood. It became a thing of quivering flesh. The wood rippled slowly into flesh, transforming beneath me. The monstrous creature drew closer and its foul breath knocked my consciousness around. . . . And then the transformation of the wood into flesh became complete and I was suddenly blasted by the earth shaking bellow of a wild animal beneath me. I was overpowered with the odour of its animal virility. Tossing and shivering, shaking its head, and bellowing again as if the sound in some way made its transformation more permanent, I realized that I had made a terrible mistake, and that I was riding on the back of a wild animal, awoken from a fetishistic sleep.[1]

The rare union of human and animal in the *ivwri* sculpture is especially perplexing because there is no clear dominance. Is a man riding a wild animal that has overcome his body, or is a monstrous creature in the process of devouring humans? Pl. 81

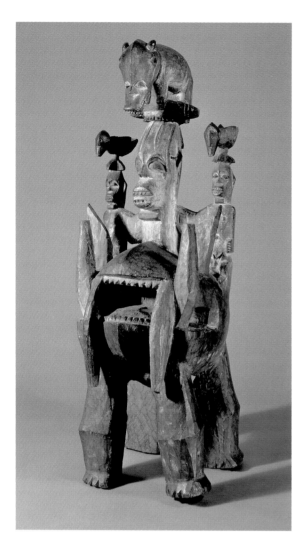

Fig. 50. *Ivwri* figure, Urhobo, Nigeria, 19th century(?), wood and pigment, H. 70 cm (27½ in.). The Trustees of the British Museum, London, 1954.AF.23.428.

Looking for answers about the creation of this hybrid, we step back more than one hundred years to the Delta province of Nigeria.

*The people virtually lived their government.*

—Obaro Ikime, 1969[2]

When this sculpture was created in the late nineteenth century, the Urhobo were proving an impediment to British plans for the region. The Urhobo stood in contrast to their neighbors, the Ijo and Itsekiri, who maintained highways of trade along what became known as the "oil rivers" of the Delta region. Relying upon an Itsekiri ruler to keep commercial interests flowing, one British major commended the Itsekiri as "the most intelligent and intractible" and "best mannered of all" in the Niger Delta. Meanwhile, he denounced the Urhobo as "shy and timid, treacherous and rude."[3] Urhobo government baffled the British officers, who couldn't find the "head" of a clan or village, let alone of all the Urhobo people. In acts of passive resistance, the Urhobo spent twenty years fending off British ideas of government, preferring to rely on a council of elders who dealt with matters of importance in open discussions. Fiery and eloquent speakers were admired, but authority was diffuse, and no clan attempted to unify control over all. Behind the scenes in most of these discussions, a sculpture like this was invoked for assistance. The confidence it fueled in Urhobo men frustrated the British and remained an enigma for most of a century. Then in the 1970s, an *ivwri* sculpture came up for sale and put cross-cultural perception to a test.

*How can anything so hideous be art?*

—Katherine White, 1975[4]

Usually quick to make decisions, Katherine White hesitated for months over the purchase of a large carving she described as "ugly, crusted like a poisoned skin." She received a call in February 1975 from a gallery owner who said he had a Nigerian figure like one in the British Museum (fig. 50). Her first reaction was negative: "There it was, under a blanket, no less. Unveiled, it was indeed a large, impressive piece. Over 36 inches, while the BM [British Museum] one is 27½. A big, vast, hard piece, but somehow lacking warmth, without ambience. It wasn't for me."

Several months passed before White reconsidered. By June, she was wavering over a trade to obtain it and worried "on and off, in all my half-awake hours, and driving in cars, and in peaceful gaps in conversations. What to do." Later in the day, she exchanged five pieces for three, plus a sum. "We spent about three hours running back and forth, using one IBEJI [her California car plate] for transport." But she admitted, "that shrine keeps worrying me. I toned it down by washing off some of those glaring white spots. It looks better. I will photograph it tomorrow and send pictures around. The two I could find in books did not have sacrificial patina at all. And this one is so thick."[5]

*Does it mean ferocious speed or swift ferocity?*

—Leon Underwood, 1947

Until the 1970s, illustrations of Urhobo art were rare, and what was known of its meaning was minimal. Two similar figures appeared in publications with captions that stretch for answers. Leon Underwood described a sculpture in the British Museum with a "fanged maw" and leopard legs painted with spots. His caption asks "Does it mean ferocious speed or swift ferocity?" He sees the central figure as a divinity or spirit, attended by baboonlike figures with human-faced birds on their heads, and concludes, "The subject of the piece seems, with its tribal totem above to be based on fleet ferocity."[6] Relying on visual analysis alone, he deems it a spirit able to sprint and eat at the same time.

*Rather an impersonal machine.*　　—William Fagg, 1964

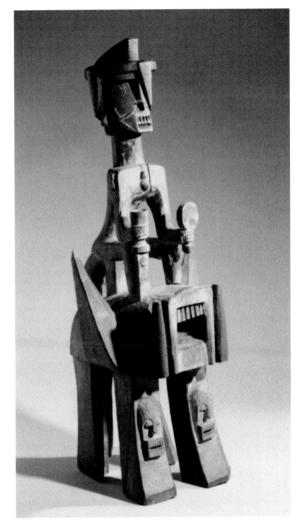

A second comparison is William Fagg's description of a carving from the neighboring Ijo in the Metropolitan Museum of Art (fig. 51). He states that it "is not for the cult of a god, spirit or ancestor, but is rather an impersonal machine for the control of the life force, and for its direction towards particular ends such as success in war or the recovery of lost goods. Its essential part is the massive quadruped which is variously said to be an elephant or a leopard and may combine the features of both. Surmounting the monster is a human figure representing the owner."[7] What is hinted at here goes beyond a visual hunch, and is backed up by consultation with a colleague who did brief fieldwork in two areas of Urhoboland.[8]

In August, White's photographs of her sculpture reached Perkins Foss, who had lived for two years in Urhoboland working with the Nigerian Department of Antiquities. At the time, he was writing his observations as a graduate student at Yale University. He immediately called White, who noted on her object card: "'That's an important piece,' he said over the phone, sounding beside himself with enthusiasm. He gave me a lot of information about it. Including the component of the patina (yam, chicken and dog blood, gin, and kola) and the symbolism of the red and white dots. Also, he analyzed the parts of the sculpture. And he gave me the town of origin. He will send me a photo of a similar piece in a shrine context and I will send him two 8-by-10s for his dissertation."[9] Foss's dissertation of the next year, entitled "The Arts of the Urhobo Peoples of Southern Nigeria," featured an illustration of the sculpture in White's collection and provided an Urhobo vision of how something so hideous can be honored by a culture.

Fig. 51. Efri figure, Ijo, 19th century, Nigeria, wood and pigment. H. 64.8 cm (25½ in.). Metropolitan Museum of Art, New York, the Michael C. Rockefeller Memorial Collection, Purchase, Matthew T. Mellon Foundation Gift, 1960 (1978.412.404).

*A magnificent metaphor for aggression.*　　—Perkins Foss, 1976

Foss commended the Urhobo's southern clans for evolving a "complex image that is a magnificent metaphor for aggression." His work transforms a crusty carving

of a hybrid beast into a complex sculpture able to "establish otherwise unobtainable levels of compassion and peaceful coexistence in Urhobo society."[10] Hideous in form but therapeutic in effect. Created to inspire wrath and to control anger. Associations unfold and require us to consider an *ivwri* from an Urhobo point of view.

> Warning: being worried by hunger brings vexation
> Hunger makes you say what you do not understand.
>
> —Urhobo praise poem[11]

Hunger is emphasized visually by a gaping mouth framed by large incisors (pl. 81). This mouth has overtaken the bottom half of the human figure, whose torso rises above. "Ivwri," the name the Urhobo have given this type of sculpture, is experienced as a quality of male character. Just as this figure has an overactive alliance with a beast in his belly, so all men must learn to deal with the force of aggression in their lives. While aggressive tendencies need to be nurtured for a man to succeed in life, they must also be carefully monitored and controlled to be effective. Feeding this image underlines the need for male personalities to check their hunger for confrontation.

> My Ivwri, here is chalk, oh!
> Chalk for children,
> Chalk for long life,
> Chalk for young-body.      —Urhobo praise poem[12]

The *ivwri* can be fed every four days, following a weekly cycle in which every fourth day is a day of rest. Two foods are favored: a locally produced gin and white chalk, still seen in spots on the sculpture's surface. Supplies of kaolin chalk are dug from riverbeds where water and land meet. Derived from this point of transition, chalk is considered a sign of otherworldliness and religious purity. And chalk has a calming effect on the eyes of the central figure, guiding the lids toward composure. Camwood, a reddish powder derived from a vegetable dye, serves as a sign of rebirth and the role women take in maintaining life. Bites of food from the owner's meal may also be fed to the *ivwri*—the residue might account for the crust that covers the top and inside of this figure's belly. Food is offered so that the *ivwri* will curtail an outbreak of aggression. An *ivwri* can also stir up the owner, inspiring his warrior instincts to defend his family and community.

> Here is your cutlass, Ivwri.      —Urhobo praise poem[13]

Four human heads are pinned beneath the feet of the crowning central creature. This *ivwri* is designed to take heads as well as protect them. Theft is a core concern for the Urhobo. An *ivwri* can bolster the boldness of a highway robber, but it can also curb losses to thieves. In its ultimate protective stance, an *ivwri* would be charged with warding off attempts to take people as slaves. Until 1930, Urhobo towns were raided by neighbors, who abducted individuals and families; at times, entire populations were uprooted. An *ivwri* formed a locus for a powerful emotional need—protection against the loss of family members and a whole community.

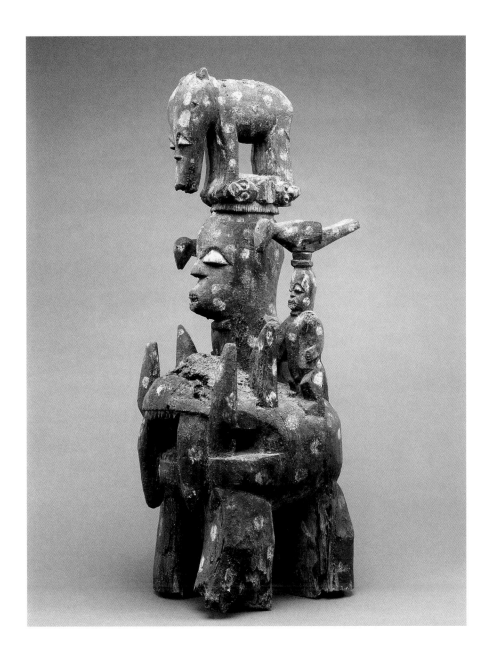

*Atarhe:* speaking out.

At the moment of birth, an Urhobo male child will announce to the world whether he has a calm or troubled character. Further signs of that character accumulate as the child grows. If he cries constantly, is unable to share, or tends to resent even the smallest misunderstanding, then a frustrated parent might take the child for diagnosis. A diviner could confirm that the child is plagued by a troubling *ivwri*, in which case a small image is placed around his neck.

From that point on, the young man keeps an *ivwri* image as a personal shrine on the family altar and serves it regularly. When he moves into young adulthood, the image goes with him to guide his behavior. Some men live with their *ivwri* as a constant companion, envisioned as a presence that stands quietly and supportively by their side. One elder indicates what can happen if the need for an *ivwri* is not detected early:

Pl. 81
*Ivwri* figure
Urhobo, Nigeria
Late 19th century
Wood, pigment, nails, chalk, deposits
H. 91.5 cm (36 in.)
Gift of Katherine White and the Boeing Company,
81.17.532

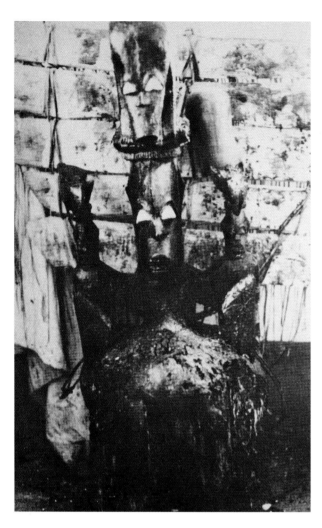

Fig. 52. *Ivwri* figure in meeting hall, Ughievwen lineage, Urhobo, 1969.

Suppose I borrow your pen. Tomorrow you return and ask for the pen. Unfortunately, I have to tell you that I have lost it. But I promise to buy you another one. I do so; you return the next day and I give it to you. But you complain that this isn't your pen. I show you that it is exactly the same. You still complain that it isn't *your* pen. So I go out and buy a much more fancy, expensive pen, and bring it to you at your house. You still complain that this isn't *your pen,* and you ridicule me to your friends for having lost your pen. Next day I get five pens, all better than the one you originally loaned me. Still you complain that none of these is your pen, and that I am responsible for having lost it. Whenever you see me for months to come, you complain that I was the one who lost your pen. You are having serious trouble from your ivwri, and these problems will continue until you have an image carved for your use.[14]

Larger-scale *ivwri,* like the one in the Seattle Art Museum, result from a consultation between a diviner and a patron. The two work with an artist to create an image of the proper size and scale to suit the individual. A new owner receives the finished *ivwri* from the diviner after engaging in a tug of war to take ownership. Next, he must face challenges from all other *ivwri* owners in town. They taunt him with a gauntlet of weapons and words in praise of war and aggression and wait to see whether he has sufficient force to command his new *ivwri.* If he loses the *ivwri,* he is deemed unready to own it.

*Ivwri* that tip the scales indicate a prominent owner. This *ivwri* is one of four likely to come from the same clan by the same artist. A near duplicate *ivwri* was photographed in 1949, then again in 1969 in a meeting hall built by thirty-two villages (fig. 52). Spoken of as an elder *ivwri,* it probably once belonged to a warrior in the second half of the nineteenth century. After his death, the family would have fed the *ivwri* to commemorate the owner and ensure his protection. As the figure was handed down by his descendants, the *ivwri* could evolve into a senior sculpture by being transferred to a collective meeting hall.

The Urhobo hall as a setting for the *ivwri* was quite unlike the museum's stark gallery. There it was given a "wing" made of wood and raffia, a reminder that the figure was not inert or stationary, but able to travel to survey trouble and potential enemies. From its space at the back of the hall, the *ivwri* also visualized aggression's role in social settings. During debates, an *ivwri* personality is volatile. A commanding speaker may be inspired by an active relationship with his *ivwri.* He may build a reputation as one who is adept at arguing—an admirable trait. But if he becomes too stubborn or contentious, if his words are too sharp, composure is lost and he can throw a meeting into chaos. Then it is said that the disruptive person is "having

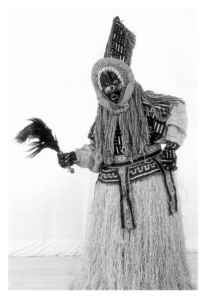

# Forest Spirits Far from Home:
# Dan Masks

A masquerade is scheduled for the night of the Seattle Art Museum's African gala. Many galleries are transformed into simulated African spaces—one is a street market, another is a nightclub featuring a dance band from the Democratic Republic of the Congo. A huge altar, concealing a live guardian, has been erected by an Igbo artist from Nigeria. On the museum's indoor staircase, an African American fashion show is the attraction of the moment. Slender models in sculptural clothing take mincing steps down marble stairs. A clockwork schedule of events is being monitored behind the scenes. In the midst of the fashion finale, Won Ldy Paye and members of his group, Village Drum and Masquerade, arrive and are directed to their private dressing room. The schedule dictates that they constitute a masquerade in exactly fifteen minutes.

Forty-five minutes later, sharp drumming from deep inside the museum signals their readiness. The rapid-fire rhythm of a *sankpah* drum moves through the stairwells. Doors suddenly swing open and two masqueraders with attendants sweep into what is normally a café, now an arena for performance (fig. 54).

> We can't create chaos.    —Won Ldy Paye, 1998[1]

This is masquerading far from a Liberian home. Instead of preparing in a forest enclosure, the performers have emerged from a theatrical dressing room with strong lights. Instead of interacting with audiences who regularly host masquerades, they perform for a crowd more likely to hold seats at the ballet, symphony, or opera. Within the museum, a kind of secret society of patrons and staff met in advance for months to eliminate just the kind of chaos that masquerades can embody. Paye has talked with me about the need to adapt his performances to suit an American audience. "Once we had Yavi grab purses in the audience, and fire swallowing and tongue cutting, but we quit doing that because we got strong reactions and realized we can't create chaos in the audience."[2]

For myself, it is the chaos that I crave. Attending masquerades as a child in Liberia supplied me with extraordinary experiences that stand out as pivotal memories:

Pl. 84

Fig. 54. Village Drum and Masquerade with Won Ldy Paye in foreground, Seattle Art Museum, 1989.

Fig. 55. Yavi masquerade at a Vai celebration, Liberia, 1969.

Being left in complete darkness for hours to await a dawn performance. Standing erect listening to waves of people running by so close that I could smell their breath but was never touched. Watching children my own age emerge from the darkness, keeping their backs exposed and their heads solemnly bowed to be accounted for after time away in forest schools. Hearing mothers discover children they hadn't seen in months or years. Watching these same children not break their stern concentration until massive feasts were served. In Liberia, masqueraders had a way of appearing out of nowhere, sometimes accosting people who got in their way, other times remaining aloof until attendants cleared their path. Quite often they accomplished feats that

shouldn't have been humanly possible. They were capable of gravity-defying moves, disappearing acts, and tornadoes of frenetic footwork. A masquerade immersed you in events and surrounded you with characters that could never be fully explained (fig. 55).

Won Ldy Paye's gallery performance holds back on illusions, and the museum places masks in a quiet containment field. Without a voice, music, volatility, movement, a mask only hints at what it once inspired. Yet, even as a minimized wooden face, the African mask has had an enormous effect on the history of art in the twentieth century. Some would say the mask helped launch an artistic revolution. Others see the mask performing a remarkable political feat—opening a door onto a field of protest and ensuing struggles between Africans and Europeans.

> The cannibal gods be praised who give us the courage for salutary massacres.  —André Salmon, 1912[3]

Two Africanesque faces rendered in one painting have been called an anarchist bomb or Molotov cocktail meant to blast apart artistic conventions of the previous century. In his painting *Les Demoiselles d'Avignon,* Pablo Picasso painted faces with features that turned the notion of beauty inside out (fig. 56). He placed them on nudes looking at three other nudes. If read literally, the composition could be seen as an encounter between two masqueraders and three women trapped in a bordello. Yet this painting has never been taken as a literal depiction. Many see this thoroughly studied work as a breakthrough in Picasso's search for a new formal vocabulary, one that severs the ties between form and content. Others account for the painting's radical force by pointing out how it disrupts the notion of a passive idealized female. The debate still rages over what Picasso was saying by adopting features of African masks.

Fig. 56. Pablo Picasso, *Les Desmoiselles d'Avignon* (and detail), 1907, oil on canvas. Museum of Modern Art, New York. Acquired through the Lillie P. Bliss Bequest. © 2002 Estate of Pablo Picasso/Artists Rights Society (ARS) New York.

LE BOUILLON DE TÊTE

ous aimeriez peut-être mieux du veau ?... Mais c'est bien assez bon pour des cochons comme vous !

Fig. 57. Maurice Radiguez, "Le Bouillon de tête," *L'Assiette au beurre* (1905).

It was the ugliness of the faces that froze with
horror the half-converted.      –André Salmon, 1912[4]

In 1920, Picasso denied his faces were inspired by African
art, but in 1937, he described a visit to the Musée d'Ethnographie
at the Palais du Trocadero to André Malraux, who published the
discussion after Picasso's death. Picasso's narration is one of the
first accounts of a European reaction to African art in a museum:

> When I went into the old Trocadero, it was disgusting.
> The Flea Market. The smell. I was all alone. I wanted to
> get away. But I didn't leave. I stayed. I stayed. I under-
> stood that it was very important: something was hap-
> pening to me, right?
>
>  The masks weren't just like any other pieces of
> sculpture. Not at all. They were magic things. But why
> weren't the Egyptian pieces or the Chaldean? We hadn't
> realized it. Those were primitives, not magic things. The
> Negro pieces were *intercesseurs,* mediators; ever since
> then I've known the word in French. They were against
> everything—against unknown, threatening spirits. I
> always looked at fetishes. I understood; I too am against
> everything. I too believe that everything is unknown, that
> everything is an enemy! Everything! . . . Spirits, the un-
> conscious (people still weren't talking about that very
> much), emotion—they're all the same thing. I understood why I was a
> painter. All alone in that awful museum, with masks, dolls made by the red-
> skins, dusty manikins. *Les Demoiselles d'Avignon* must have come to me that
> very day, but not at all because of the form; because it was my first exorcism-
> painting—yes absolutely![5]

Precisely what Picasso was exorcising has led to much speculation. Many artists
and art historians find it radical enough that he exploded the human figure and face
into fractured surfaces. Patricia Leighton asserts that the radicalism doesn't stop with
his visual audacity. Picasso might also have intended to catalyze the outrage over
French policies toward Africa in the first decade of the twentieth century.[6] In 1904
and 1906, scandals regarding colonial policies and atrocities were breaking in the
news, inciting Picasso's friends in Montmartre. Journals and anarchist newspapers
like *L'Assiette au beurre* and *Les Temps nouveaux* featured cartoons by artists protesting
the pillage and massacres perpetrated on African populations in the French and Bel-
gian Congo (fig. 57). A French audience at the time might have seen Picasso's mask-
like faces as an attack not only against formal constraints in art, but also against
European efforts to control African colonies with abusive force. This double-edged
exorcism could explain why reactions to the painting at the time were so volatile, why
Georges Braque would say, "It's as if you were drinking gasoline and spitting fire."[7]

For many years, one of the two faces was ascribed to the influence of a Dan mask
(see fig. 56, detail). Yet Picasso didn't see such a mask during his first Trocadero visit.
None was available for viewing at the Musée de l'Homme until 1931, and no examples
were noted in his friends' collections. From 1907 until his death, Picasso owned Afri-
can art but did not try to distinguish regions or cultures among his holdings (fig. 58).
He and Parisian dealers accumulated Bamana, Fang, Pende, Guro and other masks
without concern for distinctions or original meanings. Many cultures were consid-
ered as one ubiquitous African culture. Masks continued to be admired for their
form, but their function was disregarded.

In the United States, Paul Guillaume and Edward Stieglitz were among the first
to show African masks, as part of a 1914 exhibition at the 291 Gallery entitled *Statu-
ary in Wood by African Savages: The Root of Modern Art.* The exhibition continued the
premise of admiring African formal qualities. At this time, African masks were con-
sidered faces to be incorporated into a modernist aesthetic, and were scarcely appre-
ciated on their own terms. Museum catalogues for years relied on generalities and
invented motivations.

A 1935 publication from the Museum of Modern Art declared:

Some [masks] that are to be handed down within the tribe from fetish-man
to fetish-man are meticulously carved; others to be worn at one circumcision
ceremony, then to be thrown away, may be contrived crudely out of soft wood
and painted with gaudy colors in some traditional pattern.[8]

And in 1950, another New York museum added:

Contrary to the civilized man's point of view, which rejects pain as a good, the
African Negro incorporates atrocious tests of endurance into his life, which
in most respects is an ordeal, a sustained, prodigiously complex ritual ended
only by death. His conception of the world is so swarming with spirits to be

propitiated, and customs to be served, that he has no time to consider what he himself is like: hence his masks, which are more common and various than those of any culture, are the least lifelike.[9]

In 1950 came a turning point in the recognition of what an African mask did in an African setting. After spending twenty years in Liberia, a missionary, Dr. George Harley, issued a monograph entitled *Masks as Agents of Social Control.* He gathered the information while collecting more than one thousand masks and witnessing events related to a secret association he identified as Poro. His missionary station happened to be in an area where people relied on masquerading to resolve the complexities of community life. Harley said his work was fueled by a conviction to record the masking tradition then being suppressed by the Liberian government, so much so "that people had given up hope that it would ever function again." The Poro society was "no longer the great educational institution it once was."[10]

The families who controlled the national government viewed masking as a threat to their authority. Liberia was governed from the capital of Monrovia by descendants of freed American slaves who had arrived in 1822. A cultural gulf divided these settlers from indigenous Liberians, as is evidenced in the Liberian Declaration of Independence, which voiced the freed slaves' "desire for a retreat where, free from the agitation and molestation, we could in composure and security approach in worship, the God of our fathers."[11] This god was Christian, worshiped in churches that sprang up along the coast. As for the indigenous beliefs and structures, one Lutheran missionary clearly stated they were not part of their vision: "We not only have to preach the gospel, but break up the whole social fabric and literally create a new civilization."[12] Their model for a strong men's association was the American Masons, emulated in the twentieth-century construction of an enormous Masonic Temple in Monrovia (fig. 59). Societies like the Poro were not openly endorsed. Harley's conviction that Poro ruled as a secret form of government among the Dan has been disputed by later

covering practical skills, problem solving, and moral principles. She sees Sande as raising girls with strong, positive images of their role as leaders. Sande teachings are said to "stress that the girls observe everything: farming, spinning, child-care, diagnosing illnesses, compounding and administering medicines, singing and dancing." In her appraisal, Sande officials use "executive strategies" when serving as community leaders and encourage storytelling in the Sande bush, where a moral or dilemma can be "debated long into the night, encouraging a more mature exploration of the human condition."[9] Sylvia Boone offers the definition of Sande as a "university of the forest" with an advanced curriculum of graded instruction in myth, history, ethics, and herbalism.[10] Focusing attention on the masks of Sande as "good made visible," she devotes her text to a poetic exploration of how the masks present ideals of feminine physical perfection and sexuality. Ruth Phillips combines a wide repertoire of approaches to set many new observations in place. She looks at the interactions between other society masquerades and Sande, the full range of other Sande masks, the names of the masks, the kinds of personalities they project, and how they are received by a Mende audience. Despite her warning against the "persistent academic delusion that definitive monographs are possible," she comes very close to writing one.[11]

This era of study enriches our examination of a Sowei mask. Each feature has the potential to send a different message to different audiences. A Sande official may see and speak of a mask in one way, and a male observer in another. This review combines comments from the authors mentioned to create a composite portrait of Mende mask aesthetics.

**A [Sowei mask] must be shiny black.**

"Black" and "wet" are both designated by the Mende word *teli.* Masks are called "the beautiful black thing" when they acquire a desirable dark hue, obtained by rubbing the surface with palm oil or shoe polish until it is sleek and shiny (pl. 85). Blackness and wetness refer to the ultimate origin of Sande knowledge—the nature spirits who dwell in rivers in the bush, embodying the medicines to be found there. The highest ideals are said to arise from the depths of their underwater home, where miraculous delicate beings are the norm. When Sande girls emerge from initiation in their perfected physical state, their skin is oiled to emulate the appearance of underwater spirits. In addition, Sowei masks are most frequently seen at night, in the darkness (fig. 65). When Sande dancing occurred at night, the black masks would blend into the darkness, until light was cast and a luminous face would emerge.

*Yivi yivi.*

No Sowei mask would display *yivi yivi,* untidy or messy hair, because "it signifies insanity." Those few who "buckle under the strains of everyday life, retreating into madness, signal their illness graphically by no longer grooming their hair, thus

Pl. 85
**Sowei mask**
Mende, Sierra Leone
20th century
Wood, metal, raffia, leather, fiber
W. 55.9 cm (22 in.)
Purchased with funds from the Mary Arrington Small
Estate Acquisition Fund, 89.68

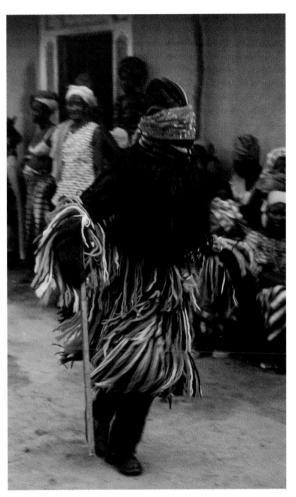

Fig. 65. Vai performer dancing as Zooba (Vai term for Sowei), Christmas celebration, Bulumi, Liberia, 1977.

Pl. 86
**Sowei mask**
Mende, Sierra Leone
19th century
Wood, metal
H. 37.4 cm (14¾ in.)
Gift of Katherine White and the Boeing Company,
81.17.185

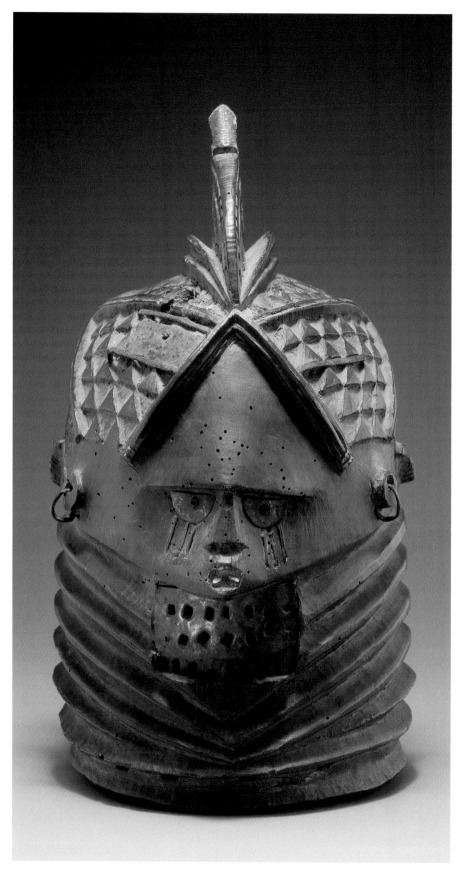

abandoning the community's standard of behavior."[12] A disciplined attention to hair is evident in masks where plaits, central ridges, and bands of decoration are all tightly defined and precisely rendered. Crisp rows of diamond patterning or lines with fine ridges illustrate a coiffure under control. Long abundant hair is seen as a sign of a productive, growing spirit, since all water people have spectacular hair. During initiation, girls reside with these spirits, who teach them new hairstyles that are more complicated than could ever be done by human hands.

**The brow is the parlor by which you enter into a relationship with another person.**

In much of West Africa, when you want to reward  performers, you "spray" coins or bills onto their foreheads. Mende say the forehead is the place where prosperity enters a person's life. Mask foreheads are broad and extended, compressing the facial features near the chin (pl. 86). In full view and free of wrinkles, the forehead announces a young woman poised and ready to meet challenges. By contrast, a woman who is feeling ill, grief-stricken, or sad may lower her head tie over her forehead to signal that she needs to be left alone for a while.

**The slitted eye is a ritual screen.**

The eyes on these masks are usually downcast, often diminished to the extent of being mere slits. The human masquerader's eyes are concealed, as the Mende consider eyes to be the most distinctive feature of a person. The screen also protects Sowo, the exalted spirit who dwells in the mask, and emphasizes that Sowo is endowed with extraordinary vision—the carved eyes and the eyes of the dancer allow her to become a "two-eyed creature with all the attendant mystical powers."[13] As a model for feminine behavior, half-closed eyes offer a reminder that direct eye-to-eye contact is considered disrespectful (fig. 66). Narrowed eyes can be seen as alluring, creating romantic privacy by literally blinding the Sowo in her focus on only one man. In other cases, slitted eyes may imply the demure qualities of a serious woman who is above playing amorous games.

**Talk makes palaver.**

The mouth of a Sowei, never open, is tightly shut and, again, often just a pursed slit (pl. 87). Silence is ideal for Sowo performers, who dance and interact with audiences but never utter a sound. An attendant speaks for Sowo to reinforce her serenity as a spirit who is not about to chat or laugh as a human would. Extending this lesson, elders offer observations about certain kinds of talking. Inconsiderate chattiness and malicious backbiting are common causes for human suffering. One example cited is the case of a child cursed by a mother. Elders speak of their understanding that a mother does this only when frustrated with her husband, but nonetheless the effect

Fig. 66. Hawa Lansana, a new Sande graduate showing ideal composure with downcast eyes, Mattru, Tikonko, Bo, Sierra Leone, 1972–1973.

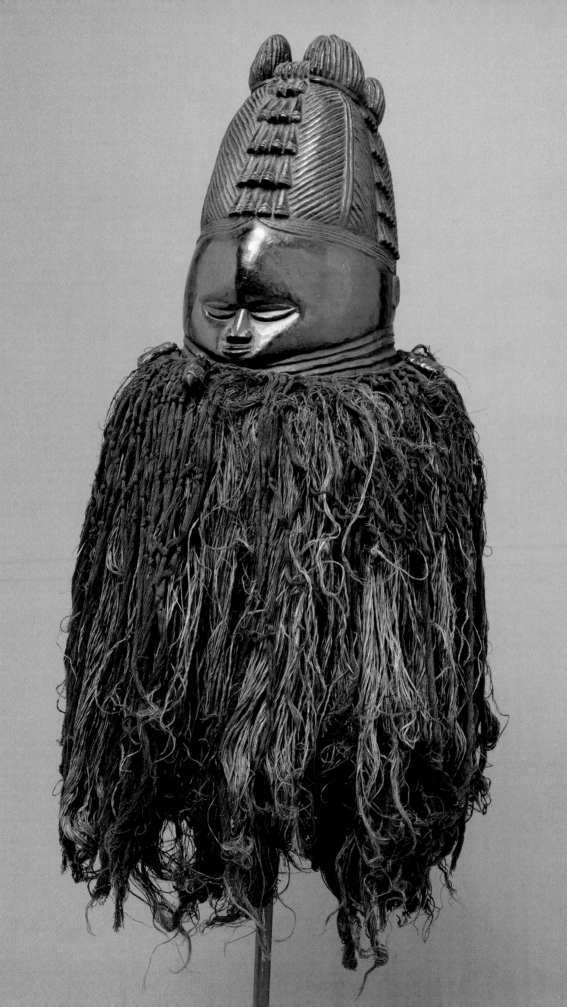

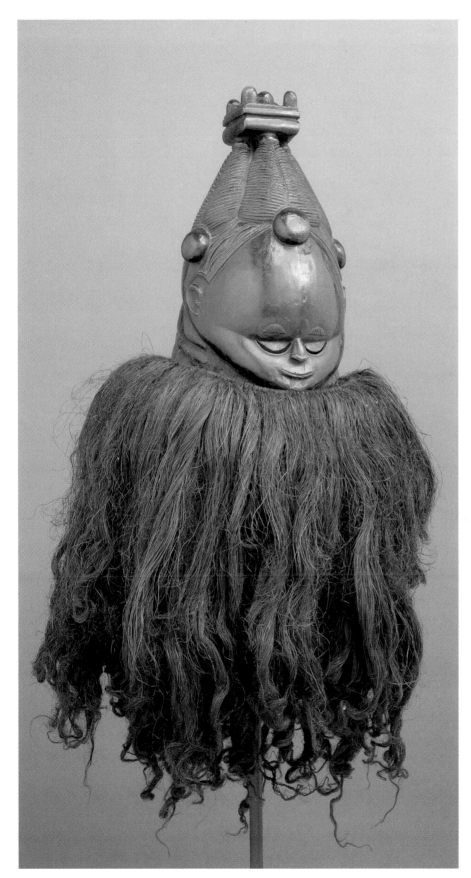

Pl. 87
**Sowei mask**
Mende, Sierra Leone
20th century
Wood, raffia, yarn, leather, tape
H. 86.4 cm (34 in.)
Gift of Mark Groudine and Cynthia Putnam, 98.56

Pl. 88
**Sowei mask**
Mende, Sierra Leone
20th century
Wood, raffia
H. 81.3 cm (32 in.)
Gift of Mark Groudine and Cynthia Putnam, 98.57

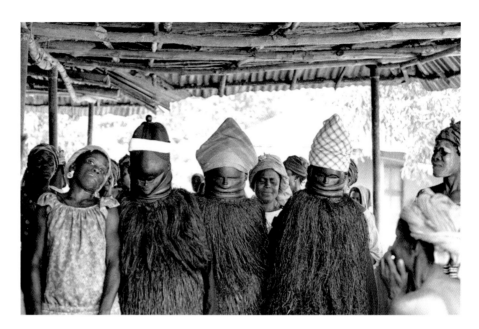

Fig. 67. Gone, Jebe, and Nyimi, the Soweis at Mattru, on their first appearance a week after initiation, Tikonko, Bo, Sierra Leone, 1974.

on the child can be ruinous. When a person becomes known as a drunk, a bully, or a thief, people conclude that he was once cursed by his mother and will suffer from a life without any hope of success. "Talk makes palaver" if not properly channeled, as Sowo demonstrates.

A ringed neck is god's *bonya* (gift).

The neck of a Sowei headpiece has to be as wide as the head since it is worn as a helmet. Necks on the masks are always endowed with rings, a convention that has spawned many readings. Rings of fat, signifying a well-fed and comfortable person, is one notion. But rather than viewing the rings as signs of corpulence, others think they suggest the new roundness and softening of body contours that occurs in adolescent girls. Rings may also be an exaggeration of natural lines referred to as "cut neck," considered a beautiful feature bestowed by God as a blessing. Mythology offers another possible reading based on the origins of Sande as a spirit living in heavenly towns under the water. When Sowo's head breaks the surface of the water, a pattern of concentric waves surrounds her. One analogy gives the rings a broader association: "Cut neck functions like a halo does in western painting, signifying what the eye sees is human in form but divine in essence."[14]

Small horns of a gray duiker antelope rim the hair of one mask (pl. 86, detail), while large bush cow horns swoop over the crown of another (pl. 85). The duiker horns, neatly carved in a row, could refer to an early twentieth-century manner of adding elements to the hair. Since large horns would be worn around the neck, the crowning bush cow horns are an artistic invention. Horns serve mainly as containers, recalling the debt Sowei owes to herbalists who prepare medicines and stuff them into horns for the masker to carry. Such horns are tied onto mask costumes or carried to activate a zone of protection around the masker, who often faces a competitive atmosphere.

Masks also carry protection in the form of amulets, consisting of pieces of paper with Koranic inscriptions encased in cloth or leather. Leather-covered amulets are mixed into the black raffia costume around the neck of one mask (pl. 87). At the top of another, a large rectangular amulet is carved at the top of the hair (pl. 88). Such amulets indicate that the Sowei has sought Allah's words to protect her and to increase her powers of attraction. In other Islamicized Sande societies, the Mori Jande, masking has been eliminated altogether.

Additions to one mask enhance its attraction. Cowry shells are carved into the hair border, while brass bands frame them, and a fragment of a star adorns the forehead (pl. 85). Cowry are a charged currency, "an ancient thing" passed down from ancestors who recognize it as the only form of exchange they will accept. Actual cowry shells are regarded as another connection with a watery domain and can be added to costumes in large numbers.

> The Mende think of *ndoli jowei* in the first instance as a dynamic personality and a talented performer and not as a static sculptural object.    —Ruth Phillips, 1995[15]

Mende endow the mask form with a name, a personality, a costume, and a volatile character. Names like Gbango (loud and troublesome), Hide and Seek (mysterious in coming and going), Quarrelsome (not having a clean heart), Pepper (wild in dancing) are called out by her attendant when Ndoli Jowei (dancing Sowei) first appears. From then on, she asserts a personality that strives for attention, often eccentrically, to remind viewers she is not subject to human rules. Her attitude adjusts to the circumstances that have called for her—somber movements lead a procession to the grave, frenzied activity is appropriate when a Sande school opens, and her dancing signals rejoicing when a new paramount chief is being installed. To maintain complete disguise, she wears capes of black dyed palm fiber around her neck and waist, and shoes conceal her feet. Women accompany her with dancing and singing, which inspire bursts of rapid steps or twirls that send her capes flying. Ndoli Jowei is not usually seen solo—Mende audiences prefer the variety of seeing three, four, or five performers at once—(fig. 67), and she has memorable counterparts who mock her dignity. One is called Gonde (funny Sowei), who wears broken masks and discarded clothes, and shamelessly approaches the audience for money. Another is Samawa, who wears no headpiece but dresses in rags, paints her face with large spots, adds a pouch to suggest a swollen scrotum, and interrupts the proceedings with loud, raucous laughter or satires of men.

> Without her, the town will not be lively.    —Saying of Mende women[16]

The ceremonial highlight of the year is introduced by Ndoli Jowei as she presides over the coming out of new initiates. All eyes focus on the initiates, who emerge in the morning from the bush, covered in white clay and flowers. In the afternoon, they come out again, dressed in modern clothes, and are led by masked officials to the town hall, where their newly refined femininity is put in a spotlight. They retire to

Fig. 68. Hannah Samba, 1973.

Fig. 69. Mariatu Sandi, 1973.

spend several days on their parents' verandas, receiving relatives and friends who award them with gifts and feasts. Afterward, they graduate into the next phase of life, either marrying or going on in school.

> Domeisia are a major source of speculation in a society which thrives on the contest of opposing ideas.    —Donald Cosentino, 1982[17]

Sande society members might not write about their experience, but they do talk. In fact, Mende women are raised with a strong awareness of proficient, entertaining speech. Oral narrative is elevated to a lively performance art known as *kpua domeisia,* or "to pull stories." Throughout their lives, Mende listen to members of their family and neighbors pull stories. Those who excel at this art form become celebrities, entertaining large audiences who come to hear gifted storytellers. Intellectual precision is admired, as their narratives take on ideas circulating in the towns where the speakers perform. To study *domeisia,* Donald Cosentino spent a year listening to men and women of one community pull stories in the evening. There he and his wife "witnessed the arguments and rivalries of the day transformed into the competing domei performances of the night," and he concluded that the "women who argue with narrative are the intellectuals of Mende society."[18]

So we turn to them for a different view of Sande society and the issues that once surrounded the masks now silently housed in the museum. On one evening, after dinner, from about 8:30 to 9:00, three women gathered on their veranda to pull

stories for themselves and a small audience of five people from their compound. They touch on aspects of Sande teachings that have a tremendous impact on their lives: how women are to negotiate their relationships with men; which aspects of their society can be questioned and which cannot; what constitutes beauty, manners, and etiquette; how a woman should handle disappointment and good fortune; and the way to show respect for the sacred—all are present in this evening performance. A major subplot to these stories also becomes clear—how women negotiate with each other. The three women who speak are rivals, "locked in a permanent state of mutual suspicion and harsh feelings" during the day, an animosity that is transformed into competitive performances at night. Donald Cosentino, in *Defiant Maids and Stubborn Farmers*, carefully recorded a sequence of such evenings, transcribing them in full. His thorough transcriptions offer the chance to hear three women spar with stories on a night in Sierra Leone. Their words can be found in the appendix. Who they are and what they offer as veiled comments about Sande are summarized here.

#### Hannah Samba pulls "A Defiant Maid Marries a Stranger."
—September 19, 1973, 8:30 P.M.

Hannah Samba was put in charge of the daily affairs of the compound after her husband died (fig. 68). She is about fifty years old, the mother of one child, and extremely dedicated to her work in rice farming. She introduces the evening with a common theme, the visiting gentleman who tests a woman he meets at a Sande society dance. The woman, Yombo, happens to be "a great fornicator" who is seduced not by a human but by a spirit named Kpana, who keeps telling her, "Our destination is not pleasant," but she insists on following him.

Samba's story features a promiscuous woman who is stubborn and willfully ignorant. She is seduced by Kpana, who takes her into the forest—a journey no woman should undertake without Sande support and guidance, because the forest is not a place where humans can live forever. She disregards Kpana's warnings, resulting in the death of her child and herself. Yombo pays the price for not aligning herself with Sande or other women, and for making decisions alone.

#### Mariatu Sandi pulls "A Defiant Maid Marries a Stranger."
—September 19, 1973, 8:45 P.M.

Mariatu Sandi is about thirty years old, a mother of three, known to abhor farming, preferring to live by her wits and handouts from her family (fig. 69). She takes the performer's seat and pushes her powers of invention and humor to the forefront. Sandi follows the basic structure of Samba's focus on the visiting gentleman but spins off from it, adding a flourish of details that fill it with exaggeration, scandal, and satire. In her version, there are twelve spirits in the forest who came to see two Sande dances. The spirits make love to twelve girls and then dance for ten months before they decide to leave.

Sandi's Yombo overturns the morality of Samba's version. She does everything she can to defy manners, etiquette, and decency. Despite all her bad behavior, Yombo

Fig. 70. Manungo, 1973.

is greeted as a cultural heroine when she returns home, revives her mother, and begins building new houses for everyone. Cosentino concludes, "Mariatu created a topsy turvy world of values, one in which 'bad' triumphed over 'good,' adultery over marriage, women over men, and most especially Mariatu Sandi over Hannah Samba.... The same faults of stubborness and sexual promiscuity account for female ruination in the first narrative and female salvation in the second."[19]

### Manungo pulls "A Defiant Maid Marries a Stranger."
—September 19, 1973, 9:00 P.M.

The third storyteller, Manungo, is about seventy years old, widowed and childless, an herbalist/midwife and official of the Sande society (fig. 70). Her version of the story again relies on the initial staging of a girl named Yombo who meets Kpana at a Sande society dance. Instead of Kpana being a spirit, however, this time he is an ancestor. He admonishes Yombo not to follow him, but she does. Kpana leads her to a land of deformed people, and gives her guidance in how to treat them.

Manungo's heroine is not stubborn and unwilling to learn (like Samba's) nor expecting the impossible—to overturn the order between men and women (like Sandi's). In her version, Yombo learns lessons in humility. After absorbing these lessons of the bush, she is ready to return home and receives the most valuable array of gifts.

Summaries of *kpua domeisia* can only hint at this lively art, which includes sound effects, gestures, facial expressions, and nuances of language and phrasing. Cosentino laments the fact that most translations give "no sense of the devastating irony which inspired them, or the awesome intellectual rigor, daredevil wit and dramatic skills which saw them through performance."[20] His careful transcriptions, however, do indicate the imaginative power unleashed when women speak about the choices they make—what men they choose, how they envision the worst in-laws, which rules for female behavior they accept readily and which they question. These are the kinds of issues facing a young girl at the age of initiation, before she leaves with a new husband to establish their own life. Just as Sande masks articulate lessons for flawless beauty, so these women articulate their ongoing life stories of what realistic beauty is.

### You know who a person really is by the language they cry in.
—Mende proverb

Mende women's language has recently been credited with tying together Africa and African America. When people from Sierra Leone were forced across the Atlantic, many were sent to one region of the United States—Georgia and South Carolina. There people known as the Gullah evolved. While no Mende women were able to take along masks or other artifacts, they did bring their words, stories, songs, and reliance on invisible institutions such as Sande. In establishing an entirely compromised life

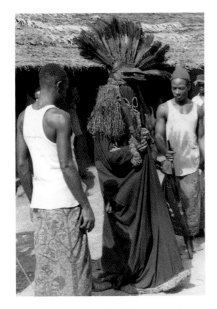

# "God's Medicine" against Witchcraft:
# Costume for Basinjom

In recent years, witches have entered the mainstream of Western culture with surprising force. Harry Potter, a literary young English boy, flourishes at the Hogwarts School of Witchcraft and Wizardry and keeps parents and children reading about his exploits. *The Blair Witch Project,* a film about the stalking of contemporary witches in America, proves that the role of the practicing witch is not fading away. From Shakespeare to Disney, J. R. R. Tolkien to Anne Rice, the witch slips in and out of fictional typecasting, and modern Western incarnations keep a growing belief alive. Witches can be boys on broomsticks, goddess worshipers, and secretive shamans.

    Bloodhounds who have no friends.     –Emma Agu, 1987

Ideas about witches circulate in both African and Western minds, but comparisons spread thin when they reach across continents. In a museum label or book caption, the term can misdirect viewers who already have their own idea of what witches are up to. Reports about witches abound in the African popular press and continue to give meaning to discomforting traits that threaten community life. In a Nigerian *Sunday Statesman* article, they are characterized as "predators, bloodhounds who have no friends.... Greed is their hallmark; an abiding zest for destroying the successful, the healthy, and the 'lucky' in the community."[1] How to confront witches and rehabilitate them is the concern of a masquerade whose costume came into the Seattle Art Museum's collection with unique documentation gathered firsthand.

    One glides backward through the ages to a land full of mystery and
    terror, to the childhood of the world, where the terror of witchcraft
    stalks abroad.     –P. Amaury Talbot, 1912[2]

The first photograph of Basinjom (literally "God's Medicine"), appeared in a 1912 publication entitled *In the Shadow of the Bush* (fig. 72).[3] A tall character concealed in a gown and a headdress crowned with a corona of feathers appears stiffly posed between two men. The trio look straight toward the camera at the author, P. Amaury

Pl. 89 (detail)

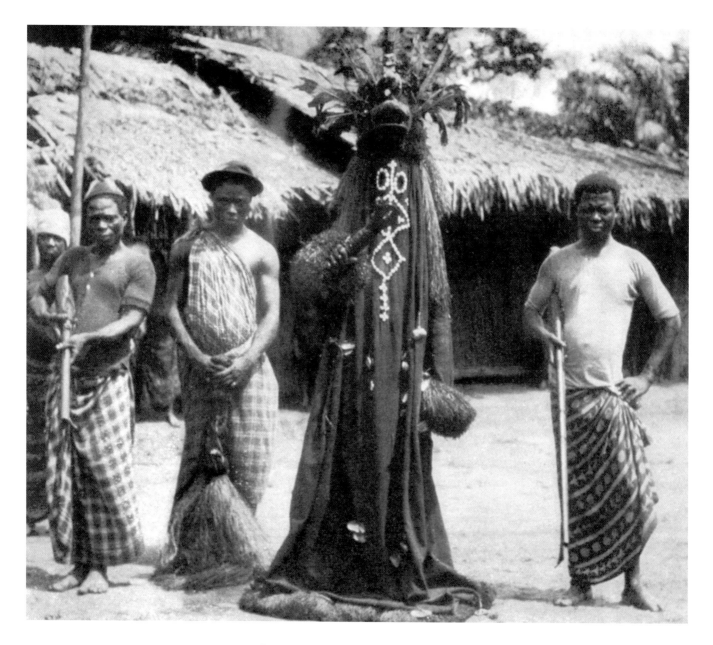

Fig. 72. "Juju Akpambe," from P. Amaury Talbot, *In the Shadow of the Bush* (1912).

Talbot, a British colonial officer of the Nigerian Political Service who was stationed in the Cross River region of western Cameroon. He spent his spare time gathering data and trying to "record the story of a people most of whom were untouched by white influence on my arrival among them in 1907." His words about the masquerader he photographed are spare. He calls it Juju Akpambe and writes that it is "supposed to be the strongest Juju for smelling out witchcraft."[4]

Talbot often laces his observations with statements about what he perceives as the deficiencies of the Ekoi (Ejagham). He states: "Like most primitive peoples, the Ekoi have the haziest ideas as to the causes of their being. . . . In the interior the old vague myths still hold their ground."[5] Vagueness prevails again as he writes, "Juju is so elusive as to defy definition, but as far as may be gathered from the vague conception of

the Ekoi, it includes all the uncomprehended, mysterious forces of Nature."[6] Despite his doubts, Talbot describes what he calls "articles of belief" about how those forces of nature interact with humans. Drawing on cases brought before the native courts of the district, he records the belief that a man can leave his human form and take on that of a wild creature. When a man wants to transform, he drinks a potion that enables his soul to float invisibly through town until it reaches the forest, where it begins to swell. Once safely hidden in the shadows of the trees, the soul is able to take on the body of an elephant, leopard, buffalo, wild boar, and crocodile. As a crocodile, a man might drag a woman to an underwater house and devour part of her.

A philosophy of misfortune.    —Malcolm Ruel, 1965[7]

In Talbot's descriptions, Basinjom remains a hazy presence. The fieldwork of another generation of anthropologists enables a closer look at who Basinjom is and what he does. Malcolm Ruel spent several years in the 1950s working among a neighboring group, the Banyang of western Cameroon. His writing carefully introduces a web of circumstances and a "philosophy of misfortune" that lead to witchcraft's domination of Banyang thoughts. He identifies one major influence that stimulated witchcraft at the beginning of the century—the attempts by Europeans to overpower small-scale community politics. By 1904, the Ejagham and their neighbors were rebelling against German colonial dictates, which later forced the population to resettle in larger villages.[8] It was during this tumultuous era that witches proliferated and demand for Basinjom's services spread. Soon thereafter, when the British established their version of government, they sidestepped traditional leaders to build roads, set up law courts, and erect schools and clinics. Local associations began asking Basinjom to offset British intrusions and relied on his help behind the scenes of the foreign administration. As colonial efforts expanded, so did the role of witchcraft.

A person alone is an animal.    —Banyang saying

Banyang witchcraft addresses a central tension facing individuals—one becomes a person through unity with one's lineage, but one can also excel beyond what that lineage considers appropriate. Personal achievement can ignite doubt or uncertainty about how much status should accrue to a single person. When someone begins separating from others and indulging in deceit, it is a sign that an animal soul has overtaken the human and is causing misfortune. Two classes of animals (or animal familiars) exist—those of a destructive nature like the python, which slithers into the body and, residing in the intestines, inflicts injury on others. The second class includes creatures like the mudfish, which causes the carrier to sweat profusely and endows him with the ability to slip out of any opponent's grasp.

Witchcraft is a person's thoughts.    —Malcolm Ruel, 1965[9]

Animal souls taking over a human were not the sole cause of concern to Ruel's Banyang informants. How people acted with their animal associates could change abilities from assets into destructive forces. A person could take on the strength and

power of a leopard or harness the command of lightning and use the powers well. But when such special abilities were employed to promote oneself and trample on others, the community agreed that the animal counterpart had to be detected and exposed.

> The power of Basinjom to see and speak the truth is always emphasized.    —Malcolm Ruel, 1968[10]

When circumstances require his presence, Basinjom comes to earth and manifests himself as a detective masquerade. Kept separate and hidden from the colonial government, Basinjom was most active in the years when communities were disrupted. British rewards for individual achievement threw the public-lineage order into question, and accusations of witchcraft escalated. Malcolm Ruel briefly describes the performance of Basinjom as a gowned figure with an entourage of musicians and gun carriers who sing along with his appearance (fig. 73). He glides into view and searches for places where misfortune and medicines might be located. As an endnote to his description, Ruel reveals that he did become a junior grade of Basinjom. Because initiates agree not to disclose secrets of the association, Ruel hints at many elements of Basinjom but doesn't discuss them openly.

> It won't be the usual mask hung on a wall with a label beside it.
> —George Ellis, 1974[11]

Katherine White aligned herself with a curator in a project that was to place Basinjom in an exceptional spotlight (pl. 89). In July 1970, she moved herself, her three sons, and her collection to Los Angeles. Soon after her arrival, Frederick Wright, the Director of the Dickson Art Galleries and an Art Council officer at the University of California, Los Angeles, asked if her collection could be featured in the university's galleries. She agreed and suggested Robert Farris Thompson, a Yale graduate and professor, as the curator and author of the catalogue. White funded two visits to Africa for Thompson to obtain materials and documentation. At the end of 1971, in western Cameroon, Thompson began hearing from people on the coast about an extremely impressive figure known as Basinjom. Traveling inland to pursue this lead, he accepted an invitation to be initiated into Basinjom teachings. Thompson's experience in a blue costume with a headdress and all its instruments resulted in a significant addition to the exhibition *African Art in Motion*, a context-rich display of White's collection.

> Obasinjom means "God's Medicine.". . . Medicine is God's gift to mankind.    —Ejagham informants, 1984[12]

One concept that stands outside Western usage is essential to the following account of Basinjom's initiation and appearance. Medicine, in Ejagham terms, is a knowledge of plants and herbs that God provided to fight witches and criminals. Medicine can be manifested in the form of a mask or be located in a container or even a person. In a story recorded in the 1980s, medicine emerges as a gift from God, who showed a man which herbs would protect him from witches and crush their

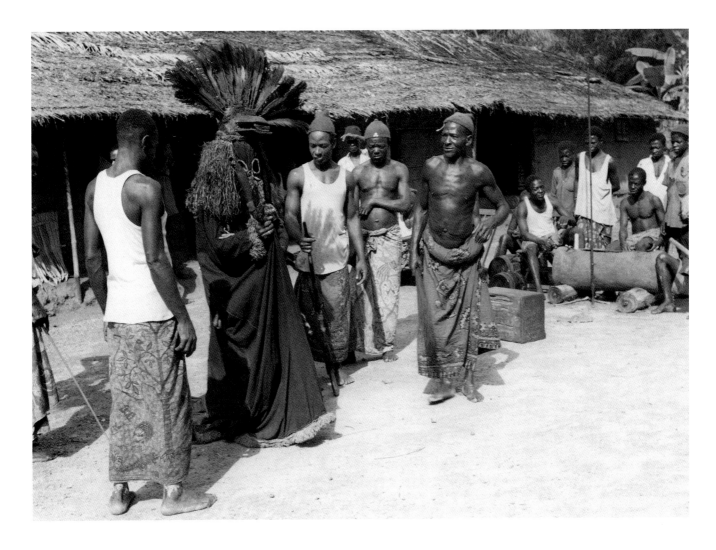

Fig. 73. "Basinjom Association," from Malcolm Ruel, *Leopards and Leaders* (1968).

influence. After providing this gift, God left man and "closed the door."[13] Basinjom is said to be the strongest of the medicines available. A Basinjom association holds meetings (*ocha njom*, "assembly of medicine") at which members eat and drink and have the mask perform. Knowledge of potent plants is a cornerstone of the association, as are the methods of contacting the ancestors to alert them that the medicines need to be activated.

> The essential power of Basinjom lies within his eyes "to see pictures of the place of witchcraft–that is the force of the Basinjom image."
> —Robert Farris Thompson, 1974[14]

When Thompson brought a Basinjom costume back to the United States for exhibition, his experiences as an initiate and performer uniquely equipped him to install it. Forming a backdrop to the actual costume, a large photomural and videos of an initiate show him preparing the mask and performing in it. The exhibition catalogue provided a detailed account of the masquerade as described by elders of the Basinjom society, who explain what materials are assembled to create the costume and how it is called upon to perform:

When a man is initiated, in a ceremony called The-Pouring-Of-The-Medicine-Within-The-Eyes (*bajewobabe*), the initiating priest and an assistant prepare a mixture of material taken from the African Tulip Tree and palm wine.... The medicine is dropped in the eyes of the initiate.... The medicine stuns the initiate. It is believed to "wash his eyes magically, so that he can see the place of the witchcraft." The medicine also aids him to gain the possession state without which he cannot wear the gown.

After this sequence, the initiate is taken to a grove where the Basinjom mask and gown are displayed next to an *ekponen* owl. A priest then narrates the essential ingredients of the medicine incorporated into the costume and their associations:

A knife (*isome*), an iron instrument whose blade has been perforated with eyes to enable Basinjom to see the place of the witches.

A rattle made of wicker to hear the sound that evil makes.

Blue feathers of a very strong "war bird," or *touraco*, that cannot easily be shot by a gun.

Porcupine quills, which prevent intrusion from strong elements, even thunder and lightning.

Eyes that act as mirrors to see into other worlds, especially at night.

A snout like the mouth of the crocodile, which can speak for the people about controversial things. Eggs are broken over this snout to feed Basinjom.

Inside the mouth, a piece of the King Stick, the most powerful tree in the forest, used to protect bodies.

On the back of the head, many herbs that have been collected and pounded together with liquids to serve as a medicinal protection. On top, a mirror enables Basinjom to "see behind," and a small upright peg with an amulet serves as a bodyguard.

Deep black and blue cloth, a color that will "not hold death," because in darkness no human or witch can perceive you.

Raffia used for hair and a hem as an element from the forest, a dangerous realm that weak men should avoid.

A genet cat skin, invoking the spirit of an animal familiar who snatches fowls and shields Basinjom from harm.

Next to Basinjom, eyes of the owl, alluding to enhanced vision in the deep forest and the bird's long, strange legs.[15]

Having mixed parts of dangerous animals and natural powers from the herbal and mineral realms, Basinjom's costume sits awaiting an assignment. In spring 1973, a sudden outbreak of dry rot in crops calls for a trial of two women suspected of

Pl. 89
**Basinjom mask and gown**
Ejagham, Nigeria and Cameroon
Collected 1972
Cloth, wood, feathers, porcupine quills, mirrors, herbs, raffia, cowry shells, rattle, eggshell, metal, genet cat skin
H. 216 cm (85 in.)
Gift of Katherine White and the Boeing Company, 81.17.1977

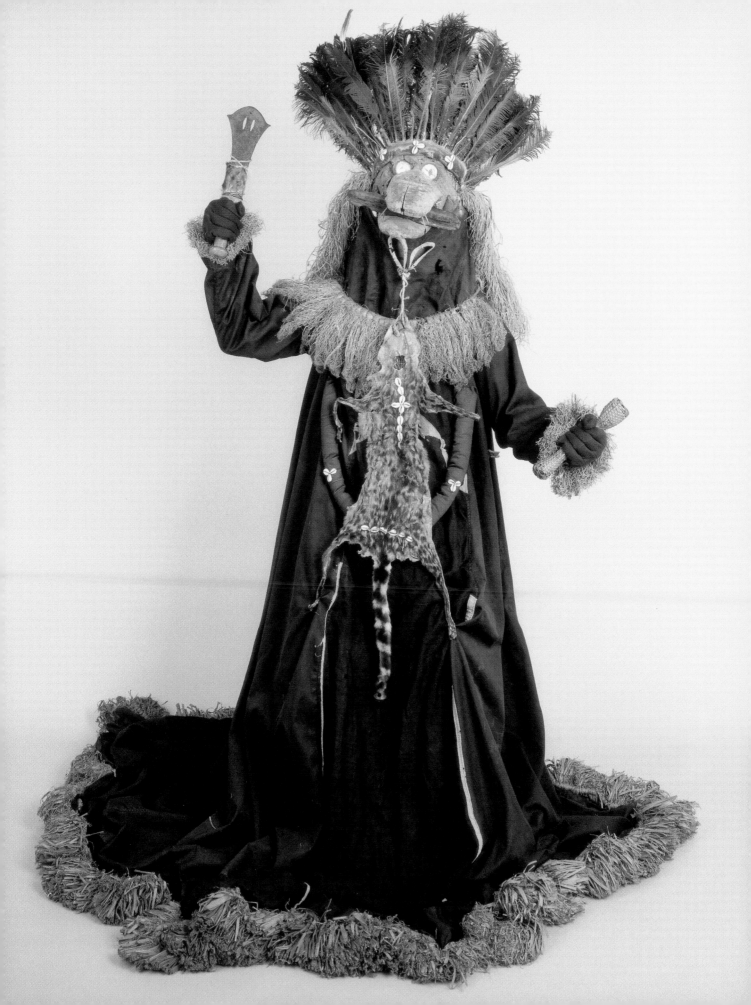

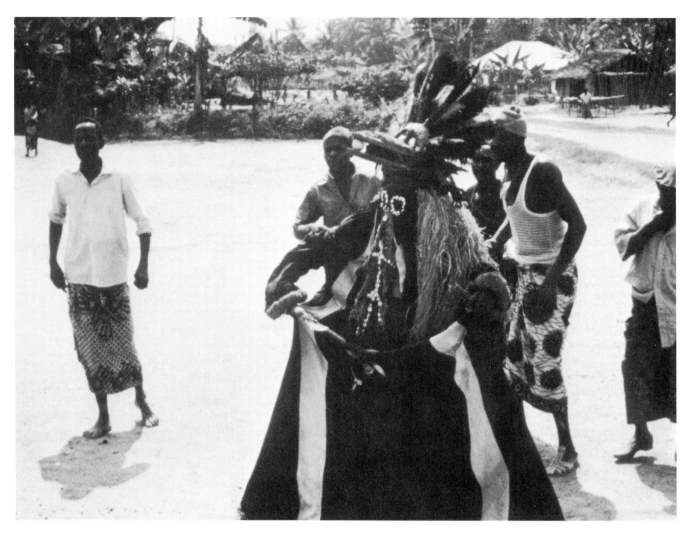

Fig. 74. Basinjom performing, Cameroon, 1973.

witchcraft. A priest invokes a ranking mask carrier, who is prepared with eye drops, an orchestra, and accompanying guardians. Basinjom holds his knife and rattle, shakes his head to listen for witches, and begins to direct an ever-growing crowd like a "mystic hovercraft" whose gliding search builds suspense (fig. 74).

Suddenly, as Thompson recounts:

He loomed over the two women accused of witchcraft. He put down the gown. The followers stopped. He knelt, bending slowly down. The followers knelt simultaneously, in perfect unison with their lord, lowering their weapons. A person explained, "He is bending down to read, to read with his knife; he wants to see things, the *bad things.*"

He turned his back on the two women, flew through the village common, and there followed more gliding and listening, more wheeling and scrutiny, with a counterpoint of head-shaking miming supernatural listening. This created gradually, but overpoweringly, an image of complex detection of all

Oro Efe, the King of the Night, appears with a microphone and asks, "Who sent for the king of secrets to appear?" Then begins a program that lasts until dawn. For hours, he blesses the audience and the powers of the universe, and does his best to dissolve tension with satire, ridicule, jokes, and jests, "so they can laugh off their grievances." His performance is said to be like a blazing fire with the power of a leopard and a voice as sweet as honey.[11] His songs and poems target current events without fear of reprisal. All thefts, sex scandals, corruption, political disputes, and abuses of power are ripe for commentary. Scandals are especially relished.

World Does Not Love a Slanderer.     —Efe performer

Efe performers are poets and social critics at the same time (fig. 76). As their bold words attack everyone from misbehaving women to politicians in high office, they must assure their audience that they speak with the voice of an unquestionable source, that of Iya Nla, the Great Mother. Sanctioned to say what no one else dares to, they are known to launch critical songs against swindlers, playboys, prostitutes, and corrupt officials. In one performance, a mask called World Does Not Love a Slanderer sang about an official who wanted to steal property rights and sell a shoreline to foreigners who would put local fishermen out of business.[12] Akin to the editorial column of a newspaper or radio, Efe songs don't just report on events but also comment on their effect on the community. In another song, Oro Efe serves notice to a young man whose behavior is annoying and even criminal:

Fig. 76. An Efe mask in full regalia, Ijio, Nigeria, 1991.

> The conceited man with all his money is teasing his elder
> Did Ogunsola marry his wife for you?
> Wicked person who pulls on the snake's neck
> If the viper bites you should I be concerned?[13]

In this song, a man is accused of committing adultery with an elder's wife and using his money to justify acting superior. His foolishness is compared to that of a man who pulls on a snake's neck and doesn't care what happens. While Efe songs are critical of individuals, they also berate politicans:

> This world is harsh for you politicians
> Anyone who wants to live in this world must be very careful
> Watch what you say, for the world is heavy
> You politicians, the world requires caution
> Those who were doing it whom we were told were not doing it properly
> "The world" cut them away as bananas are cut from the stem
> Those who were doing it whom we were told were not doing it properly
> "The world" blew them away like shafts from wheat.[14]

In the 1940s, one Efe performer was arrested for ridiculing colonial policies, but was later released on the argument that the words were not his own. Throughout the colonial era, physical revolt was discouraged because of the brutal retaliation it could unleash. People would rely upon the Efe singer to air their distress over colonial policies and to direct a dose of ridicule at the foreign officers.

Pl. 91
**Efe mask: Path Clearer**
Yoruba, Nigeria
20th century
Wood, enamel paint
Diam. 54.6 cm (21½ in.)
Gift of Mark Groudine and Cynthia Putnam, 95.130

Pl. 92
**Efe mask: bird holding snake**
Attributed to Alaiye Adesia Etuobe of Ketu
Yoruba, Benin
Early 20th century
Wood, pigment
H. 37.8 cm (14⅞ in.)
Gift of Katherine White and the Boeing Company,
81.17.584

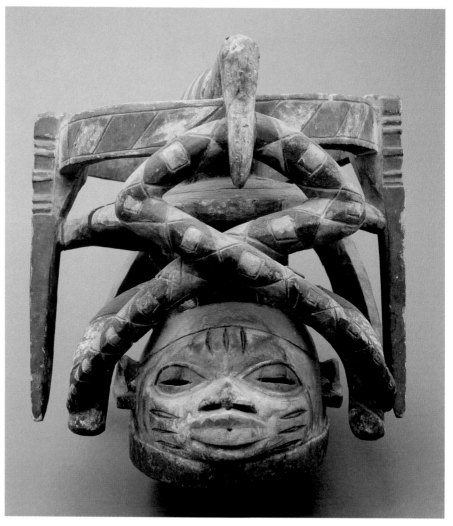

A fowl perches on a rope. The rope feels uneasy. The fowl also feels uneasy.　—Yoruba saying

The Efe singer's flair for taking risks is evident in the headdress he wears. A tense situation is enacted atop the singer's head (pl. 92). A bird is holding onto a swirling snake, while the human face below is a study in composure. Bathed in white chalk, the Efe face would stand out in the darkness of the night and evoke the need for the cool, covert patience of the mothers to deal with this kind of violent encounter. Birds and snakes approach confrontation differently. Powerful mothers are known to turn into birds at night and attack sleeping victims, while snakes are thought to rarely attack unless they are provoked, and then not to let go. Interlacing this duel is a belt with sheathed knives on either side, adding the potential of a human attack. Knives refer to Ogun, an *orisa* (deity) whose special skills with iron were first employed when all the *orisas* arrived on earth and found themselves trapped in the thickness of the primeval forest. Ogun used his iron cutlass to cut a path, thereby opening the world for humans to inhabit. He offers tools and weapons to be used when necessary, but he fiercely opposes those who use the inventions unwisely. Careless violence is subject to Ogun's wrath, just as the wrath of Efe is expressed with ridicule and satire. Wearing a mask to advocate balance and reason, the Efe performer paces back and forth in a slow tempo all through the dark night.

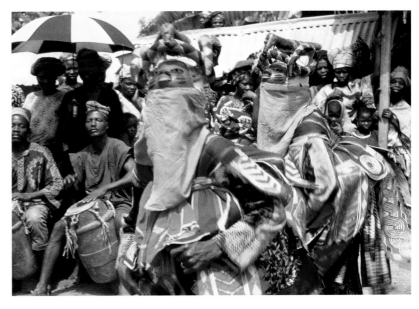

Fig. 77. Pair of Gelede masqueraders dancing, Imeko, Nigeria, 1970.

For the moment, life feels like a paradise.　—Babatunde Lawal, 1996

After hours of singing and offering prayers, jokes, and riddles, the Efe masquerader retires at dawn. Everyone rests until the next afternoon, when families attend the larger Gelede spectacle—three to seven days of extensive performances. Pairs of masqueraders dance into view and mirror each other's movements, matching the drum phrasing of songs, proverbs, and slogans (fig. 77). As the afternoon progresses, the rhythms intensify, testing the precision of the dancers. Each duo must move in tight unison as their leg rattles keep time with the drumming. Their bodies become instruments themselves, somewhat akin to tap dancers, whose legs accent every move with sound. The Gelede headdresses they wear offer a moving parade of diverse subjects—a promiscuous woman, a dignified priest, a banana stalk, and two snakes swallowing a porcupine. The afternoon performances are an occasion when "everybody is in a joyous, celebratory mood as the music takes over the body; even the aged, the sick, the bereaved, the poor, and the distressed temporarily forget their problems. For the moment, life feels like a paradise."[15]

Character is the essence of beauty.　—Yoruba saying

The virtues and vices of Yoruba women are portrayed in two of the museum's Gelede headdresses, one neat and controlled, the other an obvious parody of gracelessness. Precisely incised triangles adorn a face with balanced, carefully outlined features (pl. 93). A broad head tie sweeps around her hair, revealing tight linear rows of braids. No details are out of place, suggesting that this is a woman of balanced character. *Iwa*, or "ideal character," is cultivated by the Gelede festival and encouraged as the source of beauty and joy in life. Positive, ethical behavior makes one attractive not only to Iya Nla, the Great Mother, but also to Olu Iwa (Lord of Character and Existence), and finally to all those who live in the community. The performer likely emphasized the grace and control of this mask with the gestures of a sociable and virtuous woman.

Just as this woman is tightly composed, her opposite is not (pl. 94). A rather plain face supports a leering woman who bends at the waist, exposing her private parts. The mask wearer's movements would depict a promiscuous woman who walks provocatively and makes suggestive gestures to her admirers. Such parody could be pushed to an extreme by the male dancer, who would interact with the audience.

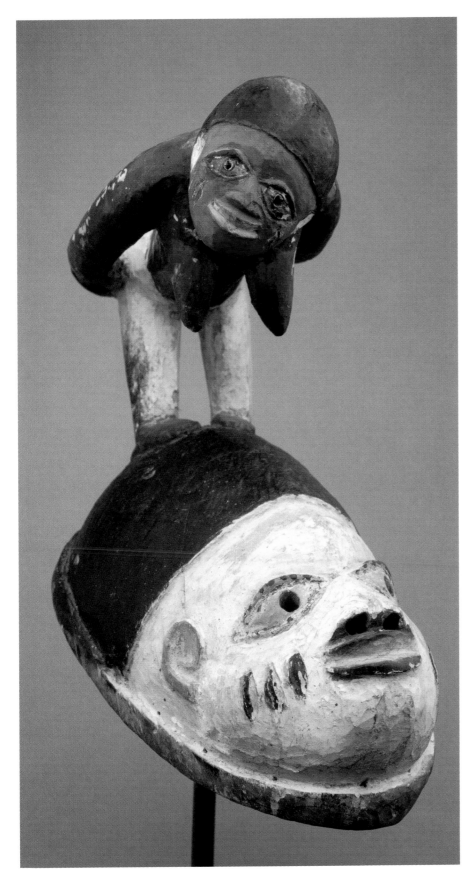

Pl. 94
**Gelede mask: female exposing herself**
Yoruba, Nigeria
20th century
Wood, pigment
H. 35 cm (13¾ in.)
Gift of Katherine White and the Boeing Company,
81.17.590

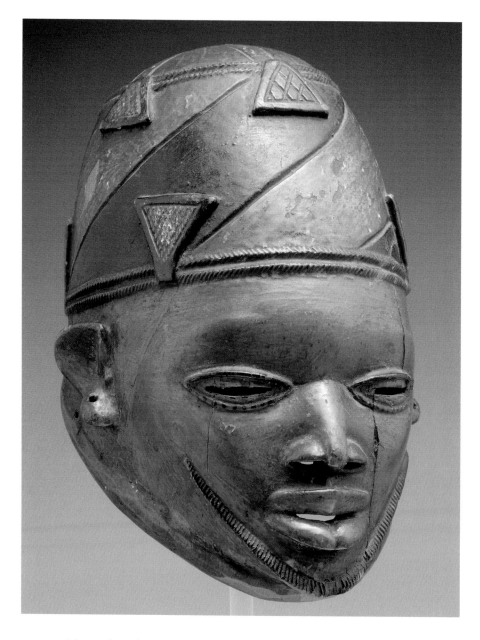

My mother, the nursing mother with the rolling buttocks.

—Yoruba saying

Men use Gelede costumes to transform their bodies into visions of mothers. Most almost double their size by adding layers of costuming to exaggerate the wide buttocks and hips that allow a safe and easy delivery of children. Sashes used for carrying a baby and head wraps borrowed from women are tied on to create a truly plump mother, whose dancing is considered far more alluring than a slim woman's. A hoop is suspended over the hips to allow them to rotate in a smooth, suspended motion, while wooden breasts are positioned to draw attention to the female form. Some performers mimic specific characters by imitating their walk or carry implements to suggest their role.

Some masks chant in Arabic. Some say amen and quote the Bible.

—Babatunde Lawal, 1999[16]

A Muslim cleric is commemorated in a headdress whose mouth seems about to speak or chant (pl. 95). To complete the impression of a devout Muslim, a performer wearing it might carry prayer beads and prayer mat and a teapot used to wash his face and feet before reciting verses from the Koran. The key to this man's identity is suggested by the amulets on his cap. In former centuries, Muslim clerics in Yoruba courts supplied protective amulets to leaders and holy persons. Christians and Muslims participate in Gelede, and Muslim support for Gelede has remained constant, despite disapproval of other masquerade forms. In turn, Gelede is circumspect in its criticism. Islam, a religion that sixty percent of all Nigerians now follow, would not become a target. Instead, Gelede focuses attention on certain kinds of individuals whose eccentricities invite satire.

> Anything handled with care becomes easier
> Anything handled with force becomes harder.    —Yoruba saying

A liquor barrel, dark glasses, fine-toothed comb, and cigarette over one ear are elements of a headdress that jokes about a certain elite (pl. 96). Two groups of repatriates with Europeanized attitudes have not been entirely well received. In the late nineteenth and early twentieth centuries, a group of Brazilian residents of African ancestry returned to Nigeria. They spoke Portuguese, were Catholic, and tended to segregate themselves. Following them were repatriates from Sierra Leone, more British oriented and Protestant. Both groups tended to part their hair as on this mask, drink Western liquor imported in barrels, and smoke. It is also possible that the mask simply refers to European colonialists who overindulged in drink, wore sunglasses, and smoked imported cigarettes. In assembling these clues, the mask jests as Gelede is best known to do: "In jesting, you approach someone in an intimate way—it is an aspect of friendship and it creates trust. It can promote well-being and purify a relationship."[17]

> The Yoruba possess and practice a most effective system of naming
> everyone in their society.    —Roland Abiodun, 1994[18]

Arobatan of Pobe, Dahomey, a master carver of the 1920s to 1940s, created a Gelede mask depicting a king on horseback with praise drummers saluting his ride (see pl. 90). In its original performance, the mask was likely greeted by a praise name and reflections of the personal histories that guide Gelede. Without knowing who this king is, we can only read the mask literally as a confident leader whose procession is supported (or about to be disrupted?) by birds waiting beneath.

Yoruba sculptors continue to be identified by distinct stylistic traits. In the effort to name artists, however, Yoruba authors provide a note of caution. Names are closely tied to a person's essence, which determines success or failure in this world. Reciting someone's name can act as a summons to the person's spiritual essence, causing it to act. Some situations call for reciting full names, but the person can then become

# Notes

1. M. J. Field, *Religion and Medicine of the Ga People* (Oxford: Oxford University Press, 1937), 196.

2. *The Complete Works of Ralph Waldo Emerson,* Concord Edition (Boston: Houghton Mifflin, 1903), 143.

3. *New York Times,* December 18, 1995.

4. Field, *Religion and Medicine,* 196.

5. Thierry Secretan revealed the lineage of the coffin tradition in *Il fait sombre va t'en* (Paris: Hazan, 1994), translated as *Going into Darkness* (London: Thames and Hudson, Ltd., 1995). He notes that originally palanquins were baskets used to carry chiefs during ceremonial processions. Kane Quaye's tutor, Ata Owoo (1904–76), carved the first version of a wooden eagle for the Teschi chief Nii Ashitey Akomfra (1902–77) in 1947.

6. Quoted in Thierry Secretan, *Going into Darkness: Fantastic Coffins from Africa* (London: Thames and Hudson, 1995), 18.

7. Vivian Burns, "Travel to Heaven: Fantasy Coffins," *African Arts* 7, no. 2 (winter 1974).

8. Linda Nochlin, *Realism* (London: Penguin, 1971), 60.

9. See Charles O. Jackson, *Passing: The Vision of Death in America* (Westport, Conn.: Greenwood Press, 1977), a compilation of essays that trace the changes from colonial America to the twentieth century.

10. *Magicians de la terre* (Paris: Centre Georges Pompidou, 1989). The National Geographic Society broadcast the film *Leaving in Style* in 1989, and the BBC aired it in forty-two countries. Directed by Thierry Secretan, the film was released in 1988 with the title *Les Cercueils de monsieur Kane Kwei.*

11. Susan Vogel, *Africa Explores: Twentieth Century African Art* (New York: Center for African Art, 1991).

12. Quoted in Secretan, *Going into Darkness,* 9.

13. Ibid., 7.

14. Stephen Buckley, "In Africa, Funerals Use Rituals of Joy to Ease Sorrow," *Washington Post Foreign Service,* December 22, 1997.

15. Secretan, *Going into Darkness,* 20.

# "Negatives That Breathe Like You and Me": Photographs from Bamako

Visitors to the Seattle Art Museum in 1997 were invited to spend $10,000 on African art. The funds were derived from a lengthy deaccessioning process, and one gallery was turned into a polling booth. Eight choices were displayed—some rooted in time-tested aesthetics, such as the fortress-like face of a black monkey mask from the Dogon of Mali, and a selection of beadwork including a rickshaw outfit from South Africa. Others were more process oriented, such as a proposal for an artistic collaboration with Fred Wilson, and an effort to purchase a portion of the Schneider archives (see "Assembling a Royal Stage: Art from the Kom Kingdom"). As thousands of votes and supporting comments were posted, a set of six photographs by Seydou Keita and Malick Sidibe inspired a wealth of statements, of which a selected few appear here:

> I'm interested in how people, regardless of race or ethnicity view themselves. I want to know and see what they think is important, not what I think *I* should know about them.

> It is important to get a culture's view of itself.

> These photographs have a terrific sense of honesty about them.

> The best way to understand others is to look through their own eyes.

> Unquestionably powerful images—combines art with documentation.

> African art, for/by/about Africans.

> Need to reflect multifaceted and evolving African cultures rather than what is expected.

> The U.S. needs to open its eyes to the interpretation of other cultures through the eyes of its own people. Exterior interpretation is often innocently biased.

> Africa is not only yesterday, it is today also.

> It gives a view of people, not just disembodied artifacts.

Pl. 98 (detail)

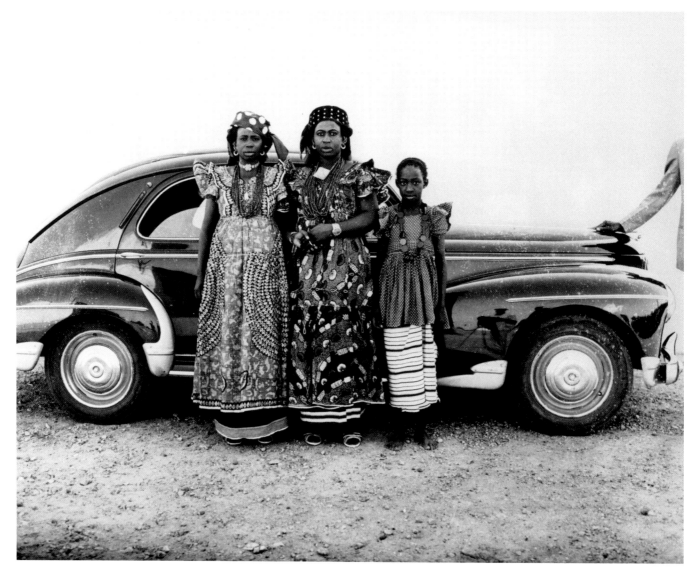

Pl. 98
*Untitled (Family with Car no. 266)*
Seydou Keita (b. ca. 1921)
Mali
1951–1952
Gelatin silver print
W. 61 cm (24 in.)
General Acquisitions Fund, 97.35

As a contrast to the symbolism of the art in African exhibits, photos are clear, startling, intimate, and realistic.

Images of prosperous Africans are rare.

Like a war story from a soldier, not an outsider who didn't fight.

After forty weeks, the six photographs did not receive the most votes, but their evident attraction for the audience (as well as the curators) led to the purchase of two from a gallery in San Francisco.[1] Just as the visitors' comments stated over and over, the photographs counteract images of famine, conflict, and odd, exotic Africans; instead, they present people dressing up for a wedding, taking children to visit relatives, having a good time at a picnic, and walking down the streets of cities like Bamako, Mali. The photographs of Seydou Keita and Malick Sidibe are perhaps so startling because they are so unsensational. It's apparent that their subjects asked to have their pictures taken, which is often not the case with photographs by outsiders. Both

responded to clients who wanted to record their families, friends, and events for their own use. Keita's and Sidibe's candid work records life in Bamako from the late 1940s through the 1970s. In the 1990s, both were caught in an unexpected wave of international recognition and sudden renown for the visual milestones they had created.

> I started by taking pictures of my family.    —Seydou Keita[2]

Seydou Keita began as a carpenter. He was given a camera by his uncle in 1935, and took a decade to learn how to use it. He says, "In 1948, I set up my studio in our house in Bamako-Koura, in what was then 'New Bamako' and which was a lively neighbourhood. That's where I took all the photos that you've seen. And today, I'm still there."

> Bamako … was a major crossroads then and had a really good atmosphere.… The whole central section was very bustling because of the cathedral, the railway station, the post office, the big Marche Rose, the Soudan Club, and a very busy zoo. My studio was in a good place.… There was always a crowd around my studio, and I was working all the time. All the elite in Bamako came to be photographed by me: government workers, shop owners, politicians. Everyone passed through my studio at one time or another. Some days, especially Sundays, there were hundreds of people. Even our first president, Modibo Keita, came by. Everyone knew about me. I had a rubber stamp "Photo KEITA SEYDOU" that everyone wanted on their prints.
>
> To have your photo taken was an important event. The person had to be made to look his or her best. Often they became serious, and I think they were also intimidated by the camera. It was a new sensation for them. I always told them to relax more: "OK, look over here, try to smile a little, not too much." In the end they liked it. It took only about ten minutes.[3]

> A lot of people getting off the train came to me to have their photograph taken on their way to visit the zoo.    —Seydou Keita[4]

Seydou Keita did not record the names of his clients; hence the number in the title *Untitled (Family with Car no. 266)* (pl. 98). Some asked to be photographed in front of the two cars Keita owned in the 1950s, as this family did. Or, rather, most of them did. A sliver of a male presence is evident in the man's hand on the hood of the car. The hint is just enough to let us know he is wearing a light suit, while the women at the center are dressed in a lineup of patterns—polka dots on all three, and wax prints on the two older women. Their faces offer a study in ways to respond to a camera: knit your eyebrows with a slightly wary reserve, stare it down with confidence, or offer youthful eagerness. Buffed and shiny, the car reflects the photographer with his camera, and its slick surface contrasts with the gritty dirt road. Seeing just the hand of a well-dressed gentleman, we can't help wondering who he is and why he set himself apart from the women in the center frame.

> Close your studio, the government needs a photographer.
>
> —Issa Traore, 1962[5]

Seydou Keita was asked to be the official photographer for the Malian government in 1962, a position he held until his retirement in 1977. Tens of thousands of negatives from his independent years of 1948 to 1962 were stored in a large padlocked chest for the better part of three decades. They remained there, largely untouched except for occasional requests—for instance, an American curator, Susan Vogel, picked up three negatives in 1974. After holding them for almost twenty years, in 1991 she placed them in an exhibition in New York entitled *Africa Explores: Twentieth Century African Art*. Displayed as the work of an unknown photographer, they inspired André Magnin, a French curator, to fly to Mali in search of the artist who had taken them. His search was brief because "the Elder Keita" was a well-known photographer. On a third visit, Magnin obtained two hundred negatives from Keita and had them printed for sale to galleries in Paris, London, and San Francisco.[6] This arrangement continues.

Working as a mechanic.      —Seydou Keita, 1995

Acclaim came quickly for Seydou Keita in the 1990s, as his work was featured in exhibitions in Africa, Europe, Japan, and the United States. But he says, "I can see that a lot of people really like my pictures. Ever since my work has been known in your country, I've had a lot of visitors, but I prefer to leave everything up to one person. That way I can live a more peaceful retirement, going regularly to the mosque, looking after the houses I've built and spending some time working as a mechanic, which I really like to do."[7]

Woodstock-in-Bamako.      – Manthia Diawara, 1998

Malick Sidibe was trained in jewelry making at the National School of Arts in Bamako. After graduating, he apprenticed to a photographer in Bamako and by 1962 opened Studio Malick. Venturing from the studio, he became a reporter, following the activities of young people in photographs that gave Bamako a reputation as a center for a world youth culture. Manthia Diawara, one of his subjects, has written about his re-creation of a "Woodstock-in-Bamako," renting a building in the center of the city and dressing right:

> I wore a red cotton-and-polyester shortsleeved shirt with "Keep on Truckin" written on the back of it. Over the shirt I put on my embroidered blue-satin jacket, combining these with my blue bell-bottom trousers and my red clogs from Denmark. When I had added my Venetian-glass necklace, my cowrie-shell juju bracelets, and my dark glasses, not only did I look like Jimi Hendrix—I felt like his reincarnation.... When we arrived the amplifiers were blaring "With a Little Help from My Friends," by Joe Cocker. There were many people who had copied our style—that is, they were dressed like Jimi Hendrix, George Harrison, Richie Havens, Buddy Miles, Sly Stone, Frank Zappa, Alice Cooper and James Brown. . . . Soon Jimi Hendrix's "Voodoo Child" filled the air, and by then we were on top of the world.[8]

# Collecting Beads and Wishes for the Future:
# Ornaments for a Maasai Bride

How museums collect, not what they collect, guided the last gathering of African art to enter the Seattle Art Museum's holdings in the twentieth century. The acquisition involved many adjustments, all suggested by an intern who helps redefine collecting to suit two cultural agendas.

**This culture has to end.**     —Kenyan government officials, 1999

The exchange began when I was invited to a meeting of archaeologists to hear a talk by Kakuta Ole Maimai Hamisi, a Maasai studying at a nearby college. It wasn't the usual student talk. Hamisi spoke as if he was two people at once—a warrior and an ethnographer, able to videotape his own initiation and critique its chance for survival at the same time. He described living in a country where government officials proclaim of the Maasai, "This culture has to end."[1] He outlined conflicts such as elders trying to keep children from going away to city schools, and of the need for Maasai to establish their own schools. When Hamisi decided a Western education was necessary, his father sold cattle to send him to college.

In preparing for his internship at the museum, I followed the standard plan of study and assembled a stack of publications about the Maasai and Maasai art. Hamisi's reviews of the publications were rarely positive. The survey revealed that the Maasai have been extensively photographed but not interviewed. Page after page of glossy photographs of even intimate aspects of Maasai life pushed Hamisi to the limit of his tolerance. We went through academic journals to seek more thorough texts, and Hamisi wondered out loud how many Maasai had ever known of such studies. He said though it might be hard to believe, he was one of the few. Out of a family of thirty-seven uncles and eight brothers, he was the only person to learn English and German, and travel to discover what outsiders said about his culture.

**A stroll in the Serengeti**     —Susan Minot, 1998

In contrast, the numbers of tourists who visit Maasailand are staggering. Millions have taken safaris to Kenya and Tanzania since the 1970s, and accounts of these     Pl. 107

# Tanzania on Foot: A **Stroll** in the Serengeti

The Masai have lived in this land around the Ngorongoro Crater for hundreds of years

"Not many people in the world have a chance to experience this," says our guide, Tim Corfield.

We are standing in the middle of a plain in western Tanzania, in the great Serengeti, in the center of a huge circle of running animals. Thousands of bushy-chinned wildebeests, having parted at one end of the plain, gallop in single file. Zebras wheel around, gazelles streak by; their horns looking blown back. The animals give us a wide berth — "the circle of fear," Tim calls it — as they would to a lion or a cheetah.

We have been walking since 8 this morning in a hot wind across hard ground with low sometimes crunchy grass. In front of us is a green ridge that a few hours before were blue hills in the distance.

Paiet, our Masai guide, tells us the name of these hills — L'ongo'oyo. The Masai are often not the same as those on the official map of the Ngorongoro Conservation Area, but this has been Masai land for hundreds of years. The Serengeti National Park ecosystem is under Government control, providing Tanzania with great revenues in tourist trade.

Most of the safaris in this famous wilderness are geared toward viewing the wildlife, probably the best viewing in the world. Game drives are the usual way to see animals. On many tours you spy game through the window of a cramped white van or, if you're lucky, from more airy vehicles with open tops so you feel like you're on a boat sailing the plains. The animals have got so accustomed to cars that lions look up, roll over and yawn.

Tim Corfield has been leading safaris on and off for

**BY SUSAN MINOT**

more than 20 years — during which time he was, among other things, sailing in the Indian Ocean and studying elephants in Kenya's Tsavo National Park. I had spent some time in Africa and asked him if it were possible to design a safari that combined driving with extensive walking.

In safari terms we may be making history; this is the first time a walk from Endulen to Nasera Rock has been done. Tim says our six-day trek is probably the longest taken in the Conservation Area — by whites. The Masai could walk the whole distance — some 40 miles — in a couple of days if they had to. We are, he says, going where the spirit moves us. It is not quite as laissez-faire as that — these safaris involve a great deal of planning. We know where we'll end up and vehicles will be in radio contact to bring supplies — water mainly. On either side of our walk we are booked into lodges — in Arusha at the Eden-like Ngare Sero, with a view of Kilimanjaro, and at the other end at the Ndutu Lodge, where giraffes glide across the long driveway and lions are spotted on afternoon game drives. It is not a rough safari by any means, though not as luxurious as Tim's usual offering of china, pressed linen and ice.

We will not have to carry anything. Our camp will be transported by donkeys or, as we called them in Swahili, punda. There was a significant moment each day when, having set out early in the morning leaving behind Tim's

*Susan Minot's new novel is "Evening," forthcoming from Knopf.*

---

Fig. 82. "Tanzania on Foot: A Stroll in the Serengeti," *New York Times* (1998).

journeys often laud the experience. After working with Hamisi, however, articles like "Tanzania on Foot: A Stroll in the Serengeti," by a novelist writing for the *New York Times,* strike me differently.[2] It recounts the experience of walking across the Serengeti with two guides, one British who is quoted and a Maasai escort named Paiet— "a bony-shouldered beautiful man with a gap tooth"—who isn't. During the walk, they "pass women in wide collared beaded necklaces triangular earrings, aluminum coils, small shaved heads" (fig. 82), but the writer doesn't talk to them. After the walk is over, a "magnificent game drive" sums up the journey as they see "wildebeests, eland, ostriches, gazelles, jackals, zebras, hyenas, plovers, yellow-throated sand grouse, Egyptian geese, bateleur eagles, sacred ibises, larks." Despite the safari being a walk through Maasailand, it is striking how little part the Maasai play. They remain largely unknown, watching tourists pass by, while the Westerners focus their attention on carefully identified species of animals—a pattern of avoidance that has become a twentieth-century habit.

As the next step in the internship, a trip into the museum's storage revealed a collection that is documented in the same way: photographs of the people wearing or carrying the objects are available, but their names and comments are not recorded. Determining the origin of this evasion became my concern. How did the safari system begin and why are Maasai so silent about it? The search for an answer led me to accounts of the first European to record his journey across Maasailand, and the first Maasai to travel to Europe and the United States.

Sixty thousand strings had to be made up.     —Joseph Thomson, 1883

Joseph Thomson, a twenty-nine-year-old Scotsman, rode into Maasai lands on a donkey at the head of a small regiment under the auspices of the British Royal Geographic Society. In March 1883, he set off with 113 porters carrying nearly four tons of wire coils, beads, bolts of cloth, ammunition, food, instruments, and supplies. By the end of March, he had reached Taveta, near Mount Kilamanjaro, the stopping place for caravans to Maasailand. Hearing about Maasai preferences, Thomson realized, "The whole of my beads had to be restrung into the regulation lengths of the Masai country. Unless in this form, they would not be accepted.... 60,000 strings had to be made up."[3] Thomson spent over two weeks stringing beads, and finished just as two thousand Maasai were headed straight toward his regiment. "[We] set our eyes on the dreaded warriors that had so long been the subject of my waking dreams, and I could not but involuntarily exclaim, 'What splendid fellows!'" As one warrior began speaking, Thomson recorded the effect: "With profound astonishment I watched this son of the desert as he stood before me, speaking with a natural fluency and grace, a certain sense of the gravity and importance of his position, and a dignity of attitude beyond all praise."[4]

On May 3, Thomson finally entered a vast treeless plain at six thousand feet to confront lines of cattle, smoke from kraals, and a group of Maasai *moran* (warrior) demanding entry fees. The *moran*s laid aside their swords and shields while porters threw beads and cloth near the Maasai before sprinting out of the way. Thomson realized he was in trouble as load after load of his carefully strung beads disappeared and the *moran*s became "overly inquisitive." The next day, a report that the Maasai were planning a dreaded dawn attack prompted his hasty retreat to the coast. Walking more than thirty miles a day, Thomson regrouped after learning that one of his interpreters had invented the threat of attack. Allying himself with a Swahili trader named Juma Kimameta, Thomson was back in Maasailand by August 11.

Early on, Thomson nearly set off a riot when several Maasai women complained that he used a camera to bewitch them. Trying to find new ways to interact and avoid conflict, Thomson began to cultivate an impression that he was a white *laibon* (spiritual leader) by experimenting with odd behavior. He used intricate instruments with exaggerated drama; he prescribed Eno's salts (an effervescent foaming drink); he danced a Scottish jig; and he let out screams of convulsive laughter. *Moran*s continued to visit him, invading his privacy ever more boldly.

Thomson pushed on to reach Mount Kenya, but learned that his presence wouldn't be tolerated much longer. In the dogged seven-month journey back to Mombasa, he was gored by a wounded buffalo, battled dysentery, slipped into comas, and traveled through famine-stricken territories. Overall, he had walked three thousand miles in fourteen months. Thomson's book, *Through Masailand*, testifies to his tenacity and infatuation with exploration. Thomson hiked for the next seven years through other parts of Africa, until he died at age thirty-seven in 1895. His final words were said to be, "If I were strong enough to put my clothes on and walk a hundred yards, I would go to Africa yet!"

Thomson's walking expedition is remembered in many forms. His books and speeches to the Royal Geographic Society in London are well-known sources on the history of East Africa. One of the animals most often seen on safari bears his name: the Thomson gazelle. In naming the Aberderes mountain range, he marked the Kenyan map with a Scottish term. Above all, he is known for his assessment of the Maasai: "A more remarkable and unique race does not exist on the continent of Africa. Indeed I might safely say in the two hemispheres.... They are the most magnificently modeled savages I have ever seen or read of."[5]

**The greatest menace of East Africa.**      —Colonel Hall, 1893

In the aftermath of Thomson's portrayal of their mythic stance (and his own heroism), the Maasai were hit by "The Disaster." Humans fell to epidemics of small pox, while rinderpest and pleuropneumonia severely depleted their herds of cattle. Ruinous droughts weakened them all. Incursions by raiders from neighboring Kamba, Kikuyu, and Kalenjin worsened the disorder. In 1891, a mortality rate as high as ninety percent crippled the herds, and while the Maasai were adapting to this loss, British officers moved in to "introduce order into blank, uninteresting, brutal barbarism."[6] Within just a few years, the mythic Maasai who had so entranced Joseph Thomson were recast as "the greatest menace of East Africa."[7]

The primary agents of this change in perception were British settlers who wanted to transform the immense rolling hills of the highlands into an agricultural heartland. When Sir Charles Eliot became governor of the East Africa protectorate in 1900, he initiated the first wave of change. A railroad opened in 1901 and began transporting settlers. Eliot argued that the Maasai inhabited more land than they needed and should be moved aside so that "superior races" could develop it. In 1902, a Land Acquisition Order cleared the way for the most fertile lands in Kenya to be turned over to immigrants from Britain, Canada, Australia, and South Africa. Their highlands property is situated in an area shaped like a fist in the center of Kenya. A treaty gave the Maasai two areas that were to remain theirs so long as they "shall exist as a race." In 1904, Maasai were removed from their grazing grounds in the central Rift valley and relegated to two areas: the Laikpia plateau and the Southern Rift near the border of the German colonial holdings.

**The highlands of East Africa ... a winter home for aristocrats.**

—Advertising campaign, 1910

The Maasai moved as white settlers took over the "white highlands." One of the best-known settlers was Lord Delamere, who arrived from Cheshire, England, to establish a 100,000-acre ranch. At first, he encouraged a few Maasai to stay on the ranch and assist him in experiments with livestock. Relying on their knowledge of cattle breeding, he became their advocate in the land battles with the British. Once the success of his ranch was assured, however, his loyalties switched. Lord Delamere became the settlers' advocate, and the Uganda railway commenced advertising trips to "the highlands of East Africa as a winter home for aristocrats."[8]

The low culture of many of the savage tribes.
—Theodore Roosevelt, 1910

Lured not by settlement but by safari, an ex-president of the United States arrived in Kenya to lead an expedition for the Smithsonian Institution in 1909. Theodore Roosevelt set a high standard for flamboyant travel and bolstered the idea of the safari when he marched for ten months through Kenya with five hundred porters, his son Kermit, and a team of scientists (fig. 83). Their weapons were said to never stop smoking, as 512 animals were killed. Roosevelt himself shot more than 296, including nine lions, eight elephants, thirteen rhinoceros, and six buffalo. One critic said the volume of killing bordered on slaughter and deplored "the devastation that is done in the name of or on behalf of museums. Do those nine white rhinoceros ever cause ex-President Roosevelt a pang of conscience or a restless night? I venture to hope so."[9]

Despite such objections, Roosevelt's visit spotlighted the safari and the museum expedition as a manner of collecting. Within the year, an expedition from the American Museum of Natural History in New York was gathering specimens, including the enormous elephant family that still greets visitors in the central lobby. Roosevelt's *African Game Trails*, which became a best-seller in 1910, established wild animals as the central attraction for a visit to East Africa—a place to experience nature but not culture. "The teeming multitudes of wild creatures,... and the low culture of many of the savage tribes, especially of the hunting tribes, substantially reproduces the conditions of life in Europe as it was led by our ancestors ages before the dawn of anything that could be called civilization."[10]

While the earliest Europeans and Americans to visit Maasailand are quite well documented, their counterparts are largely unknown. The first Maasai to visit Europe is only briefly mentioned in texts. One Maasai was taken to Germany by Carl Hagenbeck, an entrepreneur who originally displayed wild animals and later presented ethnographic shows called *Volkerschau*, which proliferated after 1874.[11] Classified as *Naturvolker* (natural peoples), his ethnographic natives were exhibited behind bars or wire fences in zoos, fairgrounds, and public parks. No specific accounts of this Maasai in Europe are known. The first Maasai to come to the United States was Molonket Olokorinya ole Sempele, who sold cattle to purchase his fare with the intent of gaining a higher education. In 1909, he arrived and was placed in an African American Bible institute in the South.[12] After learning about lynchings and feeling the effects of intense racial prejudice, he returned to Kenya and spoke of white Americans' treatment of black people. "He would tell how white children took hold of a black doll, painted it up with thick white lips and white eyes to look like a golly wog, and then threw sticks and stones until it was broken."[13] For the next forty years, friends said he

Fig. 83. "Mr. Roosevelt and One of His Big Lions," from Theodore Roosevelt, *African Game Trails: An Account of the African Wanderings of an American Hunter-Naturalist* (1909).

would recall such memories, especially when British missionaries seemed to trivialize what an African had been saying.

Maasai artifacts entered museums during this era. The initial illustration of African objects in the British Museum's *Handbook to the Ethnographical Collections* of 1910 is a lineup of shields and spears from all over the continent (fig. 84).[14] A Maasai spear leads the lineup. Spears fanning around a central shield became a classic format, repeating the heraldic displays of the European past. This arrangement of shields and spears underlined what separated the foreign from the native warrior: their choice of weapons. Spears were no match for the new class of arms that the European and American soldier and sportsman carried. Theodore Roosevelt spoke of the beauty of his weapon, a double-barreled elephant rifle, one of many specialized rifles he carried with him on safari. The British became nearly invincible in battle when the automatic rifle was invented. A Maasai spear on display in 1910 was an outdated weapon of the past, overwhelmed by the superior new technology of the colonial enterprise.

Maasai soon faced pressure to move even farther from their homelands. White highland settlers stirred up dissent over the lands allocated to them in the 1904 treaty. By 1911, a new treaty was being drawn up. The majority of Maasai felt that armed resistance would be hopeless; instead, many decided to fight the move in the courts. This initial attempt by people in East Africa to protect their rights through the political process failed. The colonial authorities moved the Maasai farther south into a new reserve and then avoided them as much as possible from that time on. An armed uprising by *moran*s in 1918 prompted the British to ban their activities in 1921. The next year was the last active rebellion before the Maasai cut off contact with British authorities. Decades of indirect rule allowed the highlands to be dedicated to the experience of the 1920s and 1930s described in Karen Blixen's *Out of Africa*. The Maasai were relegated to the role of exotic "smocked yokel":

Fig. 84. "Types of African Spears," from British Museum, *Handbook to the Ethnographical Collections* (1910).

> Again the enchanting contradictions of Kenya life; a baronial hall straight from Queen Victoria's Scottish Highlands—an open fire of logs and peat with carved-stone chimney piece, heads of game, the portraits of prize cattle, guns, golf-clubs, fishing-tackle, and folded newspapers—sherry is brought in, but instead of a waistcoated British footman, a bare-footed Kikuyu boy in white gown and jacket. A typical English meadow of deep grass; model cowsheds in the background; a pedigree Ayrshire bull scratching his back on the gatepost; but, instead of rabbits, a company of monkeys scatter away at our approach; and, instead of a smocked yokel, a Masai herdsman draped in a blanket, his hair plaited into a dozen dyed pigtails.[15]

Spartan, Aristocratic warriors, scornful of civilization.

*—National Geographic Magazine*, 1954

The Maasai became known as idealized warriors who defied civilization. An expedition from the American Museum of Natural History contributed a report to *National Geographic Magazine* in October 1954 with this portrayal of the Maasai role:

Masai, once terrors of East Africa, live today on a vast reserve....

These spartan, Aristocratic warriors, scornful of civilization, fearlessly hunt big game with spears and swords [fig. 85]....

Virile warriors in earrings and hair braids kindle a fire with iron age tools....

Nor has the white man offered much in a material way that attracts them. The only concessions I observed were occasional incongruous aluminum pots; woolen blankets ... calicos....

They are a temperamental, sullen, difficult, and diffident people. The haughty moran eyes the visitor and his entourage with disdain. Beneath the forbidding surface of the Masai, however, lie substrata of warmth, humor, fidelity and integrity. This deeper character is discovered only through prolonged and rather intimate association. The casual visitor never sees it.[16]

Still alive is Blixen's romantic vision of a "pith helmet and lace" lifestyle that flourishes amid safely restricted aristocratic warriors.[17] The fantasy of a thrilling safari adventure is evoked in tourist brochures and travel writing. So compelling is the lure of seeing the "wild kingdom" in relative luxury that an entire industry has sprung up. Kilaguni was the site of the first game-park lodge to provide safari service

in 1962. Airlines began transporting visitors in the 1960s, and tourism exploded in the 1970s. Big game hunting was accommodated until a government decree banned it in 1977. Safaris quickly switched to a photographic hunt, as the number of tourists rose to a million yearly by 1990. Tourists often see Maasai as photogenic subjects and sellers of souvenirs, but lack avenues for any further association. This suits the Kenyan and Tanzanian governments; they enforce laws against Maasai practices and want access to their lands, but thrive off permits sold to tourists who come to photograph the natives.

> **I looked as carefully as I could, without making them nervous, to see what I might want to bargain for.** —Katherine White, 1978[18]

Katherine White took her three sons on a photographic safari in 1978 on what was to be her last trip to Africa. Her journal entries for the trip begin with an inventory of the 120 objects she brought back, and then follow with a daily account of her search for the right object to purchase. White made note of every belt, calabash, and staff that caught her eye. As her accounts underline, the art was extremely personal, often literally attached to its owner. Many whom she approached wouldn't sell what they were wearing, but a few did:

> Yesterday afternoon, as we were entering the Masai Mara Reserve, some old highly decorated Masai ladies approached the car with things to sell. New necklaces of gaudy beads, trinkets, calabashes. I bought two silver wound-wire earrings on an old cord. I thought they had some wear. Then a marvelous old lady had some unique earrings standing from the tops of her ears. I couldn't figure them out. Slim, dark, some kind of wood, from a thorn tree perhaps. She was reluctant to sell them, but she finally did, for only 5 shillings.
>
> Among others was a young *moran* who wanted money for posing. He was not quite beautiful enough. All his jewelry was new, and not enough. He kept standing about, leaning on his spear, and looking superb. Those long legs, those easy swaying lines, that Egyptian-like head.
>
> We drove downtown to look. A marvelous old man with a white feather headdress, ostrich plumes and one of those woven brass wire lip plugs [fig. 86]. I was fascinated to see how they were worn. I asked for a photograph, the lip plug and a large ring he had on a thumb. We struck a bargain for 20 shillings [$2.25]. And then he tried to remove the plug. It got so heart-rending, I couldn't watch. It was grown in. Quite a crowd collected. We waited and waited. We even got 10 shillings back. The poor old man was frantic. Finally it was delivered to me, and I wasn't sure I could touch it. I felt I had part of that old man's anatomy in my hand. It was extremely worn.
>
> We got a soft drink in town at one of the bars. We were the odd ones, but it seemed peculiar to be shoulder to shoulder with one of these "authentic" natives in full regalia. The fatted hair, the sprouting earrings, the jewelry, the loincloth, knife, and cloak. The dirty feet in dusty sandals. The ankle rings.[19]

A collection of art from East Africa was waiting in storage when Kakuta Ole Maimai Hamisi arrived at the museum. The limits of the story it told were clear: Katherine White had roughly noted where she bought items, but hadn't asked the owners about the art. It wasn't common to do so, given the invisible wall between tourists and the people they saw while on safari. Although tourists observe this wall, anthropologists have undertaken studies of Maasai culture; the first in-depth study of Maasai art appeared in 1987.[20] And yet the pages written about, and the photographs taken of, the Maasai by European and Americans still far outweigh those written by Maasai.[21] Similarly, the number of Maasai who visit or study in the United States remains low in comparison to the million Americans who visit Maasailand each year.

> What if Maasai were to decide what Maasai art belongs in the museum? —Kakuta Hamisi, 1999

At the end of his internship, Hamisi presented a proposal to the museum's Committee on Collections asking for funds to acquire Maasai art. It was the first time the committee considered an abstract proposal—there was nothing to evaluate but a possibility, and Hamisi could not state a price for the art. In his home community, far from the major tourist pathways, the idea of selling art is not common. Neither is a cash economy prevalent in a region where cattle are still the primary measure of wealth and exchange. Even the idea of a museum is not familiar. Hamisi's account of the formation of the Maasai collection reveals how the museum's request turned into a community project that amazed everyone involved:

> When the money from the museum came, it was a surprise in my bank account. I called a meeting of the community to talk. I started by asking, "What have we been talking about that can benefit us all?" I talked about how medical services, schools, and water projects have all been promised by the government and missionaries, but the promises haven't been fulfilled.
>
> Part of what the community was remembering was this past of forgotten projects and how hard a time I had in getting my education. When I wanted to come to the United States to study, a member of parliament who knew the Hamisi name and knew of my father's disagreement with politics (he burns his voting cards) had sent a letter to the U.S. Embassy telling them not to issue me a visa. He said that sending a Maasai man was not a good idea because they would develop diseases when they left the country, or they would disappear. I had to go to the U.S. Ambassador myself and ask her to issue one. She went against the wishes of this man of parliament and gave me the visa.
>
> So, when I talked with the community, I said, "Remember when I was finding the passport and visa? The MP said I would disappear or bring back disease. Here I am and this is the disease I will bring—a school that has been promised but never appears." This was well received with much respect and welcome.

Fig. 86. Elder, Lodwar, Kenya, 1978.

I told them that in return there was a museum that would like some Maasai things. I read a list I had made up, and some of the women were shocked that I knew about their ornaments. And with the *mankala* board and donkey bags—people had forgotten about some of these things. I told them I didn't want to collect them myself or collect them from any particular person, but wanted to do something that would benefit them all. That every child from any family would be able to go to the school. We just need to have things ready when I go back in January. While you are collecting, Samuel [the school-teacher] and I will go to buy materials for the school. I didn't want them to see me as the collector, but left it up to them to decide what would come. We did have problems. Forty or so women who are now Christian said they didn't want to give anyone devil objects, related to devil worship, but they did want

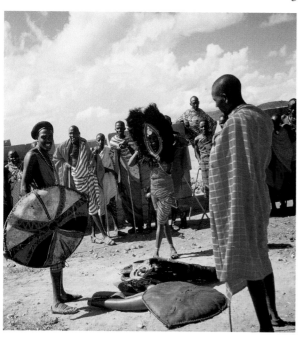

Fig. 87. Maasai collection being presented to Kakuta Hamisi by members of the Kaputiei section, 1999.

their children to go to school. Others pressured them to contribute and they did bring a calabash. All along, Samuel and I talked about how to keep this from being an issue that created individualism or became destructive for the community. During this time, the *laibon* [spiritual leader, prophet and healer] came to visit. This doesn't happen often. While he visited, women sang Christian songs to protest his visit. He said he wouldn't confront them, that "those are little things."

The community was pleased with the efforts. We didn't pay ourselves, only the architecture guy. He gave me a list of materials to make the school and we went to get them in a Kamba [neighboring peoples] town. The whole way was very powerful and emotional. We had to go to Loitokitok during rainy season. The Kamba store was surprised to see Maasai buying things for building. It hasn't ever happened before. They gave us a truck to carry things back, but it was going over a poor road and it took five days to return. We had to get the community to help by collecting rocks to make a bridge across a river that covered the road. Then they collected rocks to make the floor level. The *morans* made bricks and joked about how "we look like Kamba people now." All the generations were there helping. It was a big group process to lift the roof. The school got built. We went and got blackboards, textbooks, pens, and pencils. There are sixty kids now, three teachers, and more kids coming. Since I left, Samuel has written that people have heard about the school and are sending children to live nearby. We did what the church and government haven't done.

For the collecting part, I did have to explain what the museum was. I called it a place where *wazungu* [white people] keep things from all over the world. That I had been to this place in Seattle where they already had some Maasai things. "In America? What Maasai would take them there?" they wanted to know. This is a place where tourists don't stop, so no one knows how that happens. I told them about how an American woman had come and gotten some things.

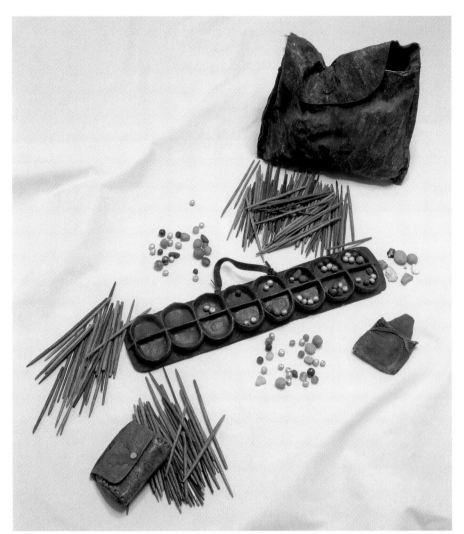

Pl. 100
Gameboard *(enkeshui)*, with leather bags
*(olbene loo-inkeek)*, counters *(isoito le enkeshui)*,
and counting sticks *(inkeek e-nkeshui)*
Merrueshi community, Maasai, Kenya
Collected 1999
Wood, rubber, leather, calfskin, rock, aluminum, glass
L. (gameboard) 61 cm (24 in.)
General Acquisitions Fund, 2000.2.1–.5

When people brought things for the museum, we did a ceremony. We cooked tea, rice, and goats and talked about how everything had been given with open hearts. My father helped to bless the whole project. This little sum did so much. But it seems like it was matched many times by people bringing their effort to it. It's a matter of trust. I think my community was shocked, confused, and amazed by what we did.

The Maasai collection now housed in the museum contains a range of art that a community chose to send to Seattle. For each object, the owner's name is noted and his or her words about the transaction are recorded on videotape (fig. 87). This thorough documentation is largely the result of Hamisi's coordination. Some of the items have seen so much use that they immediately convey a sense of the owner's long possession of them. A gameboard, worn smooth, is accompanied by two leather bags: one filled with round counters made of aluminum and glass was given to a Maasai man by a colonial officer (pl. 100); the second bag is filled with myriad small sticks used to count hundreds of game animals over many years. A donkey bag, calabashes, and a length of fence are reminders of the once completely portable, pastoral

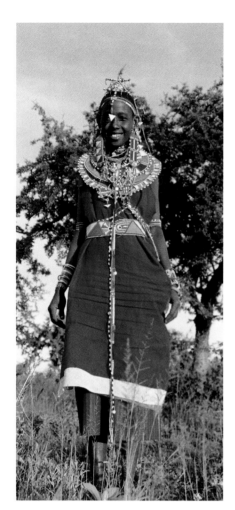

Fig. 88. Nasha ene Sipoi modeling bridal costume now in the collection of the Seattle Art Museum, 1999.

nature of Maasai life. Most of the objects illustrate that Maasai art reaches its peak of expression in ornaments. Personal adornment is worn as ensembles—that of a young warrior includes a spear, shield, ostrich feather headdress, necklaces, shoulder strap, armband, wristband, thighband, and ankleband. An elder's flywhisk, authority staff, and snuff bottle are the basic ornaments that hold importance in later life.

**You know from whence you come but not where you are going.**

—Maasai saying

Artistic brilliance is reserved for the person who is the most vulnerable. A bride as she prepares to leave home is adorned in jewelry of an exacting order. Twenty different women of the Merrueshi community of the Irkaputiei section of Maasai territory contributed twenty pieces to complete a vision of the bride as she sets out on the long journey to her bridegroom's homestead (fig. 88). Their selections show the color preferences, patterns, material choices, and specific sequence that a Maasai bride is required to wear. This is the showcase for the women's talents as beadworkers and their sense of collaboration. A bride's costume is a collection of beadwork, stories, and wishes for the future.

A young girl between ten and sixteen is told she is leaving childhood by her father on the night before her departure. He blesses her and advises her in the duties of a good wife. The next day her female relatives dress her with careful attention to each and every item of clothing. One by one, layers of her costume are added and fitted. She carries little with her—a collection of beads and a milk calabash tied onto her back. The calabash expresses a symbolic wish that her new family will provide her with milk for the rest of her life. As a new bride, she faces an unknown future. She may cry and walk very slowly, or be dragged away from her mother's house in a dramatic separation from her family.

Wearing her full bridal apparel, she walks all the way to her new home with her husband and his best man. She is expected to be reluctant, and to stop suddenly and refuse to budge when the final destination is in view. The bridegroom's female relatives rush out to greet her, first with teasing and mocking comments, but then with enticements and a feast when she finally enters her husband's homestead. The milk calabash is taken from her back, and the milk inside becomes her gift to the children of her new family. She sits all day while children and relatives come to meet her and examine her layers of ornaments.

**There is so much to explain that we don't even know how to begin.**

—Kakuta Hamisi, 1999

Hamisi affirms that women do the beadwork. Men devote all their efforts to tending cattle, sent from heaven to allow a perfect life for the Maasai. Chosen to care for these divine creatures, Maasai men are not to pollute themselves with other efforts. The grass that cattle eat is produced by God-given rain and is a holy sign. But anyone who practices agriculture, kills and eats wild animals, or works metal is tainted by handling the products of the earth. Men are not to form anything, but women form children, build homes, and create ornaments.

Maasai women in the twentieth century seized upon the artistic potential of beads provided by outsiders. In the nineteenth century, ornaments were largely made of iron, copper, and brass wire shaped by blacksmiths. Ornaments woven of fresh leaves and grasses added a layer of perfume. By 1902, massive quantities of small, durable, multicolored beads were being traded along the East African coast. As Maasai women gained access to beads through inland trade, they began to create patterns with them. Eventually, women made all Maasai ornaments, rendering obsolete the iron ornaments forged by blacksmiths of the past. What had been heavy wire spirals became light supports for colorful beads applied much like paint on canvas.

Color preferences are clear: white, blue, red, green, and orange. Yellow and black are secondary and mediate the primary colors. Patterns are built of main colors and carefully aligned accents that keep ornaments lively. Hamisi points out examples such as a necklace of primary blues and red, which "would be boring" without the two white strands that separate the primaries (pl. 101). Certain layers are compulsory, like the small blue necklace that is always worn on top; it has red and white beads on the inside and orange on the outside (pl. 102). High contrast is achieved by setting strong colors (red, blue, black) against weak (orange, green, yellow, white). Some patterns have symbolic importance. In a medallion-style necklace, the round shape signifies the universe, and the button in the middle represents the moon (pl. 103). According to Hamisi, young girls say this ornament is "like the moon that will light up the night when I need to find my warrior."

Women work closely together to create an assembly like the group of twenty ornaments for the bride, choosing pattern after pattern that declares which of the sixteen sections of Maasai territory is her home. Just a glance at an earflap can indicate where a women is from, and a trained eye can perhaps detect precisely who

Pl. 101
**Bull necklace** *(norkiteng)*
Nalepo ene Matinti
Kaputiei section, Merrueshi community, Maasai, Kenya
Collected 1999
Wire, glass beads, plastic
Diam. 34.3 cm (13½ in.)
General Acquisitions Fund, 2000.12.2

Pl. 102
**Necklace** *(emankeki kiti pus)*
Noolarami ene Solonka
Kaputiei section, Merrueshi community, Maasai, Kenya
Collected 1999
Wire, glass beads, plastic
Diam. 18.4 cm (7¼ in.)
General Acquisitions Fund, 2000.12.7

Pl. 103
**Medallion-style necklace** *(orkamishina)*
Kumolasho ene Kenedi
Kaputiei section, Merrueshi community, Maasai, Kenya
Collected 1999
Leather, glass beads, button
Diam. (medallion) 8.9 cm (3½ in.)
General Acquisitions Fund, 2000.12.12

Pl. 104
**Earflap** *(inchonito oo nkiyaa)*
Ngoto Saitoti ene Moipei
Kaputiei section, Merrueshi community, Maasai, Kenya
Collected 1999
Cowhide, glass beads, sisal twine, metal
L. 17.78 cm (7 in.)
General Acquisitions Fund, 2000.12.9.1–.2

Pl. 105
**Bride's headdress** *(enkishili)*
Ngoto Moris
Kaputiei section, Merrueshi community, Maasai, Kenya
Collected 1999
Glass beads, wire, plastic, metal
H. 14.8 cm (5⅞ in.)
General Acquisitions Fund, 2000.12.13

made it for her (pl. 104). Each section maintains its repertoire of patterns, and each generation is challenged to invent a distinctive new ornament. In this group, the triangle pattern representing an antennae is the latest design, reflecting the fact that many Maasai are beginning to use radios on a regular basis (pl. 105). Its presentation was accompanied by sung words from the youngest of the women: "I have antennae to call the warriors from far distances."

> Wives, children, and livestock bring visual returns every day.
>
> —Maasai saying

Considerable cost and effort go into a bride's ornaments. One necklace in this group is named the bull, because the family must sell a "bull" to purchase enough beads to complete it. When preparations for a wedding are underway, a mother and father will usually travel together to Nairobi to purchase beads. Wealth put in the

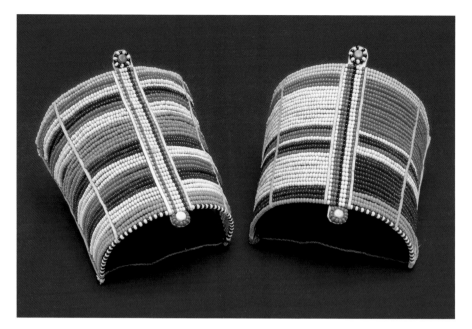

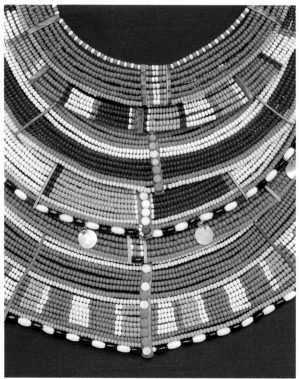

bank is not seen, whereas an investment in ornaments yields daily visual rewards. Upon returning from the shopping trip, the family is approached by women of the community who offer their beading services. Maasai women show varying enthusiasm for beading—some are tight perfectionists (pl. 106) and others are less so, but the push to exchange beading talents is constant. The bride herself creates nothing for her ensemble, but waits to receive layers from women in the community who decide among themselves which ornament will be made by which woman. Men are also given ornaments by women who favor them, and the layers of ornaments a young *moran* wears show how popular he is with the women around him. In this way, women's art has the potential to identify not only your origin but your standing. As Hamisi says, "The more jewelry you have, the more it shows how special you are and how differently you need to be treated." A collection of ornaments is also a collection of compliments from other people (pl. 107).

Maasai culture hasn't ended, despite a full century of insistence that it must. After a century of little exchange, there is now a start with the Merrueshi community and their new notion of what collecting entails. Kakuta Hamisi is fulfilling the role of an ethnographer-writer who intends to make sure that children are not "taught to see the world of the Maasai as a simple mind culture. This is the common argument. There are two different worlds—either school or Maasai, either hold a pen or hold a spear. They are two different worlds and they can't be combined because one is outdated and the other is updated." As places where people and their collections do meet and combine, museums provide a forum for reviewing notions of value and wishes for the future.

# Notes

1. Kakuta Ole Maimai Hamisi, conversations with author, 1999. Subsequent quotations from conversations with author, partially videotaped and all transcribed, June 1999 to May 2000, and from collection notes prepared by Hamisi and entered in the object files.

2. Susan Minot, "The Sophisticated Traveler," *New York Times,* September 1998.

3. Joseph Thomson, *Through Maisailand* (London: Cass, 1885).

4. Ibid.

5. Ibid.

6. Quoted from a British officer's letter, 1890, cited in Richard Waller, "The Maasai and the British 1895–1905: The Origins of an Alliance," *Journal of African History* 17, no. 4 (1976), 538. Waller provides the estimated mortality rate (p. 530).

7. Ibid.

8. Mohamed Amin, James Eames, and Deborah Appleton, eds., *Insight Guides: Kenya* (Boston: Houghton Mifflin Co., 1993), 56.

9. Report by Cransworth in Charles Miller, *Lunatic Express* (New York: Macmillan, 1971).

10. Theodore Roosevelt, *African Game Trails: An Account of the Wanderings of an American Hunter-Naturalist* (New York: Syndicate Publishing, 1909–10), 2.

11. Hilde Thode-Arora, *Pfenning um die Welt: Die hagenbeckschen Voelkerschauen* (Frankfurt: Campus, 1989).

12. The school was the Boydton Academic and Bible Institute, Virginia.

13. J. T. Mpaayei, personal communication to Kenneth King, cited in "The Kenya Maasai and the Protest Phenomenon, 1900–1960," *Journal of African History* 12, no. 1 (1971), 117–37.

14. British Museum, *Handbook to the Ethnographical Collections* (London, 1910), 187.

15. Isak Dinesen [Karen Blixen], *Out of Africa* (New York: Random House, 1937).

16. Edgar Monsanto Queeny, "Spearing Lions with Africa's Masai," *National Geographic Magazine,* October 1954, 487–95.

17. Phrase from lecture by Angela Gilliam, Seattle Art Museum, 1995.

18. Katherine White Journals, Seattle Art Museum.

19. Ibid. This encounter was with a Turkana elder, but the episode reveals the degree of personal involvement with this art form so well that it is included here.

20. Donna Rey Klumpp, "Maasai Art and Society: Age and Sex, Time and Space, Cash and Cattle" (Ph.D. diss., Columbia University, 1987).

21. Tepilit Ole Saitoti, *Maasai* (New York: Harry N. Abrams, 1980).

# Appendix: Sande Society Stories

The following transcribed narratives are reprinted from Donald Cosentino, *De°ant Maids and Stubborn Farmers: Tradition and Invention in Mende Story Performance* (Cambridge: Cambridge University Press, 1982), 164–79. See above, "Beauty Stripped of Human Flaws: Sowei Masks."

## 1. A Defiant Maid Marries a Stranger

Date:            September 19, 1973
Time:            About 8:30 P.M.
Place:           Verandah of the Samba compound, Njɛi Woma quarter of Mattru,
                 Tikonko Chiefdom, Southern Province, Sierra Leone
Performer:       Hannah Samba, a widow about 50 years old, a farmer
Audience:        Three adult women, one young man and three children

HANNAH:    *Dɔmɛi ɔɔ Dɔmɛisia.*
AUDIENCE:   *Sa Kɔndɛ.*
HANNAH:    Behold this girl from long ago, she was a great fornicator. She continued fornicating for a long time, then they initiated the Sande society in the town. Spirits came from the big forest; they came to this dancing place. One of the spirits was named Kpana. When that spirit came, he spoke words of love to her. She accepted these words of love spoken to her, but she said nothing of it to her parents. The spirits slept the night, then at daybreak they begged leave to go. They said, 'we are going tomorrow.'

She and her companions (they were five) went with these fellows; they accompanied them. Now they went accompanying them. Then their lovers said to them, "My dears, go back. Our destination is not pleasant." For that reason they said, "Go back!" Then they returned, those four, and she alone remained. Then her lover said to her, "Yombo go back!"

She replied, 'Let's go there.'

He said, 'My destination is not pleasant, for that reason, go back!'

'*Koo,*' she said, 'Kpana, your dying place is my dwelling place. No matter where you go, I must go!'

She begged him a long time. He gave her a hundred pounds. 'Oh,' she said, "I'll go for sure now.' She said, 'Even if you gave me three hundred pounds, I'd follow you wherever you go.'

So he said, 'All right.'

As they were going, this Kpana ... all these things he had, these handsome features ... behold, he was a Big Thing! His human features, all those features he had borrowed, they were finished. As they reached a place, he would go to visit that person and return his own handsome feature. As they reached another place, he would visit that person and return his own handsome feature. So he changed back into a spirit. Then they reached deep into his own forest.

Before they arrived at his own place, while that fellow was changing himself, a great fear came over her, but there was nothing to be done about it because they had gone so very far. There was nothing to be done now for her return. So she showed her womanness, her heart was strengthened now. They traveled far now to that Big Thing's own place.

At daybreak this Thing would go to the bush, the hunting place. He'd go there and catch this person, then he'd go back and catch an animal, a bush animal, and he'd come with it.

He would say, '*Hɛ hɛ,*' he would say, 'Yombo, Yombo, the smooth one or the hairy one, which do you prefer?'

'*Koo,*' she said, 'Father, we have always eaten the hairy one over there.'

He said, 'Then here it is.'

Then she took the hairy one and the Big Thing took the smooth one and ate it. He ate it all.

They stayed there. They sat together, and so they knew each other now. She stayed there and then she bore a child.

That Big Thing, long ago he'd sleep for a year. When he was sleepy he would lie down and he would sleep for one full year, and then he would wake up. (Ah, this stubbornness she had, she would show it again in the same way.) So this Big Thing packed up plenty of things, plenty of food, enough for her for one year; he gathered it all, and he came with it. He packed it all in one house till it was full, because he slept one year before he would wake. Then that Big Thing informed her about that.

'*Kwo,*' she said, 'I don't agree to stay out alone. We two, let's go into that house together.'

'*Ee,*' the Big Thing said to her, 'Yombo, this thing I said to you, listen to me.' He said, 'I will sleep for one year.'

She said, 'Let's go into that house together, I'll make that sleep too.' She thought it was a joke he was playing on her.

So they entered that house. She and that Big Thing, they entered that big story-house. It was all made of iron, even the window sills. So that Big Thing entered: *gbugbuŋ gbugbuŋ gbugbuŋ.*

Then all that house was locked, it was finished *seŋ.* Then he went and lay on his bed. When he went and lay on his bed, the Big Thing made this snore: I WILL SLEEP A YEAR, I WILL SLEEP A YEAR, I WILL SLEEP A YEAR.[1] He made that snoring sound. He stayed making this snoring sound a long time. He did so for two months, then for three months. In the fourth month the child in Yombo's hands became sick. Even though the child was sick in her hands, oh friends, the whole house was locked with iron! Thus, she could do nothing at all to open it. When this child was sick now in her hands, she thought it was a joke this Big Thing was playing on her. Oh *yaa.* She sang a song to this Big Thing lying there in sleep. She said:

> Don't sleep *lekemɔ,* don't sleep *lekemɔ.*
> You deceiving in-laws, you deceiving in-laws,
> Your child, look at him dying in my hands.
> Look at me dying like this.
> I WILL SLEEP A YEAR, I WILL SLEEP A YEAR.

She stayed singing that song. She stayed singing that song. Then that child died in her hands. When that child died in her hands, she herself fell down. She too fell and died.

For a long time that Big Thing was lying down. The year completely passed and he awoke. When he awoke, he discovered their bones there. He discovered them scattered there, she and her child. When the Big Thing got up, he took a straw broom and

an empty dustpan and he gathered those bones *we we we*. He went and threw them away.

Therefore stubbornness isn't good. Whatever you do, whenever a person says, 'Don't do this,' listen to him.

My story passes to...

## 2. A Defiant Maid Marries a Stranger

Date:          September 19, 1973
Time:          About 9:00 P.M.
Place:          Verandah of the Samba compound, Njɛi Woma quarter of Mattru,
                    Tikonko Chiefdom, Southern Province, Sierra Leone
Performer:    Mariatu Sandi, a women about 30 years old, mother of three children,
                    a cook, a gin-seller, a nursemaid
Audience:    Three adult women, one young man and three children

MARIATU:    *Dɔmɛi ɔɔ Dɔmɛisia.*

AUDIENCE:  *Sa Kɔndɛ.*

MARIATU:    Behold these spirits long ago, there were twelve of them in their forest. Then a dance was held in the town; it was a big Sande initiation dance, a dance for getting married. There were two dances being held in one town. Then all these spirits, they all changed into young men. Oh! the beauty of these young men! When all the women saw them, they wanted them, without even getting a present! So they were all dressed up and coming to the dance; then they came and they all made love in the town—these twelve, all of them. They got twelve girls at this dance, and they danced for ten months—there remained only two months for completing one year.

Then they begged leave, they said, 'We are leaving tomorrow.'

All those small things which they had, they gave to their lovers. Then at daybreak they caught the road. Their pals went along as guides. There was one girl among them who was very stubborn; moreover, she was really seeking a man. (This story I'm telling, I'm telling it for us fornicators, I'm telling it for none other than we who truly commit adultery; it's our story I'm telling. We whose ears are closed to every warning, we stubborn people and we insatiable fornicators, this our story.) Then these companions of hers, the eleven girls, they went back. So of these twelve spirits also, eleven spirits all came out from their places one by one. They came to their meeting place on the big road; then those eleven went back.

So he remained alone, he and his girlfriend. So he said to her (this spirit is named Kpana, the girl's name is Yombo), he said to her, 'Yombo—return! There where we're going, there it is bad.' He said, 'You see all your comrades have returned; you too, I beg you, go back.'

On his finger there is a beautiful gold ring. When he went like this [*turning gesture*], it glittered. Really, long ago white people took it and turned it into electricity which shines so today...

AUDIENCE: *Kwo!*

MARIATU:     Then he gave it to her and said, 'Go back!'

She said, 'I won't go back,' She said, 'Wherever you go, I will reach there. Your dying place is my sleeping place.'

This spirit then took out a kola from his trousers (from the small place where we put something—we call it *bɔi*, the white people call it pocket—it was on his trousers); then he took out the kola from the inside of the *bɔi* and he split it and gave part of it to her. So this girl took it in her hand, and the spirit also took part of it in his hand.

They went far, they passed one bush; then he said to her, 'Yombo, wait for me.' He said, 'Let me go into the bush.' (It is a shit place in Mende. You people, when you're out walking a Mende man might say, 'Let me go to the bush,' it's the wish to shit which is on his mind.) He entered the bush but it wasn't shit he was shooting. The first person he reached was the hairy person. (As you white people there, your hair is now, so too was his hair which he had lent to the spirit.) The spirit's own hair was really only one strand on his head. Then he took this hair and he went with it.

He said, '*Ee*, Hairy Fetingo my dear, I have your hair. Give me my one hair back.'

So Hairy Fetingo then grabbed his own hair and returned the spirit's one hair to his hand.

AUDIENCE: *Kwo!*

MARIATU:     As he was coming out then this Yombo said, 'What the hell?' She said, 'What's coming?'

He said, 'Don't fear me, it's me Kpana.' He said, '*Hɛ hɛ hɛ* . . . Yombo, Yombo, your own kola, my own kola—isn't this it?'

Then he pulled this kola from his *bɔi*, his pocket; it's really the one. He said, 'Your own kola, my own kola, isn't this it?' He said, 'Let's go!'

This now caused a great fright. They went on and they reached Hakawama. Then he entered with two legs. He went and he returned them. Only one leg is under the spirit. He had returned them to him. I say it was like elephantiasis. Then he returned and Yombo feared him.

She said, 'Why is it as we traveled today my father's legs were two, but now he has one leg?'

He said, '*Hɛ hɛ hɛ* . . . your own kola, my own kola, isn't this it?'

She said, 'Father, let's go then!'

This created a great fear in Yombo. All those things God made for mortal men—his fingers, his hair, his neck, everything—this Kpana returned them.

Then they went and they reached a river. At this water-crossing place long ago there sat this fellow at the water's edge. He crossed the river with people in his boat. His name was Sherbro Man. As they were going then, this spirit told the Sherbro Man that he should cross the water with them. Yombo herself, as she walks beside men she is happy; she sucked her teeth at this fellow, Sherbro Man. Then she sang this song:

Sherbro Man—Sherbro Man—Sher . . .

You all say it.
AUDIENCE: Sherbro Man—Sherbro Man—Sher. . . .
MARIATU:   Cross the river with me-o
           I can't cross the river with you,
           You big fat lip.
           You go about eating dirty broom straws.

They continued like that, then they went and they reached his hometown. So this Sherbro Man remained sitting at the riverside.

Thus they reached this spirit's cement-block houses which long ago this spirit had built. It's only in America that there is this type of house. In the whole of Freetown, all Freetown, there isn't a block house of this kind. (If you tell lies, it's like this you should do it, you should arrange it so): the mirrors of these block houses, it is those which long ago the white people worked over and fastened to their car fronts which go about today on the roads helping people.

At daybreak this spirit would go to the hunting place. He'd go hunting and catch animals; sometimes he'd catch nine hundred animals. Of living people, sometimes he'd catch seven people. Then he'd come with them and pile them *bushu*, he'd pile them *bushu*, then he'd fall down. He lay there, he was exhausted. He remained lying a long time; the sun would set over there in the sea.

Now hunger wasn't troubling Yombo, simply because as soon as they arrived, he gave food to her which would suffice for two days. So Yombo was experiencing fullness.

He said, '*Hɛhɛ*, Yombo, Yombo, the smooth or the hairy one, which do you prefer?' (It's the devil's voice which is heavy like this.)

Yombo replied, 'As for us, Father, we usually eat the hairy one.'

Then he said, 'Take whatever you like.' (The spirit spoke like that.)

So Yombo remained taking care of this meat. While she was preparing this one, that one would be spoiling; that one would be drying; that one would be frying; that one would be steaming; that one would be salted. This fellow also put those human beings, all those seven people he had caught, in a place where he could eat them for seven months.

They stayed like this for a long time, then Yombo became pregnant. She bore a child. The child's name is Bobo (his father's name is Kpana, his name is Bobo Kpana). That child stayed there long, then he grew and he became truly handsome. He reached the age of a grown man, this Bobo Kpana.

So one year passed. Then Kpana went again to the animal-hunting place. When Kpana went to this hunting place, he would stay there for up to nine years hunting for these animals. He stayed in this hunting place because Yombo hadn't done anything to these nine hundred animals; some had maggots in them.

Then one man came and said, 'I've come, let's stay together in this place.'

She said, "Hm-m-m, I agree to this proposal to stay together which you've brought, because I'm here alone, the only living person, I and this my small child.' She said, "This person who long ago came with me is a spirit. Any kind of food I

want, he hunts for it; he puts it in this house; he fills it *koobɔŋ*. When it's there we'll be eating it, we'll be playing in it, whatever we want with it, we do. But as you've come here, whether from Jericho or from in back of Freetown or from the stone-growing place, from wherever, father's nose will discover your smell. He'll come and when he comes, he will eat you yourself!'

He asked, 'Why?'

She said, 'He eats people. The only people he doesn't eat are me and my child. He doesn't eat only us two. Despite all that,' she said, 'we'll stay here.'

Then this girl cooked food quickly and she gave it to this fellow, to this guest. The guest's name is Majia. Then she gave it to Majia and he ate it. Oh ya. Then this spirit's coming-back time arrived.

A big storm was brewing. It was that very storm that God shared out between the land and the sea. When you are sitting by the sea and you hear it *daa daa,* it was such a storm; it does that in the sea. That storm would do that long ago, whenever the spirit returned. That very storm by the seaside which you hear *daa daa.* Oh ya. It started from over there and it reached nearly to the end of the world.

She said, '*Koo,* young man, this living together we've been doing, my husband's arrival time [*wati*] is now approaching.' (White people, you call it *taimi,* we call it *wati.*)

She said, 'The time is now approaching. This is what he said he'd do, and he's coming.'

Then shit came out of the girl. That very shit, it was none other than pig shit; it came out of her. Oo!

Then he came. So she picked up the youth and carried him there, to the tenth story of this skyscraper, this many-storied house that he'd laid—so far, *poloŋ!*

Actually, when this spirit would come, he'd drop down for seven years before he woke up. Just as he arrived, the spirit came and assembled those things. He said, '*Hɛhɛhɛ,* Yombo, Yombo, the hairy one or the smooth one, which do you prefer?'

She said, 'Father, it's the hairy one we eat, we in our own country.'

He said, 'Well then, take it.'

This spirit then lay down. His nostrils started doing this, so he said, 'Hm-hm, a fresh-fresh person is smelling.' (That one was a spirit.) He wanted to know what the girl had done for those seven years he had been to the flesh-hunting place.

'*Ee,*' she said, 'I say Father, you know Kpana Bobo is a human being; myself, I'm a human being. You say a fresh-fresh person is smelling; what about these people you came with, aren't they fresh-fresh people?'

He said, '*Hɛhɛhɛhɛhɛ,* Yombo, Yombo, I don't know what you're thinking of. Don't make a fool of me. I say a fresh-fresh person is smelling.'

They kept on [arguing] like that for a long time. Then that spirit forgot [about it]. So he arranged all those affairs.

So this person who had come today, whom Yombo had lifted to the sky, he had a *kpafei.* This *kpafei* was the kind twins also have. It was long and thin and small like this; it was inside his hair. All this wealth passing in the world, you white people, that wealth (of yours), it is Yombo who long ago came with that wealth which you white people came with. You who are giving us money, who are partial to our affairs, it is

Yombo who brought it. Well, then Yombo gathered up all that wealth and the lover brought out his *kpafei* for the sake of that one meal she had given him.

He said, 'I have struck the *kpafei gba!*'

The spirit was lying asleep because he used to sleep for even more than seven years. He was lying in this sleep.

He said, 'I have struck the *kpafei* here *gba!*'

He said, 'The block house, the skyscraper, the zinc roof, anything whatsoever a person needs, bags of rice, a thousand bags of hard rice,' he said they should all enter in his *kpafei*. He said that a thousand goats should enter into this *kpafei*. He said a thousand sheep; he said anything whatsoever, a thousand of them—cows, ducks, chickens, all—should enter (the *kpafei*).

Then this lover said he would strike his *kpafei* here and Kpana Bobo should then enter this *kpafei*. He said his mother also should enter and she entered in. So one year passed *tuŋ*. This spirit was in sleep; he slept, he slept, he slept *pu*. This fellow hit the road with them. As they were going *taki taki taki,* they slipped *tele* and they fell. Ah, then this spirit who had slept for five years awoke from his sleep and he hit the road. There he is hitting the road. Oh, the town is far. When you would be returning, you'd forget the road you had gone on, you would take another road. But this fellow, he knew the road which went to town.

They continued going, then this spirit said, 'Aa, great God, if you took a person and you came with her to your town, and you gave (gifts) to her, and you did everything for her, and then she went and she didn't even say goodbye to you—Oh, oh! it's me Kpana,' he said. 'Whatever she wanted I did for her. She stole all my wealth—my cows, my sheep, horses, chickens, ducks, pigs, everything—she went with them. She didn't even say goodbye to me! Oh Maker, that's the truth, I don't see her anymore, she's not here. Oh let me reach her now.'

I say, when this spirit arose the distance between them was from this verandah pillar here to the door of that house over there.

Then that fellow turned and from the inside of the *kpafei* Yombo said, '*Kpo!* Buddy, turn around, the spirit over there is coming up behind us.' Then she too said, 'Great God, suppose a person comes with somebody's child to his own town and doesn't return with her to her own sleeping place, doesn't return her to her own sleeping place? This spirit came long ago with me. He met me long ago on love business, he loved me; he said, "Come with me," but he wants to eat me! Maker, help me so that I might reach my own family.'

I say, a wind it is that set upon them. They remained going a long time, *haaŋ*, then that spirit slipped and fell. He was to remain four hundred hours in that fall. He was paralyzed, he couldn't get up.

They remained going *haaŋ*. At last they reached the outskirts of the town. The spirit had truly failed now, for when he saw the people in the town, then he became afraid. He didn't go on any further, but he returned. When he returned, there was nothing there, merely an empty farmhouse. He discovered that termites had eaten and finished off everything. All is broken and scattered *wojoŋ*. Food too he couldn't get; that spirit himself, he could get nothing.

So that fellow arrived beside that town with these people. Look at the house. Look at the town.

Then he set them down and said, 'We have reached there.'

Kpana Bobo and his mother Yombo got down then, and they greeted all the townspeople. All the people had missed them, but they didn't recognize them, for she had been just in her youth. She was a lovely, lovely youth when she got up long ago and followed that spirit.

Her real mother who had given birth to her, she had dried out. They had ground her up and put her in a jar. When her child came back, just then they turned it upside down and they shook her out. So that woman returned; she changed into a living person in God's chiefdom. Then she went and saw her child, and they went about greeting people.

The people agreed when she said, 'Hey, give me a place to build on.'

I say, no sooner was that said, then all of a sudden there was a town like Salɔŋ over there (like Freetown, where you were recently). So it was that town was like that. At once they were all joined together and cement was smoothed on there and tar was rubbed on and streets were laid everywhere reaching to all the forests, completely finished, seŋ.

Yombo it is who brought cement houses. She it is who long ago came with riches; she long ago brought cow stables and tame pigs. That stubbornness Yombo practiced long ago, her own suited her. Ah, Yombo has done this for us today. We who now stay in shiny places which they call 'zinc roofed,' we used to put elephant grass on top of our houses. Yombo it was whom that spirit enriched with his wealth. It is thanks to that food which she gave that young man, it is that which long ago brought wealth to the world, all that wealth of old.

I've heard that and I've said it.

## 3. A Defiant Maid Marries a Stranger

Date:           September 19, 1973
Time:           About 9:00 P.M.
Place:          Verandah of the Samba compound, Njɛi Woma quarter of Mattru,
                Tikonko Chiefdom, Southern Province, Sierra Leone
Performer:      Manungo, a woman about 70 years old, widowed and childless, an
                herbalist/midwife
Audience:       Three adult women, one young man and three children

MANUNGO: *Dɔmɛi, ɔɔ Dɔmɛisia.*
AUDIENCE: *Sa Kɔndɛ.* (Don't tell a long story, Manungo.)
MANUNGO: It's the ending of jealousy I'm going to explain to you.
AUDIENCE: The *dɔmɛi* you told yesterday, don't tell it again!
MANUNGO: That's not what I'll tell you. I'll tell about jealousy; that's what I'll show to you.

There was a dance long ago; they initiated a great Sande society in a town. So a great dance took place. *Jeŋe jeŋe jeŋe* then the ancestors came out; ancestors, they were spirits, I'll call them ancestors. Then they came to that dance. They were two only.

A girl named Yombo. The bush person who came long ago is named Kpana. He proposed love to her. His mate, his name is Jinabemba, he proposed love to another. So they made love for three days at this dance; then they said, 'We're going.'

So they accompanied them. Then his mate told his own girl to go back. He said, 'Go back!' So she went back.

Yombo said, 'No matter what, you and I will go together.'

Her lover replied, 'Over there where we're going is far. Therefore, don't follow me!'

'*Koo,*' she said, 'my dear, since you've already loved me, I love you. Over there where you really stay, where you come from …'

He said, '*Ee?*'

She said, 'You and I are going there.'

Then they went. While they were going, they came to a small stream and they crossed it. He had a kola nut; he split it and gave part to her and kept part himself. So they went a while longer…

AUDIENCE:   Don't tell lies.

MANUNGO:   If I'm lying, when frogs make their croaking… I'll stop there, I'll say no more.

Then they crossed a small stream, and he split the kola *va,* and he gave his girl her own, and he kept his own. Then he said, 'Don't go back!'

She said, 'I won't go back.' So they went on. They went on a long way, then *va,* a chain came down from the sky. *Yoyoyoyo,* it came down.

He said, 'Girl…'

She said, '*Ee?*'

He said, 'With this chain, you and I will go to that town.'

She said, '*Ee.*'

He said, 'Hold this chain well.'

She said, '*Ee.*'

He said, 'Hold on to my waist tightly. I'll hold this chain, and you hold me tightly, hold on to my waist tightly. If one lets go of this chain, he'll fall and die.'

So he held that chain and said:

> *Jeŋ jeŋ jeŋ jeŋ jeŋ*
> *Ma jeŋ ki jeŋ*
> *Jeŋ jeŋ jeŋ jeŋ jeŋ*
> *Ma jeŋ ki jeŋ*
> Let's hold the rope well, let's go.
> I told you long ago
> My destination is Bugbalee.
> *Jeŋ jeŋ jeŋ*
> *Ma jeŋ ki jeŋ*
> Let's hold the rope well, let's go.

He would say, 'Let me say to you …'

She said, '*Ee?*'

He said, 'When you joined me, as we were going, I explained to you that when we reach that town, if you see a frog, or an earthworm, or a person with sores, or a sick person, or a leper, and if they come up to you with joy, you must greet them. You must not back away; do you understand?'

She said, '*Ee.*'

He said, 'You must not back away, do you understand?'

She said, '*Ee.*'

He said, 'Do you understand?'

She said, '*Ee.*'

> *Jɛŋ jɛŋ jɛŋ*
> *Ma jɛŋ ki jɛŋ*
> Let's hold the rope well; let's go.

They continued going; they continued going; they continued going; they reached a town like Mattru is now. They reached there and he said, 'You see that town there?'

She said '*Ee.*'

He said, 'Love …'

She said, '*Ee.*'

He said, 'I told you we love each other. For three days I stayed in your town, you said you and I should come; I said "Don't come," I said, "my sleeping place is far": you came closer, *koniiiŋ.* Now, as we're going [to the town], if you see a person with sores, or a frog, or a worm, if it comes to you *jogba jogba* [saying] "My wife has come! Mother has come! Something has come!", don't back away! If you back away from them, you'll be severely punished.'

> *Jɛŋ jɛŋ jɛŋ*
> *Ma jɛŋ ki jɛŋ*
> Let's hold the rope well; let's go.

*Kpuŋamɛ,* they arrived in the town. People rushed to them: *kpi,* you'll see that one coming, *tiŋ,* big balls is coming *diŋde,* all sorts are coming (shouting): 'Our wife! Our brother has come with our wife. Our brother is coming …'

Then that one came and she hugged him *vigba,* they embraced. Then that one came, *vigba,* they embraced. Then that one came, vigba …

They entered the house, *kote.* He said to her, 'I said to you …'

She said, '*Ee?*'

He said, 'If my real mother who bore me, if you see her and if she has a sore, if she has a sore on her and there is nowhere that pus doesn't come out of her, and blood comes out of her, don't back away from her, okay? If she cooks food and gives it to you, don't back away from it, okay? Whatever sort of person comes, even a leper, remain seated. If she cooks food and gives it to you, don't back away from it, okay?'

She said, 'Yes.'

When she went, they all did (as he has said) with her. One month finished there, *kpoŋjoŋ.* Behold—all those people were good people!

So at daybreak her husband's mother said to her, 'Young lady, boil a little water so I might wash, okay?'

Then she boiled that water and she gave it to her. She washed with it. She showed her woman's strength for three days. Twice she brought the boiled water. On the third day she said, 'Girl...'

She replied, '*Ee?*'

She said, 'This water you've boiled for me so I could wash. Go in that forest now. You'll really see a wood which is very hard, like this *nikii* whip; it's really tough, *klekle.*'

She replied, '*Ee.*'

She said, 'You break it. Shake the leaves off, tie it tightly and come with it. Then you wash this sore, treat it *seŋ,* and then strike it *voli.* When you see something jump out at you, that will be yours.'

Then that girl left her washing and cut that thing—that *nikii* whip—quickly. She came with it. She cleaned the leaves off *poli;* she tied it like the *kɔɔgba* bundle which Wunde society people had long ago. When she came to that sore, she whipped it; she whipped it, *tɔnjɔŋ.* A gold ring which was the first on a chain jumped out. *Tɔnjɔŋ:* iron boxes, three iron boxes which were huge jumped out; all the iron boxes were her own. She went back and she whipped it again. She got that thing, that leopard's tooth, which if you had long ago, you were rich. So they lifted that big box, and the girl got up then, and she went with it to her house.

Then he said to her, 'Yombo...'

She said, '*Ee?*'

He said, 'When you take leave of me (your leaving-time is approaching), let me tell you: don't spoil things! When you take leave of me (your leave-time approaching), I'll report it to my family. When you go...'

She said, '*Ee?*'

He said, 'That box in that house, that iron box, if you see a very, very dirty one... are you listening?—don't pick out the shiny one! Okay?'

She said, '*Ee.*'

He said, 'Don't pick out the shiny one! Okay?'

(Co-wives' jealousy is what I'm getting to now.)

She said she agreed. They slept two nights. On the third she was going. So he went and arranged her leave-taking with his family.

He said, 'This girl who came accompanying me says she is leaving now.'

They said, '*Koo*—Kpana, let's sleep on this. At daybreak we'll discuss it.'

In the morning the girl washed herself completely. She brought her own mother-in-law's water and she washed. They said, 'Let's go there.'

Behold this they had built, a round house. It was a round house they had built. There is a center pole, one hundred people could sit on that seat. People of olden times used wood like that over there to circle a pillar with a seat.

So they crowded about *veŋjeŋ.* They said to her, 'Come and sit.' Then they gave her a chair. They said, 'My dear...'

She said, '*Ee?*'

'Our brother has come with you, but you say you are bidding us goodbye, you

are going. Therefore, of those boxes standing there, which ones do you want to go back with?'

Then she pointed at one dirty one. So they took that one and set it over there. Then she pointed at another, and they took it and set it over there. Then she pointed at another, and they took it and set it over there. All three boxes, they are really boxes. Those who don't lie say that box—those three boxes—which that person pointed at stretched from here to that bridge over there. As for me, who *am* a liar... well, I'll stop there!

Then she went. The road they had gone on long ago was very far; her journey wasn't short. One mile—that second one—then *tjatjala* she jumped out there. Her family cried out; they were very happy; they were very happy; they were very happy.

Her co-wife and her own child are there. (This fornicating we're doing, we and these women are doing it... the ending of jealousy is what I'm getting at now...) That girl handed over those gifts to her family—goats... all sorts of things—my father, that family was now rich! That woman nagged her child all the time, 'Look at your mate. You're forever looking to get laid, but you get nothing for it. Look at your mate, she and you from one house! Those fellows came long ago, you hung around with them, but now she comes back with all that wealth for her family!'

God Almighty said, 'This [affair]—yes, I'll also see the end of this!'

After a short time, another dance was held again. *Wujugu,* a lot of people came again to that dance. When they came *feŋ,* her child hung around with that fellow. Her own now, he too slept for two nights, on the third...

AUDIENCE: Was it the same fellow?

MANUNGO: No, it was another. They slept for two nights. She said, 'Let's you and I go.'

'Let's you and I go.'

'*Koo,*' he said, 'girl, don't go!'

'Sweetie, my dear,' she said, 'let's you and I go there.'

He said, 'Don't go!'

'My dear,' she said, 'as I've said, let's go there!'

They went far. As they were going he said:

Swing me gently *vio,* swing me gently-o.

A chain was entwined around her. I'll sing this song:

Swing me gently *vio,* swing me gently-o.

It was a chain. You know how quick tricks are!

Swing me gently *vio,* swing me gently-o.

*Kunje,* they jumped down and landed in the town. Behold the town over there.

He said, 'Girl...'

She said, '*Ee?*'

He said, 'When we go there, you and I, you will see sick people. You will see a worm, you will see a millipede, you will see all sorts of things. Don't back away from them! Do you understand?'

She said, '*Ee.*'
He said, 'Now that we're reaching the town, have you understood me?'
She said, '*Ee.*'
He said, 'You've seen the town, have you understood me?'
She said, '*Ee.*'
He said, 'This instruction I'm giving you, don't disregard it!'

> Swing me gently *vio,* swing me gently-o.
> Swing me gently *vio,* swing me gently-o.

*Kunje,* they landed in the town—'Our brother's come with our wife!'

'*Koo,*' she said, 'what the hell is this? Good heavens, my dear family, look at these nasty things—the filth I've entered into—ah, this screwing around will really throw someone's head off! God Almighty, don't let such filth get on me here.'

While she sits there then a person comes, his balls swinging *tiŋbeŋ.* '*Koo,*' she says, 'what kind of dangerous thing is coming?'

Since she came as a guest they cooked food that night. They cooked food and gave it to her. She ate it, '*haaaa*' (she was vomiting). On the third day she still hadn't eaten. The fellow said, 'This marriage is bothersome to me.'

'*Koo,*' she said, 'my dear, my dear, if it's like this here, since you brought me here, then try to help me for I'm going. I'm returning tomorrow.'

The fellow said, 'Is that right?'

She said, '*Ee!*'

He said, 'Let me report this tomorrow to my family since you're going back.'

That night he reported to his family, he did everything *seŋ.* He said, 'This girl I came with wants to return; therefore, I'm reporting to you.'

The people again said, 'We agree.'

At daybreak the following day, as the dawn was breaking, they filled their huge round house full to the top: *kpa.* Then they said to her, 'Girl, you came with our brother, you and he came and we loved you boundlessly, yet, nonetheless, you're going back. From among all these boxes …'

She said, '*Ee?*'

They said, '… take your heart's choice. The one you choose you may take and go with.'

Then her head went like this, she showed her choice like this: 'That's it. I want that very shiny one with gold rubbed all over it, the one with gold rubbed all over it!' (Really, if you didn't squint your eyes or when you open them, if you didn't squeeze them hard, you wouldn't be able to set your eyes on it.)

So he took that one and he set it aside. Then she looked at another and he set it aside. Her mate had taken three but she took four! They set them on her head …

> Swing me gently *vio,* swing me gently-o.
> Swing me gently *vio,* swing me gently-o.

She's gone. Behold—she's gone.

*Kule*: suddenly she reached the town. Her mother said, 'Oyaya, my child…'
That huge box, *ngwungwungwungwungwu* (they struggled to pick it up).

AUDIENCE: Will they be rich soon?

MANUNGO: Ah, my family, those boxes, none of the people could set their eyes on them unless they hung a cloth before their eyes. Then they could set their eyes on them.

AUDIENCE 1: Manungo, why didn't he, her husband or lover, explain about those boxes to her?

AUDIENCE 2: She didn't listen to his words so he didn't explain to her… don't make her go backwards!

MANUNGO: They went and spent the day; then they slept the night *gbu*. At dawn then she assembled her family like a wife who has returned from her husband's place laden with gifts her man had given her.

AUDIENCE: Just her family?

MANUNGO: Mm-m. Just her family. Then that girl said, 'My family, let's lock our house up tightly.' So they locked up the house tightly. They closed their bedroom doors tightly *kpaŋ kpaŋ kpaŋ*. Like our house is right now closed *kpaŋ*, so it was the same with their own. Then that person opened the big box and all those Things' teeth were like this. They killed them all! They cut their heads off!

Ah, therefore, to have your eyes set on a thing is not good. I've heard that little story and I've told it. My story now reaches to you…

## Note

1. The Mende words *nga yii foo* also simulate the sound of a person snoring.

# Index

## Photography Credits

Primary photography by Paul Macapia. Additional photography by Basel Mission Archive: figs. 17, 18; The British Library, London: fig. 8; The British Museum, London: figs. 50, 84; Eduardo Calderón: pls. 40, 42, 43, 62, 63; Henning Christoph: figs. 7, 11; David C. Conrad: figs. 12, 13, 14; Henrietta Cosentino: figs. 66, 67, 68, 69, 70; Adolf Diehl, courtesy of the Photographic Archive, Linden Museum, Stuttgart: fig. 27; Teresa Domka: figs. 78, 79; Eliot Elisofon, courtesy of the National Museum of African Art: fig. 77; Ron Forth: fig. 48; Paul Gebauer, courtesy of the Metropolitan Museum of Art, New York, Archives of the Department of Art of Africa, Oceania and the Americas: figs. 24, 26; Rosalind I. J. Hackett: fig. 75; Kakuta Ole Hamisi: figs. 88, 89; Franko Khoury: fig. 49; Hans-Joachim Koloss, Berlin: fig. 37; Babatunde Lawal: figs. 76, 77; Schecter Lee: fig. 51; Paul Macapia: figs. 3, 4, 47, 54, 62; Kris McClusky: figs. 55, 59; © 1986 The Metropolitan Museum of Art: fig. 51; Fred Meyer: fig. 19; courtesy of the Morris Library, University of Delaware: figs. 42, 57; Lester Mount: fig. 65; Kenneth Murray, courtesy of Perkins Foss: fig. 52; © Musées de la Ville de Paris: fig. 41; © 2001 The Museum of Modern Art, New York: figs. 10, 56; Bruce Onobrakpeya: fig. 53; Samuel Orekai: fig. 87; John Pemberton III: fig. 6; Claude Picasso: fig. 58; Edgar Monsanto Queeny: fig. 85; Chris Rainier: fig. 82; Kermit Roosevelt: fig. 83; Malcolm Ruel: fig. 73; Cynthia Schmidt: figs. 63, 71; Evan Schneider: figs. 23, 28, 31, 35, 36, 38; Gilbert Schneider: figs. 25, 30, 32, 33, 34; Thierry Secretan: figs. 80, 81; Robert Farris Thompson: figs. 2, 5, 46, 60, 61, 74; Katherine White: figs. 9, 20, 22, 86.